Water-Mixable Oils

First published in 2023
Search Press Limited
Wellwood, North Farm Road,
Tunbridge Wells, Kent TN2 3DR

Text copyright
© Sarah Wimperis, 2023

Photographs by Mark Davison for
Search Press Studios except for
pages 20–21, 44, 48, 54 and 90;
photographs by Sarah Wimperis.
Photographs and design copyright
© Search Press Ltd. 2023

ISBN: 978-1-78221-857-9
ebook ISBN: 978-1-78126-820-9

Suppliers
If you have difficulty in obtaining
any of the materials and equipment
mentioned in this book, then please
visit the Search Press website for
details of suppliers:
www.searchpress.com

You are invited to visit
the author's website:
www.sarahwimperis.co.uk

Publishers' note
All the step-by-step photographs in
this book feature the author, Sarah
Wimperis, demonstrating how to
paint with water-mixable oils. No
models have been used.

DEDICATION

This book is dedicated to my lovely Dad
who bought me my first paints and
got me my first job, illustrating at the
BBC on *Jackanory*; and my Mum who is
endlessly proud and encouraging. Also
to my ever-patient partner, Dave, who
is my constant support, and my ever-
present factotum; my five adult children
who are all excellent creative spirits
and my 10 grandchildren who, I hope,
like me, will have the opportunity to be
creative throughout their lives.

I would also like to take the opportunity
to thank all of the people who have
supported me through buying my work
over the years.

ACKNOWLEDGEMENTS

Thanks to Royal Talens, Jackson's
and Winsor & Newton for supplying
the paints used in this book.

FSC
www.fsc.org
MIX
Paper | Supporting
responsible forestry
FSC® C012521

Water-Mixable Oils

A beginner's guide to painting in this vibrant medium

SARAH WIMPERIS

SEARCH PRESS

Contents

6 Introduction

8 The qualities of water-mixable oils

10 Materials and tools

10 The paints

12 Brushes

14 Application tools

16 Surfaces

20 A space in which to work

22 Easels

24 From the studio

26 Maintenance of your materials

30 Colours and mixes

30 The capsule palette

32 Mixing colours

35 Mixing the paints

40 Mark-making

40 Brushes

42 Other tools

43 Seeing things differently

PROJECTS

1. Exploring colour 46

2. Painting from a photo 54

3. Painting an abstract 64

4. Still life 78

5. Landscape 90

6. Buildings 102

Troubleshooting 116

Aftercare 120

Storing your paintings 120

Transporting your paintings 121

**Using a mount to crop
your paintings** 122

Frames 123

Glossary 126

Index 128

Introduction

This book is intended to be an homage to water-mixable oils, and a fun and enjoyable introduction to this exciting and satisfying medium. I wish you *bon voyage* as you set off on this creative painting journey; maybe we will meet one day, paintbrushes in hand, a bag full of water-mixable oil paints and a spring in your step – because you are having so much fun!

Water-mixable oils are one of the most forgiving mediums to paint with: they are slow drying, allowing for the blending and shaping of colours and forms; when wet, the paint can be scratched into, using various tools and found objects to great effect. Lighter colours can be painted over dark, so you can 'ping' in those highlights right at the end of a painting. You can rarely go wrong with water-mixable oil painting; but if you do, you can always scrape it off and start again. Unlike conventional oils, there is no need for solvents – you can clean up with soap and water!

The trick with painting in any medium is confidence, and the only way you will feel confident in what you are doing is to practise. The old saying 'practice makes perfect' is true; however you also need to ask yourself, 'what is perfect?', especially in art, where your likes and preferences are so individual. So, I prefer to apply the saying, 'practice builds confidence'. Imagine that you want to play the violin. You have never picked one up before and you are not really quite sure how to make it work, but, despite that, you still want to play. You know in your heart that it is going to be a good, long time before you can make any sound that resembles something that people would want to listen to. The same applies to taking up painting: it's going to be a long road. However, if you give yourself a break and don't expect to produce Monet's 'Water Lilies' straight away, you can simply appreciate the art and the process of painting.

As you take up your paints, I want you to feel that you are playing, messing about like a child and just enjoying yourself. Have fun with the paint; explore the colours, mix up some interesting shades and tones. Find out how your brushes work and what they can do by playing and experimenting with paint and surfaces.

The projects in this book are all designed to help build your confidence, and to teach some of the techniques associated with oil painting. All painting is, of course, open to personal interpretation, and all artists have their own set of tried and tested techniques that suit their artistic style and personality; these often evolve from years of trial and error. However, I hope that I can provide you with a few shortcuts to some of those '*Eureka!*' moments.

The materials listed in this book (see pages 10–29) will give you a basic starting kit for working with water-mixable oils, including a capsule palette of colours and suggested tools and brushes – in fact everything that you will need to get started with this glorious medium. If you are anything like me, you will want to get painting straight away and read around the subject later!

The main message to remember is: enjoy the process of learning, play, experiment and, above all...

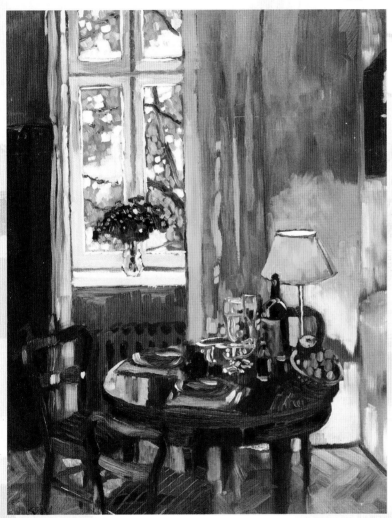

...have fun!

7

THE QUALITIES OF WATER-MIXABLE OILS

I am always surprised when people start to learn to paint in watercolours; to my mind they are much more complex than oils. The attraction must be in the simplicity of set-up and brush cleaning. In contrast, to the beginner, oils may appear to be quite intimidating. With all the turpentine, special oils and recipes involved, there are so many things to remember, let alone knowing how to control the paint. Plus, the smell gives many people a headache, or worse – if you are painting at home, you may not want your kitchen to smell like an artist's studio. Similarly, if you are painting with an art club, the venue may have restrictions on the use of solvents.

The solution is *water-mixable oil paints*.

Water-mixable oils are perfect for people who have an interest in oil painting but are put off by certain characteristics of conventional oil paints. They are as ideal if you are a beginner to painting as they are if you are a full-time, professional artist. I have used water-mixable oil colours exclusively now for six years – that is a lot of paintings rendered in water-mixable oils: well over a thousand!

Water-mixable oils are the same as traditional oil paints in that they offer all the qualities of traditional oils – rich pigments, a buttery consistency, long drying times, and the potential to evolve your style of painting. There is one big difference, of course – there is no requirement for solvents or other mediums.

The manufacturing process of water-mixable oils adds an emulsifier to the paint, which enables brushes and other equipment to be rinsed with water, and finally cleaned thoroughly with soap and water. They can also be thinned with water for use in the early stages of a painting. Water-mixable oils now have such a reliable consistency that you can paint without having to worry about any additional mediums, although there are mediums available that can used for advanced techniques.

In short, they are a simple and hassle-free entryway into the world of oil painting.

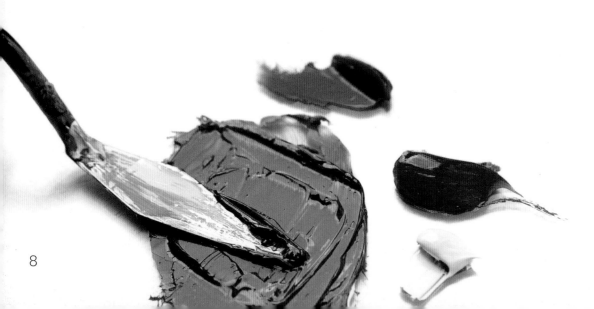

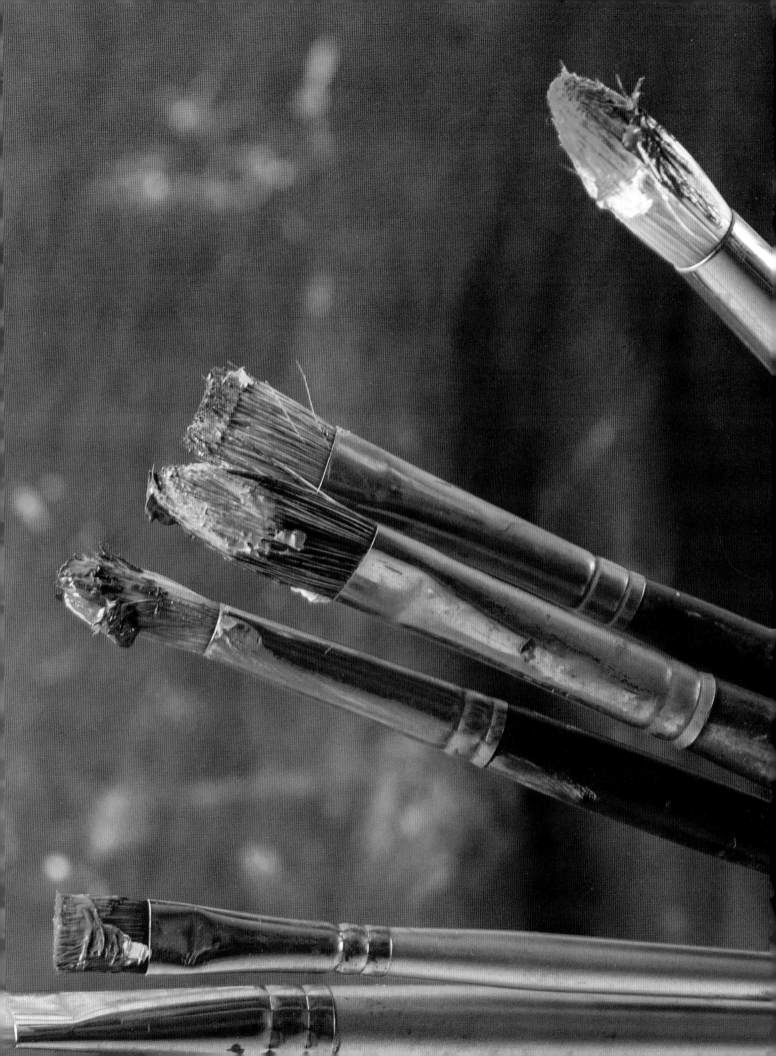

Materials and tools

THE PAINTS

There are several brands of water-mixable oils available; they are all going to do the same job. One manufacturer might make the paint slightly stiffer, while another makes paint that is much looser, or 'buttery'.

The different makes of paint do not vary much in price either, but what you will find, confusingly, is that the names of the colours differ slightly. Don't panic: I shall explain the capsule palette of colours in just a while (see pages 30–31).

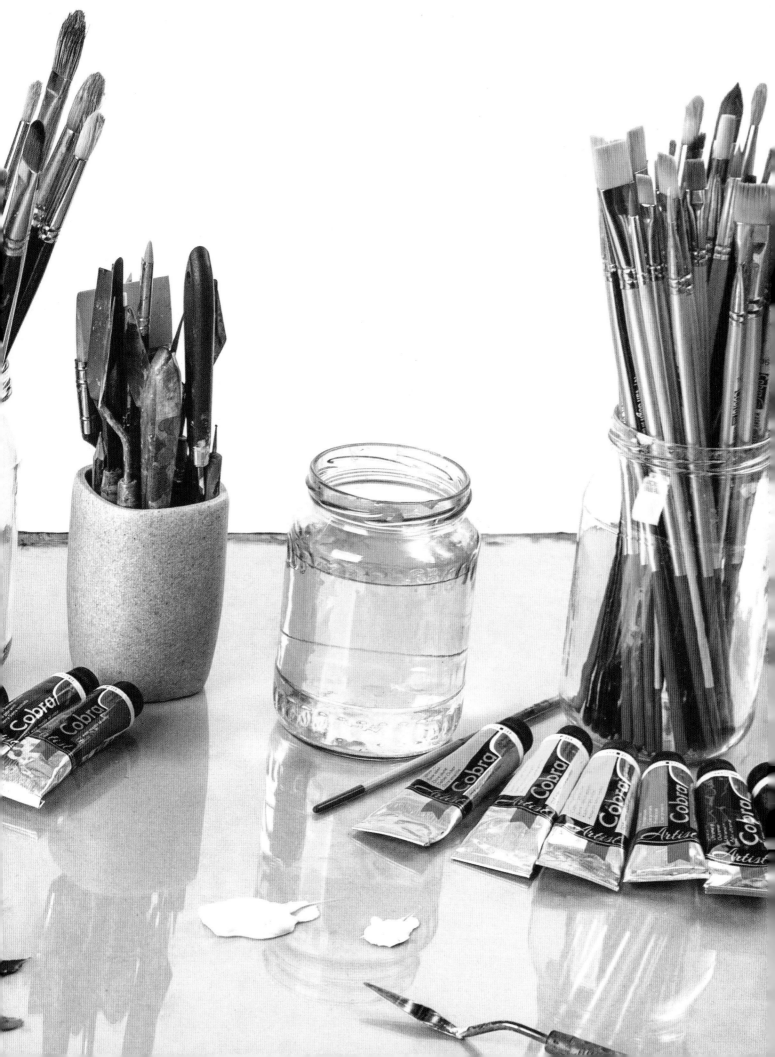

BRUSHES

Most art supply stores, either online or locally, will have a dizzying array of brushes to choose from – brushes are particularly important pieces of equipment, and any painter would have difficulty working with bad brushes. Don't buy the cheapest you can find; the bristles will shed and you won't be able to paint with them. I suggest that you buy from a proper art supply shop only: do not be tempted to buy brushes from a supermarket or discount store.

You need brushes that are made specifically for painting with acrylic or oil paint, and you will need at least four brushes – preferably more. Do be prepared for them to be costly, but they will serve you well over time.

One of the advantages of using water-mixable oils is that you can use synthetic bristle brushes with the paints, which is ideal if you are vegan or vegetarian. The turpentine and white spirit used with *conventional* oils tend to destroy synthetic bristles very quickly.

You will need a couple of large brushes, a couple of medium and a couple of small brushes of varied shapes: the different brush shapes have unique names and all make different marks, best described in the Mark-making chapter (see pages 40–42).

I also have some very old brushes of varying sizes that I keep clean and dry; these are as soft as babies' hair and I use them exclusively for blending colour with a very light fast flicking motion – great for depicting a cloudless summer sky, where the blue goes from pale green through to deep ultramarine!

I have a very cheap fan-shape brush, that isn't quite as clean and soft, but which makes the perfect paint vehicle for grasses. I also own several stiff old brushes of different sizes for scribbling or scratching paint onto the surface.

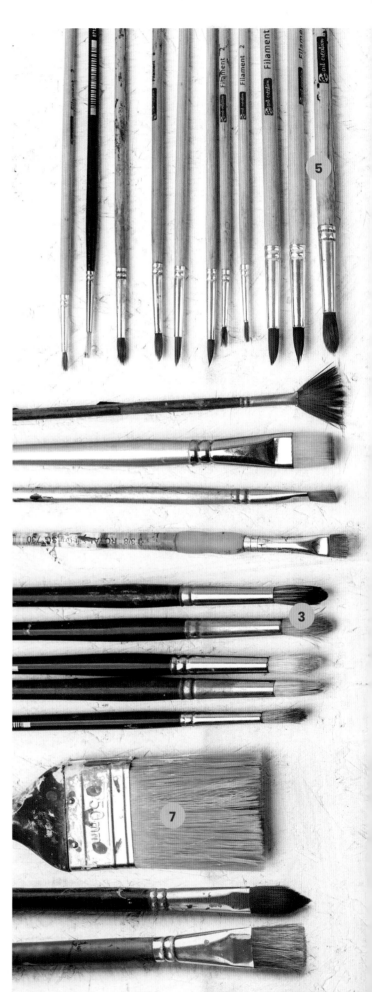

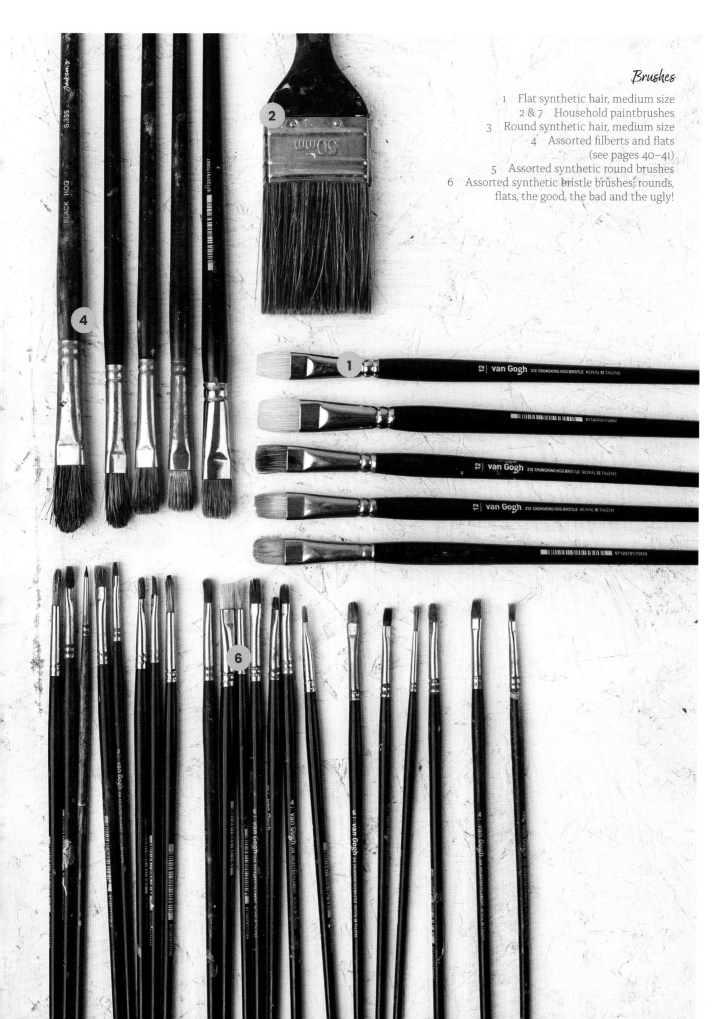

Brushes

1 Flat synthetic hair, medium size
2 & 7 Household paintbrushes
3 Round synthetic hair, medium size
4 Assorted filberts and flats
(see pages 40–41)
5 Assorted synthetic round brushes
6 Assorted synthetic bristle brushes; rounds,
flats, the good, the bad and the ugly!

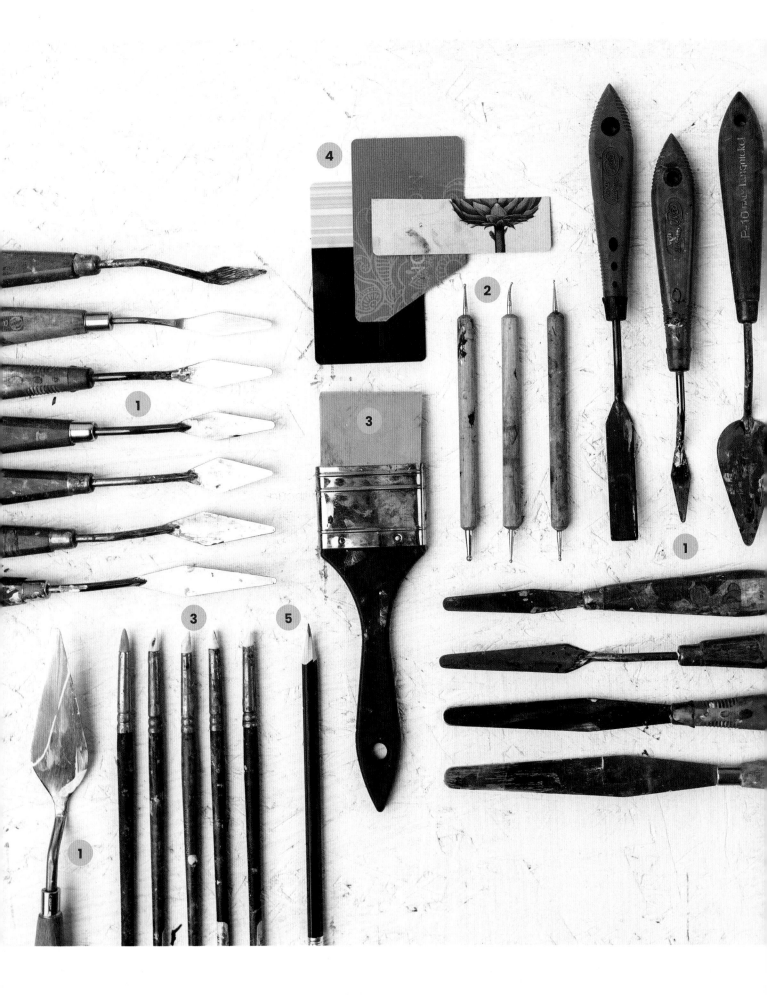

APPLICATION TOOLS

You will be surprised at how many tools can be added to your collection of mark-makers!

PALETTE KNIVES

As well as for colour mixing, I use palette knives to paint with, or to transfer paint to a large area to then be worked with a brush. I also use them to plaster paint on the surface to create big shapes. In addition, I use the thin edge of a palette knife to print lines with the paint: the knives are very flexible so you can press paint onto the surface with them.

PAINT SHAPERS

You can buy these from art shops: they look like paintbrushes but have a rubber tip with which you can push paint about.

PLASTIC CARDS

Old credit cards, old business cards or paint sample cards, dipped edge-on into wet paint, can be very useful for painting thin branches or fence wires, for instance.

SHARP PENCIL

Use a sharp pencil to draw into the paint.

NAIL TOOLS

These sticks with rounded metal tips are made for applying nail-varnish dots to your fingernails. They are cheap to buy and very useful for putting dots onto your painting, scratching out lines or generally drawing into the wet paint.

STICKS (NOT SHOWN)

These are, well, stick-like! I use bamboo skewers (although cocktail sticks or toothpicks work just as well). They are hugely useful for scratching through wet paint to create thin, pale lines.

Application tools

1 Assorted metal palette knives
2 Nail tools
3 Paint shapers, small and large
4 Plastic cards
5 Sharp pencil

SURFACES

The surface that you paint on must be suitable for oil paints. Even though this book is all about using water-mixable oil paints, many of the basic principles of conventional oils still apply to water-mixable oils.

Crucially, find a surface that you like: the surface that you choose is a matter of taste, so try a few out.

You will also find that the behaviour of the paint varies on different surfaces. On stretched canvas, for example, you will find the surface has a slightly bouncy or springy feel. Canvas board has a very obvious textured pattern. Some repaired wooden panels have a super smooth, slightly slippery surface; and hand-painted surfaces can either show brushmarks from the application of gesso (see page 18) or be sanded smooth between coats of gesso if you prefer.

HOW MANY SURFACES DO I NEED?

The last thing you want is to run out of surfaces while you are on a roll, so keep at least five in your stock of art materials.

You can use any of the following:

Stretched canvas: Simply put, a canvas stretched over an open wooden frame;

Canvas board: I personally avoid using these as I don't like the texture;

Wooden panel: Similar to a stretched canvas, except that the canvas has been replaced by a piece of wood, which has been prepared for painting.

Oil paper: Available in special pads, suitable for oil painting.

A piece of board: This is usually hardboard or MDF that has been gessoed (see page 18).

IN CLOSE-UP

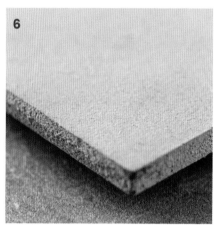

What size?

When you first start painting in water-mixable oils, work on a surface that is about 30 × 40cm (11¾ × 15¾in) – approximately A3-paper size (see page 19 for a list of the paper sizes I refer to). This is big enough for detail, but small enough to enable you to finish the painting in a reasonable time – I don't want you to get bored!

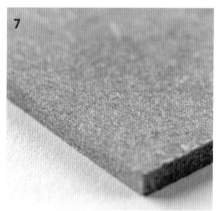

Surfaces

1 Canvas board
2 Deep stretched canvas
3 Gessoed wooden panel
4 Stretched canvas
5 Oil paper in pad
6 Homemade gessoed MDF 3mm (⅛in) board
7 MDF 3mm (⅛in) board, unprimed

BESPOKE PAINTING SURFACES

As an alternative to using traditional surfaces, you can make your own. I buy MDF sheets that I paint on the reverse with household emulsion. I use a coloured emulsion so that I can tell which is the side for the art (the front) and which is the reverse. The boards need to be painted on both sides to protect them from damp.

On the front – the painting side itself – I apply three or four coats of white gesso, which I buy in a big tub. Gesso is a white paint mixture – a binder mixed with chalk or gypsum. It is smooth, opaque and partly absorbent.

I paint a lot so I need a lot of surfaces! I prep my surfaces about once a week.

Prepping the reverse with emulsion.

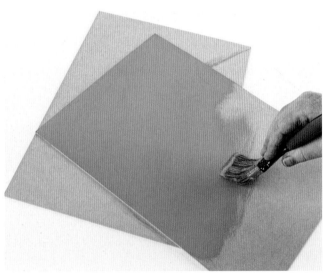

Prepping the front with gesso Sludge™.

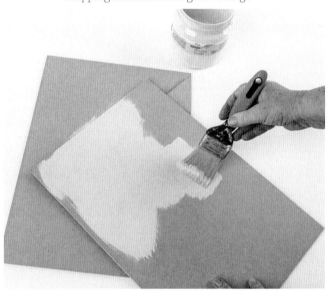

I buy tester pots of emulsion to prime the backs of my painting boards; it helps to protect the board from getting damp and warping, which it can do if only one side is primed.

Emulsion is also cheaper to use than gesso and perfectly fine for the backs of the boards. The reason that I use tester pots is that I like to use different colours, and the pots are fairly small so don't take up loads of shelf space in my studio.

I use eco-friendly gesso to prime the front of my boards. It has a tooth so that the paint doesn't soak into the board but rather adheres to it; the oil soaks into the medium instead.

The gesso that I use is a make called Sludge™. It is made from the recycled pigments from the manufacturer's washing process. It is a natural, mid-grey tone, which is useful for seeing colours correctly as you paint onto it. It has a nice 'tooth' – not too rough and not too smooth – enough to grab the paint well. It's not wildly expensive, and it's kinder on the environment, which eases my conscience!

PRECUTTING YOUR BOARDS

I buy the boards that I paint on in batches of 30 at a time, at approximately A3 size – 42 × 29.7cm (16¾ × 11¾in). Any paintings larger than that, I tend to paint on a stretched canvas.

I prime my boards at roughly A3 size then cut some up into A4 sizes and A5 sizes (see list, right). No board is wasted: one A3 board makes two A4 boards; two A4 boards make four A5 boards and so on.

It is useful to stick to standard paper sizes from a framing point of view: it's often easier to find frames to fit, plus, if you have multiple paintings at the same sizes, you can swap your paintings in and out of your frames.

Paper sizes

A3: 42 × 29.7cm (16¾ × 11¾in)
A4: 21 × 29.7cm (8¼ × 11¾in)
A5: 21 × 14.8cm (8¼ × 5¾in)

The precut, primed board.

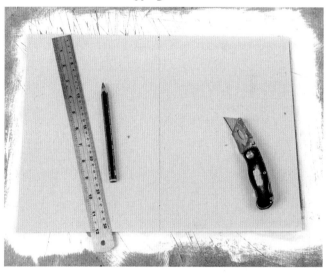

Chopping the board.

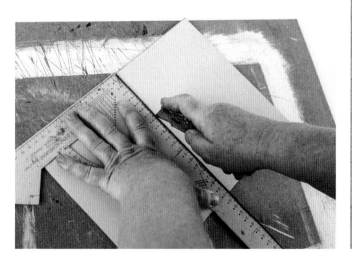

Cutting into one A4 and two A5 boards.

Boards cut.

A SPACE IN WHICH TO WORK

Everyone needs a little space to call their own: now that you have chosen to learn to paint with water-mixable oils, it's the perfect time to carve out that space. You can of course set up on the kitchen table or in the corner of your bedroom, but it's better if you can find somewhere you can leave everything out, ready for when inspiration grabs you.

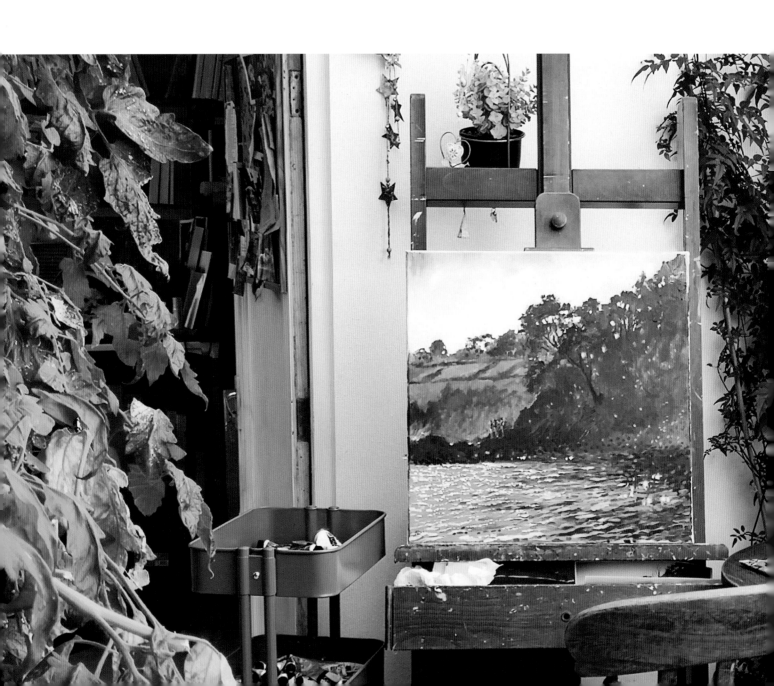

YOUR WORKSPACE

As I've already mentioned, the advantage of water-mixable oils over conventional oils is that they don't smell, so painting at home becomes a possibility. A workspace is simple and easy to set up, and the clean-up is also straightforward, requiring just soap and water (see pages 26–29).

You will need a table large enough to fit a palette and a table easel (see overleaf) and preferably a place to lay out your paints. A **PVC cloth or oil cloth** is useful to protect the surface of your table, so that you do not have to worry about making a mess as you work. Have to hand a **box for your paints** and store your **brushes** in an **old jar**, bristles up.

You may also need a **chair**: I find that an office chair on wheels is useful as you can scoot back from your work to check its progress from a distance. Obviously, you can simply just stand up and step back but I like the speed and ease of my wheeled chair.

Useful but not essential is an area where you can set up a still life or prop up your source material.

Finally, I recommend that you put a cork noticeboard up on the wall. It's a great place to pin inspirational images, and store your paintings to dry (see below).

My studio

My studio is a conservatory on the back of my house: it's 3 × 5m (10 × 16ft 5in), and I wish it were bigger. It is too hot in the summer and very cold in the winter; I combat this by having a shade sail up in the summer and by spending a fortune on heating in the winter. My studio has French doors that lead out into my little garden and is just big enough to house a very large easel and three tables – one for watercolour work and one for small oil painting. Big oil paintings are worked on the large easel (see overleaf) which has wheels so it can be manoeuvred easily. The third table is where I prep all my painting boards and also do my sewing projects.

I have lots of shelves filled with sketchbooks, art books, still-life objects, art materials and lots of very precious junk. At one end there is a wall that is a cork noticeboard where I have stuck very narrow wooden battens to hold all the little paintings that I do every day. I also have a small frame and canvas store just off my studio where I keep art materials and equipment for my workshops.

The whole place gets very messy and very occasionally I will tidy up and feel very proud of myself, but always, without doubt, it is my favourite room in my home.

EASELS

Easels are used to keep your work steady and in an upright position, which, when working with water-mixable oil paints, is useful because you can reach areas of your painting without getting your hand or arm covered in paint or smudging your work. It is also easier to step away from your painting for a longer look when it is propped on an easel.

I own several different types of easel, but you don't need as many as this: a table easel alone is fine if you are starting out.

TABLE EASEL

A table easel is very useful: it's much easier to work with your board or canvas on an easel rather than laying it flat on the table.

You can buy a fold-away easel at very little expense. My table easel is quite old and used to belong to an artist friend of mine who died many years ago, so it is not only a very much used piece of my kit, but it also reminds me of my art mentors of the past.

FRENCH FOLDING EASEL

My French folding easel has travelled with me on many painting trips and is my *plein air* companion. Although there are lighter options, I like this one because it has a useful drawer in which to store brushes and paint, and it can support a large canvas easily.

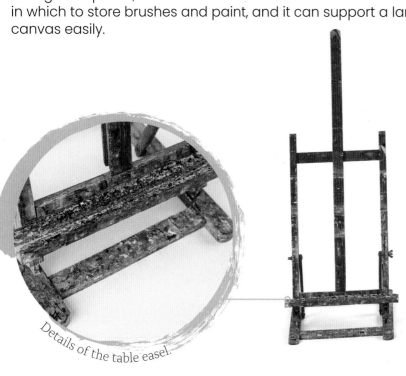

Details of the table easel.

A family of easels
From left to right, table easel, French folding easel and large easel.

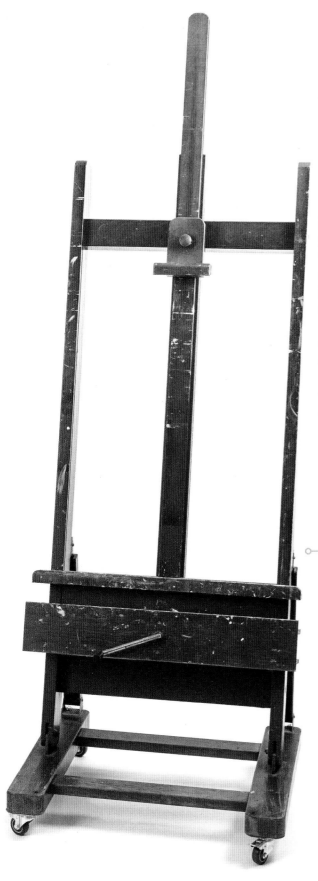

LARGE EASEL

My large studio easel is also quite old and was given to me by a gallery. It is fantastic for supporting huge canvases; it also has a drawer, and a wonderful winding mechanism. I love it because it makes me feel like a nineteenth-century Impressionist!

The winding handle effortlessly moves the canvas up or down; winding down enables shorter artists, like me, to reach the top of a large canvas. Winding up enables the artist to comfortably sit and paint the lower part of a big canvas.

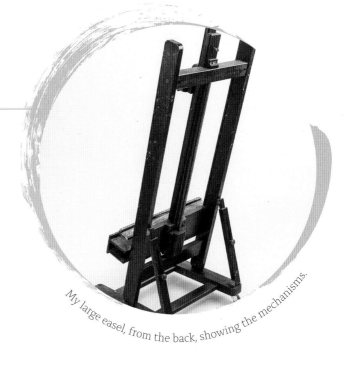

My large easel, from the back, showing the mechanisms.

FROM THE STUDIO

A studio, however small, always has a wealth of other essential equipment as well as the obvious paint and brushes.

I have tried to list everything that I can think of, but I am sure that, as you progress with your own painting, you will make your own collection of Really Important Things!

1 Palette

Use a flat object as your palette – it's much easier to work on a completely flat surface than a plate, for example. I personally use a sheet of glass with the sides taped (to avoid cutting myself), with a sheet of brown paper underneath to help me see the colours. Glass, or perspex, is really easy to clean as well. Alternatively, you can buy traditional palettes made of wood or plastic.

2 Sketchbooks

Have several! You will need one that takes multiple mediums, so look for excellent-quality paper so that you can draw and use pens and paint within the same book, maybe even at the same time. You also need a cheaper one for scribbling ideas and layouts; this sketchbook is for your eyes only – here you can make a mess and it doesn't matter. Lastly, keep a tiny sketchbook to carry in your pocket for inspiration on the go.

3 Pencils and marker pens

Choose a pencil that you enjoy drawing with, and that you like to feel in your hand. A softer lead, 4B or 6B, will be more versatile; a mechanical pencil is useful, as it is always sharp. You can also use a marker pen for designing the layout of your painting.

4 Acrylic paints

Use these paints for colouring or prestaining your canvas and for 'drawing out' your painting. Acrylic dries fast, which is useful as I know that you will be impatient to begin your painting!

5 Jam jars

Typically used for holding water, they are also useful for storing brushes, pencils and palette knives. Be warned, jam-jar collecting for storage can become a bit of an obsession!

6 Paper towels or old rags

These are always needed for wiping brushes on, for squeezing out excess water after cleaning and for wiping out paint on your work. Old sheets torn up make great paint rags.

7 Mobile phone

Taking digital pictures of your work can really help you to see things with fresh eyes and spot what's missing or not looking as you want it to (see pages 45 and 84). Seeing your paintings on a screen is like typing out your writing: it gives you a fresh perspective.

8 Palette knives (see pages 14–15)

For mixing colours, applying, moving and scraping off paint, and much more.

9 Red glass or plastic (see page 45)

Alternatively, use a small piece of clear plastic coloured red with a marker pen. The red tint helps you to look at your work in progress, a view or a source image, and see the tonal values more easily.

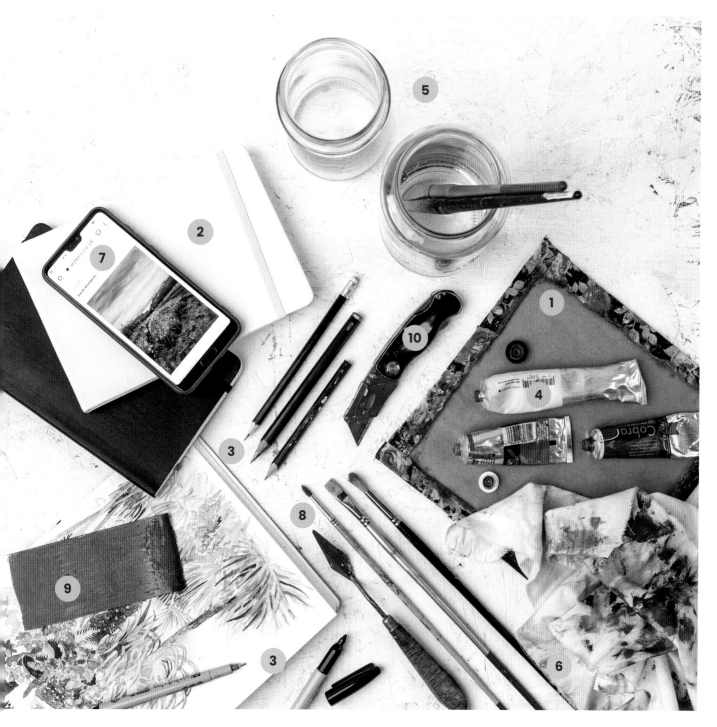

10 Craft knife

For sharpening pencils, or cutting card or thin board, a retractable craft knife is always useful. Mine has a replaceable blade, therefore is always sharp, and it folds away, safely, so that I can carry it with me.

Apron (shown on pages 7 and 29)

I have a very paint-covered wrap-around apron; it saves my clothes and also indicates to people that I am working!

MAINTENANCE OF YOUR MATERIALS

Art materials can be quite expensive, especially when you are setting up to paint for the first time, so it makes sense to look after your precious purchases. It is too easy, after a painting session, to fling the brushes in a pot of water and go and make a cup of tea – but don't! Try to make it a habit to clear up properly: your brushes will thank you and your workspace will be ready for your next painting session.

KEEPING YOUR BRUSHES CLEAN

If you are painting an area of related colours, greens for example, then to switch between colours you need only wipe the brush on a paper towel or a handy rag. To do this, just wrap the bristles in the cloth, squeeze, and pull the paint off the brush with your fingers. When most of the paint has come off, rub the bristles gently on a clean corner of the cloth, as shown below.

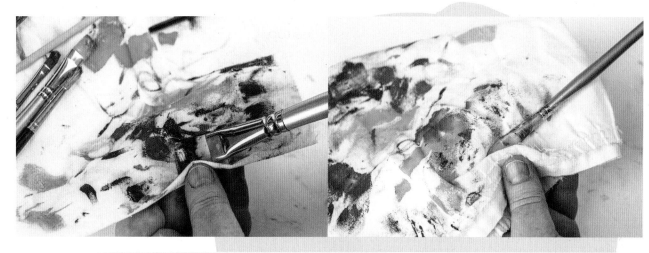

Never leave brushes in a jar of water – it's the fastest way to ruin them. Lay them flat, or store them bristles-up in a pot or jar, as shown right.

WASHING YOUR BRUSHES

If you are switching colours dramatically while painting, from a blue to a yellow for example, then you will need to clean the brush more thoroughly. Swoosh it in a jar of water (see right), then gently squish the bristles in the base of the jar, giving the water time to penetrate right through the brush. Be gentle: don't scrub madly, as this will ruin the shape of your brush.

Take out the brush, wipe the excess on the side of the jar, then dry the brush on a clean paper towel. Make sure that you dry the handle as well; you don't want water to run down into your paint.

Be sure *not* to use really hot water, and make sure that you rinse your brushes well.

When you have finished a painting session, it is a really good idea to give your brushes a wash with brush soap, which is an oil-rich soap specifically for washing brushes.

Alternatively, you can use washing up liquid (dish-washing detergent).

Your water jars themselves will need a good wash every now and then, as paint residue will gather around the top.

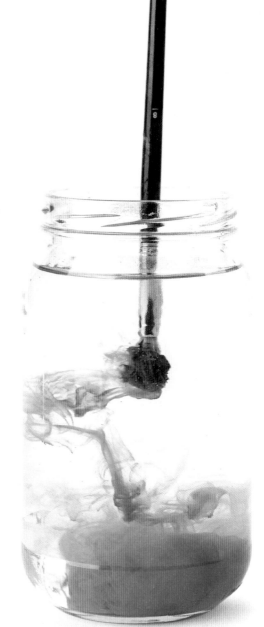

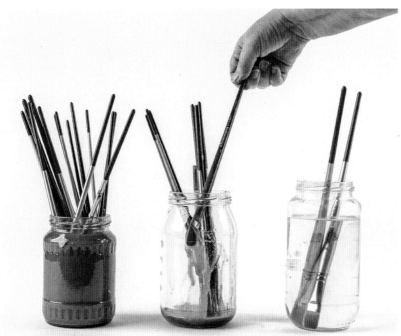

Washing up your brushes

Dirty brushes should be partly wiped off; pressed into washing-up liquid, then left in water for the next stage of rinsing.

27

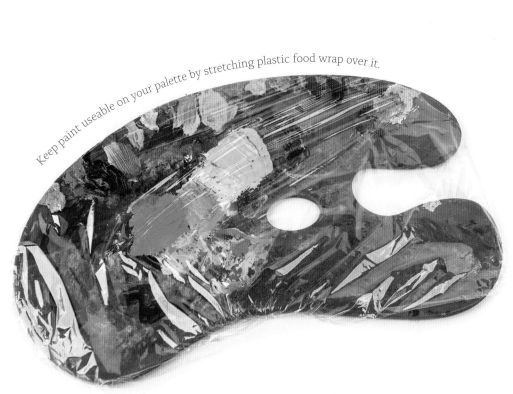

Keep paint useable on your palette by stretching plastic food wrap over it.

YOUR PALETTE

Keep paint useable on your palette by stretching plastic food wrap over it. Scrape excess paint into manageable piles around the palette, and keep the mixing area clean. You don't need to clean it with soap and water; just rub it clean with paper towels or studio rags. Do this often.

Alternatively, you can scrape the paint off the palette, and onto the inside of a food storage box lid. Put the box onto the lid, upside down, and the paint should remain useable for a week or so.

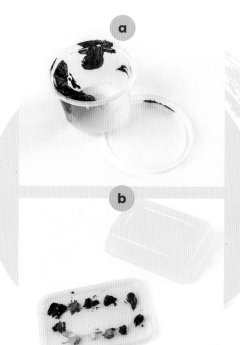

a Paint decanted into a pot, with a lid on, will stay useable for a week or longer!
b To save several colours, decant them onto the lid of a plastic box, then place the box over the top, effectively using the box upside down.

YOUR TABLE SURFACE

If your table or covering cloth gets very messy, use a damp cloth and a tiny bit of washing-up liquid (dish-washing detergent) to clear it up.

I used to use baby wipes as cleaning wipes as they remove paint from anything, but since realizing how bad they are for the environment, I try to use old rags and soapy water; this method works just as well.

YOU!

Your face, hands and feet (yes, I have seen that!) can be washed with soap and water; the places where you will get most paint are your hands and your forearms.

A sturdy apron is fantastic as you can wipe your brush on it while you are pondering your next painting move! It will become a testament to your painting life, displaying your most dominant colour choices!

Your painting clothes – apron and suchlike – can occasionally go through the washing machine.

Your apron will become a testament to your painting life!

Colours and mixes

Imagine the scene: you are in an art supply shop – so many paint colours, so much choice... Confusion reigns! What to do? Which colours to choose?

Let me try to explain the colours that you need. The palette shown on these pages – which I call a 'capsule palette' of 11 limited colours – will allow you to paint any or all of the projects in this book.

THE CAPSULE PALETTE

Your capsule palette should contain a red, a blue and a yellow – the primary colours – plus white and a dark brown. This palette will allow you to paint subjects as diverse as abstracts, landscapes and even portraits.

With these five colours you *can* mix almost any other colour, but this can be quite hard work, so I advise that you keep to hand a few extras. I like to have two types of red in my palette: a warm, bright orange red such as Cadmium red, and a cool, dark, purplish red – Alizarin crimson.

Now for the blues: French Ultramarine is a warm blue that has a tint of red in it, so is more purple in appearance. Cerulean blue is a brighter, cool greeny-blue. I like to keep a cool yellow – the acidic Lemon yellow – and a warm yellow: Cadmium yellow.

This selection gives me two each of the primary colours, of different temperatures.

I also keep big tubes of white as well as green, which is useful – I like a good, dark green such as Permanent green deep.

I rarely use this colour on its own, however; I usually add other colours to it.

Lastly, I keep a really dark blue – Prussian blue – and two earth colours, Yellow ochre and Burnt sienna. These colours are the most muted and earthy of the primary three.

You don't need any other colours, but you will find that buying colours becomes an addiction; a few extras are always nice to have, so every now and then you can pop in a little wonderful bright 'ping'. For now, though, stick with this list.

In terms of the brands, I usually use Cobra water-mixable oil paints by Royal Talens, but Jackson's Aqua Oil range* and Winsor & Newton's Artisan water-mixable oils are just as good. The chart opposite shows the colours in the capsule palette, and compares the similarly-named palettes across these three brands.

* available only while stocks last as this product has been discontinued.

COBRA	JACKSON'S	WINSOR & NEWTON		COBRA	JACKSON'S	WINSOR & NEWTON	
1				Primary cyan	Cerulean blue hue	Cerulean blue hue	**6**
Titanium white	Titanium white						
2 Permanent lemon yellow	Cadmium lemon yellow	Lemon yellow		Ultramarine	French ultramarine blue	French ultramarine	**7**
3 Cadmium yellow medium	Cadmium yellow mid hue	Cadmium yellow hue		Permanent green deep	Sap green	Phthalo green	**8**
4 Madder lake	Alizarin crimson	Permanent alizarin crimson		Yellow ochre	Yellow ochre	Yellow ochre	**9**
5 Pyrrole red	Scarlet lake	Cadmium red hue		Burnt sienna	Burnt sienna	Burnt umber	**10**
				Prussian blue	Prussian blue		**11**

Key

1	Whites	6	Cool blues
2	Cool yellows	7	Warm blues
3	Warm yellows	8	Greens
4	Cool reds	9	Earth yellows
5	Warm reds	10	Earth reds
		11	Earth blues

MIXING COLOURS

When you have the primary colours, red, blue and yellow, you can mix any colour that you want. Add white and you can make tints, or lighter versions, of any of your mixes; add black and you can make shades, or darker versions. You can also lighten and darken colours by adding other colours and at differing amounts.
Experiment, have fun and try to see how many different colours you can mix from your basic set of colours.

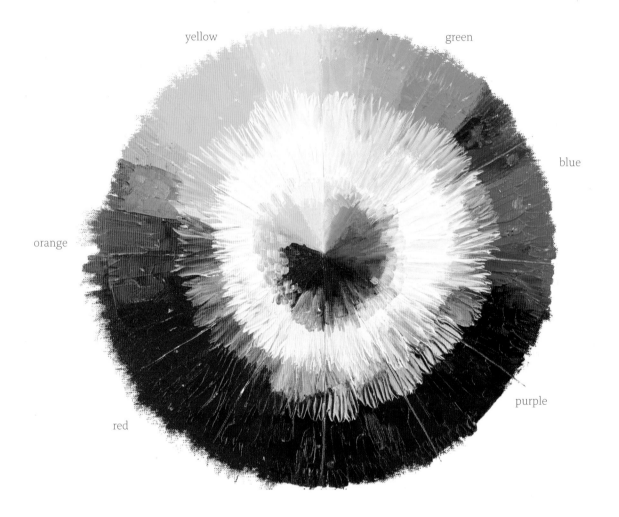

yellow

green

blue

orange

purple

red

The basic colour wheel

I've made this colour wheel with the water-mixable oil colours listed on the previous page. A simple colour wheel is made up of 12 colours, a combination of the three primary colours: red, blue and yellow. The three primary colours are essentially the parents of the remaining nine.

The terminology of colour

Hue is another name for colour.

A **tint** is a colour mixed with white.

Shade is a hue or colour that has been darkened by adding black. Note that if you rely on using black, it is very easy to get a dull and extremely boring colour; instead try darkening a colour by mixing in a little of its complementary (or opposite colour on the wheel).

Tone describes a colour's lightness or darkness. When you look at colours or paintings as a black-and-white image, you are seeing only the tones of all the colours.

Value Is another term used to describe the lightness or darkness of a colour.

COMPLEMENTARY COLOURS

Complementary colours appear opposite each other on the colour wheel: red and green, blue and orange, yellow and purple. When the colours are placed next to one another, they appear more intense; when they are mixed together, they neutralize or calm one other.

For example, if you have a very bright unnatural-looking green, add a tiny speck of red or pink, and it will calm right down. Alternatively, a garish pink can be softened by adding a tiny bit of green.

To give you an idea of how little a tiny speck is, look at these examples: green with a tiny bit of its complementary, pink; pink with a tiny bit of its complementary, green; blue with a tiny bit of its complementary, orange; and orange with a tiny bit of its complementary, blue.

Do your own experiments to see how these tiny specks of colour can really calm down your mixes. I will show you how to mix your paints on the following pages.

HOLDING YOUR BRUSHES

Keep in mind that your brushes are not pencils. Don't hold them right down near the bristles; hold them loosely and quite far up the handle. Keep a good distance between you and your painting surface, use your whole arm and get into 'dancing mode' with your brushes – relax and be loose, at least at first.

You can then practise getting the brush to make different marks for you: twist it and turn it, though always respecting the bristles – by that I mean, twist and stroke the colour on; try not to scrub it on.

Be generous when loading your brush with paint: gently roll the brush in the paint, almost like picking up candyfloss (cotton candy) on a stick!

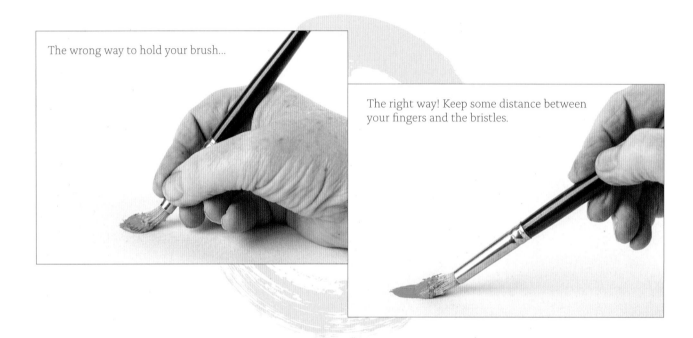

The wrong way to hold your brush...

The right way! Keep some distance between your fingers and the bristles.

USING A PALETTE KNIFE

I find palette knives essential for mixing oil paints. Other artists may use a brush to mix, but I find that brushes get ruined by doing that, and you lose a lot of paint inside the brush. I have one small palette knife and one larger one that help to manoeuvre the paint into nice piles on my palette once mixed.

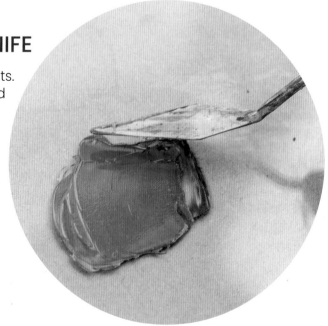

MIXING THE PAINTS

MIX ON A FLAT SURFACE

I find it is best to arrange the colours, squeezed from the tube, around the two edges of my square glass palette (see pages 24–25), leaving both a nice big space in the centre for mixing, and space to collect the mixed colours.

MIXING A SIMPLE GREEN

Take a little of your first colour. Always start with the lightest of the two base colours, so choose a yellow – here, Cadmium yellow.

Cut off a bit of colour with your palette knife and move it to the middle of your palette. Then wipe the knife clean and cut off a tiny bit of Ultramarine blue, place it next to the yellow and, with your knife, begin to mix them. Imagine you are mixing a very tiny pile of concrete – squish it down, pull it together, squish it down and pull it together until it's mixed completely.

1 Scrape some Cadmium yellow with the tip of the palette knife.

2 Add in some Ultramarine blue.

If you want to lighten the mix at this stage, add more yellow, or some white, or both. See what happens if you add some Lemon yellow and Titanium white. The possibilities for mixes are endless.

You can save some of the complete mix in a nice pile along the edge of your palette and carry on mixing with the remainder to make a a range of different colours – here, greens.

3 Manipulate the paint with the palette knife.

4 Add in some Lemon yellow to lighten the mix...

5 Mix in a hint of Titanium white to lighten it further.

6 Your mix is complete!

MIXING A VERY BRIGHT GREEN

For this mix, I have chosen Lemon yellow and Cyan blue to make a vivid green. Take the lightest of the two base colours (yellow); cut off a bit of the colour with your palette knife and move it to the middle of your palette.

Wipe the knife clean and cut off a tiny bit of the blue; place it next to the yellow and with your knife begin to mix them. Again, imagine you're mixing a very tiny pile of concrete.

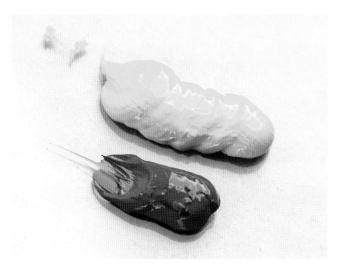

Blue and yellow before mixing.

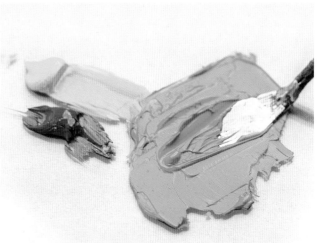

Blue and yellow during mixing.

Add some more blue until you have the green that you want.

If the mix looks too bright, add a tiny bit of red; mix again.

37

MIXING A BRIGHT PINK

Take some Titanium white and a little bit of
Alizarin crimson; as before, add the darker
colour to the lighter in small amounts. Mix with
your palette knife until you are satisfied with
the shade of pink.

 If you would like to tone it down a bit, add a
tiny bit of green as this is the complementary
colour of the pinks and reds on the
colour wheel.

MIXING PURPLE AND ORANGE

Blue and red mix to make purple, but the type
of purple you get will depend on which blue
you choose and which red you choose. Do
some experiments and see what your colours
will do.

 Once you've made a purple, again you can
tone it down a little bit by adding a tiny bit
of the colour that is opposite it on the colour
wheel: orange.

The oranges will vary just like the purples depending on which of your yellows and which of your reds you combine. You can turn a bright orange into a burnt orange, or almost Yellow ochre, by adding a little of its complementary colour – in this case, purple.

By playing around with your paints you will learn about the huge variety of colours that you can make.

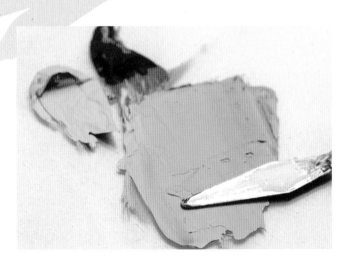

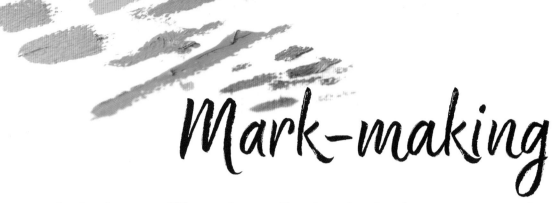

Mark-making

In simple terms, different shapes of brush and tool make an assortment of marks, all of which are of benefit to your work with water-mixable oils.

Don't worry too much about the names of the brushes for now; go into an art supply shop and get yourself a selection of brushes that are suitable for oil or acrylic painting. These will work very well for you. (See pages 12–13 for more on choosing your brushes.)

I recommend getting your collection of brushes and tools and experimenting with what they can do. Mix up some rich, glorious colours, get yourself some oil painting paper and begin to play. This is honestly the best way in which you will begin to understand what your tools can do for you, so that the next time that you want to suggest a fence wire, or some grasses, you will instinctively know which brush or tool to grab.

BRUSHES

FLATS AND BRIGHTS

The brushes shown below can be called 'flats'; the bristles are flat in shape, long and with square ends. Flats hold paint well, and can be used for applying thick, creamy paint.

The medium flat brushes, also known as brights, are also flat in shape, with square ends but with shorter bristles; they make quite visible brushstrokes. Think of them as adding 'bright' marks to your paintings. Use them for creating straight edges or blocky shapes.

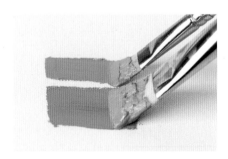

Flat strokes with large and medium flat brushes.

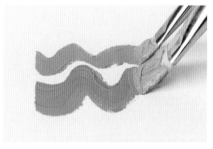

Wavy lines with large and medium flat brushes.

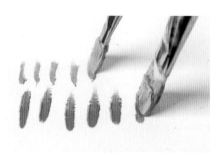

Dashes with the tips of large and medium flat brushes.

Small brushes

Ensure you have to hand a small version of each brush shape; these will be useful for tiny marks and details.

Soft brushes

Get a couple of really soft brushes (suitable for acrylic painting), which are fairly large and soft to the touch. These will be invaluable for blending, softly stroking two colours together on the canvas.

Fan brushes

Very old, and slightly dirty, fan brushes that are stuck with dried paint make excellent marks, like grasses, or hair.

FILBERT BRUSHES

The round 'filbert' brush gets its name from its supposed resemblance to the nut of the filbert tree – a type of hazelnut. The brush itself is flat in shape but the bristles have a round 'belly' that tapers to a point (think of the bottom of a heart shape). This brush can hold lots of paint but also lets you 'twiddle' out thinner marks as well.

Flat strokes with large and medium round filbert brushes.

Dabs with large and medium round filbert brushes.

BIG BRUSHES

A few household paintbrushes are also useful to have, as it's great to go in with a big broad stroke of paint, especially at the beginning of a painting. Plus some of them are soft enough to use as blenders.

OTHER TOOLS

PALETTE KNIVES

As well as being very useful for mixing paint on your palette, palette knives can also be used to apply paint to your canvas. You can lay paint on in a broad stroke (see below left) or use the edge of the knife to make lines and narrower strokes (see below right).

Using the palette knife as a palette

When you've mixed a colour, load it up on the palette knife and hold it near the canvas. This will turn the knife into a miniature palette that will make it easier to take the paint to the picture with a paintbrush.

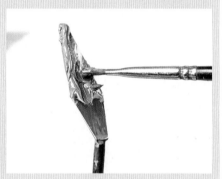

NAIL TOOLS

Made for applying dots of varnish onto fingernails, these tools are excellent for scratching thin lines through your paint to the canvas below or to an underlayer of paint, or for applying tiny dots of paint.

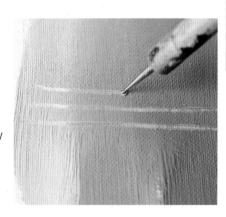

PAINT SHAPERS

These brush-like tools come in all shapes and sizes; they are made of hard but bendy silicone. Use them to smooth paint onto the surface, move the paint around and create all sorts of effects.

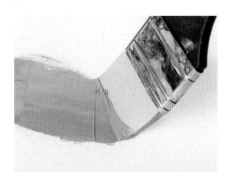
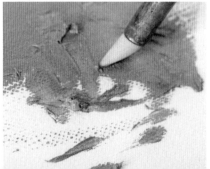

Seeing things differently

Don't rely on just one way to assess your work; you need some tricks to remove yourself from your painting. It is important that you remain slightly objective – that way, you will be more self-critical, able to correct mistakes and see when things are not working.

Everybody, no matter how long they have been painting, makes mistakes or has off-days when nothing works. I think that a real artist is someone who is prepared to constantly strive to improve their work and grow their knowledge of their subject.

USING A MIRROR

If you look at your work in a mirror, you will see it with fresh eyes, and things that don't work or that you have simply forgotten to put in will leap out at you.

It is so easy to get used to looking at your painting from one perspective that you simply miss things. So, using a mirror presents you with a fresh new view.

UPSIDE DOWN

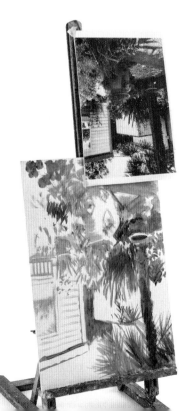

When you are trying to copy a source image, photograph, *nōtan* or sketch, try turning both your source image and your canvas upside down and then drawing it out that way.

We often make assumptions about the shape of something when it is familiar, and we stop really looking for the shapes. Imagine that you are trying to draw a chair from a source image. Your mind thinks, 'that's easy, I know what a chair looks like', and you draw away, not really looking at your reference. Instead, turn your source image, and your drawing, upside down, and you will see the angles and the shapes as they really are, rather than how you assume they are. It honestly really helps – give it a go and see!

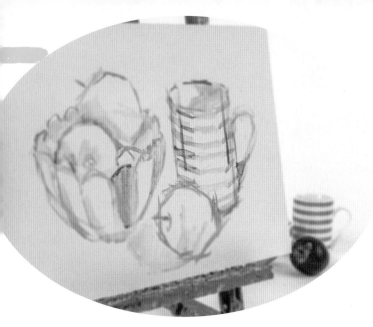

SQUINTING YOUR EYES

When you almost close your eyes while sketching, all the distracting detail will disappear, leaving you to see (only just) the bigger shapes. When you are starting a painting, you need to see the big shapes and not be distracted by the minutiae.

NŌTAN

Nōtan is an excellent way to plan a painting, to look at your subject and break it down to just light and dark components.

Squint your eyes so that you can only just see the light shapes against the darkest shapes. Simplify what you are seeing and, with a large brush pen or marker pen, make a simple black-and-white sketch.

Doing a *nōtan* study will help you demystify or simplify the scene in front of you; whether you are working from life or from a photograph, you will be able to see whether your composition works or whether you need to adjust it before you start painting.

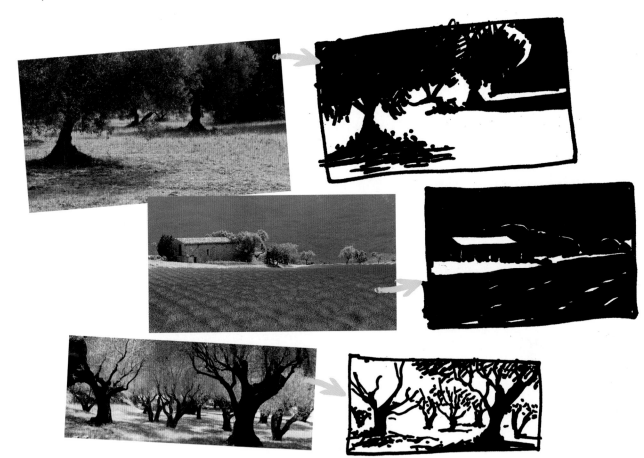

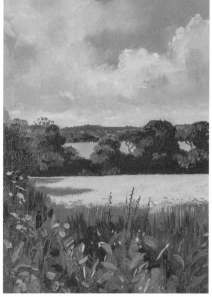

SEEING RED

View your work from behind a piece of coloured glass or plastic: red will show you the tones of everything in black and white, or rather black and red. Colour can confuse things, so simplifying what you are looking at, down to the tonal value, i.e. light, mid-tone and dark, helps you to get the balance right in your painting.

BLACK AND WHITE

Photograph your work and then turn it into a black and white image so that you can see if it is working tonally.

Take a picture on your mobile phone; you can then convert the picture into black and white and then push up the contrast if you want to really simplify the tonal values.

GIVE IT TIME

Prop up your work on a shelf or leave it in a drawer and give it some time before you return to it. Looking at something after a break will help you see it with fresh eyes – you will see any mistakes, as well as the good parts, of course.

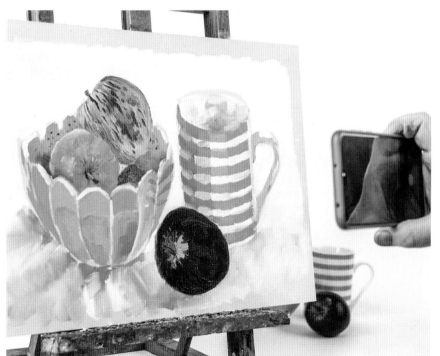

AS A PHOTOGRAPH

Take a snap on your phone or digital camera and look at your work on a screen; again, you will see the good and the bad, as well as anything that might be missing. Seeing your painting through a lens is as if you are looking at someone else's work; you can see objectively if any adjustments are needed.

Exploring colour

A fabulous way to get into, and understand, painting is to emulate paintings and styles that you like. It is how Vincent van Gogh (1853—1890) taught himself to paint, and, for this first exercise, where I want you to practise mixing colours, we will be using one of his paintings as a starting point.

This painting is based on van Gogh's 'Olive Orchard'; the original measures 92 × 72cm (36¼ × 28½in) and was painted in 1889. It shows us gnarled old olive trees in an orchard painted in such a way that the leaves and the sky seem to be shimmering and moving in the heat.

The sky is made up of lots of short brushmarks in varying shades of blue and the same treatment is given to the leaves. For our purposes, therefore, it's perfect.

Before you begin

When starting to paint any project, get into the habit of laying out your tools and paints. You will soon see which you favour and you will have to hand everything you need. As your confidence grows, you will make your own decisions about what you like to use.

First of all, I would like you to make at least six different blues; mix up some nice piles of colour on your palette, do the same with greens, so that you have a good library of greens and blues to paint from.

YOU WILL NEED:

Surface:

○ Oil paper, 40 × 30cm (15¾ × 11¾in)

Colours:

○ All the colours in the capsule palette, listed on pages 30—31

Additional paints:

○ Acrylic paint in Ultramarine (optional)

Brushes and additional tools:

○ Flat brushes, small and medium

○ Filberts (round brushes), small and medium

○ Palette knives (for mixing colours)

YOU WILL LEARN...

• to mix colours

• to manipulate your paintbrushes

• to roll the paint on and off your brush

• patience and perseverance in putting down all those marks!

1 Plot out where the trees meet the sky with small brushmarks: you are just giving yourself a guideline at this stage. You can use a diluted mix of any acrylic colour you choose, to mark out where everything goes. If you are feeling confident, go straight in with some brushmarks in some of the green mixes that you have made. Also mark in where the distant foliage touches the yellow grasses.

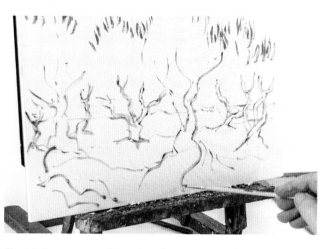

2 Mark in the trunks of the trees. Notice how the trunks are made up from a series of fairly straight lines. Use Ultramarine (oil or acrylic) to mark roughly where they go; don't worry about getting it exactly the same as in the original.

3 Make some direction lines to remind yourself of the movement in the grassy floor of the orchard. Remember that the direction of your brushstrokes will be describing the shape of things, the way the leaves move, the direction of movement in the grasses and the way that the tree trunks grow and twist.

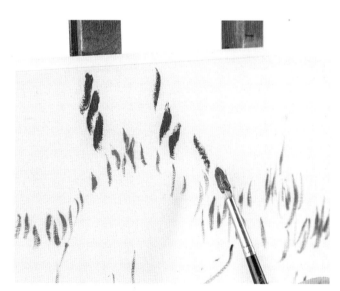

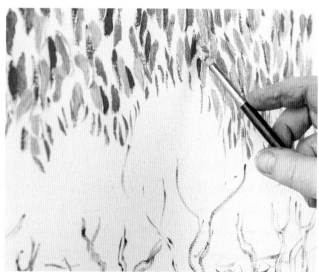

4 Start painting the sky. Resist the urge to 'colour it in' and instead build up the sky with lots and lots of small brushstrokes all over the area. Load your brush, then twist the paint off and onto the canvas; you should get three or four brushmarks from each loading. Put different blues next to each other. Van Gogh's style was to work with impasto, which means 'thick paint', so try to let the brushmarks show; don't smooth out the paint.

5 Keep laying the different blues next to each other, so that the sky begins to resemble a woven tapestry of blues.

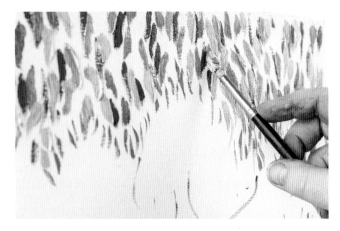

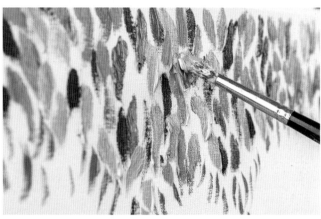

6 As you paint, imagine the heat in the air, the shimmering dry heat of an olive orchard in Provence. You can almost hear the cicadas – the broken colour mimics the broken sounds.

7 Once you have built up lots of different blues, choose a slightly smaller brush and make exactly the same type of brushmark, this time to fill in the gaps where you can still see the white surface that you are painting on.

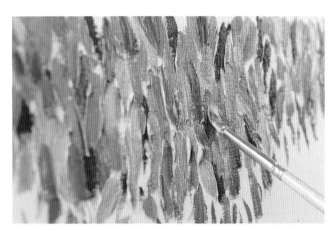

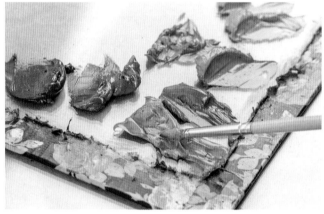

8 Try to make only four or five brushmarks from each brushload. You don't want to work the colours together; you must be able to discern all the different blues.

9 Now repeat the sky-painting experience with the greens to represent where the trees are. Try again to vary the greens and to maintain the thick brushmarks in the paint.

Top tip

Van Gogh spent a lot of his time, while he was living in London, in the National Gallery, studying the works of his favourite artists, including Édouard Manet (1832–1883), and Gustave Doré (1832–1883), whose engravings he admired; so I think that he would be very pleased that people were using his work to teach themselves the joy of painting.

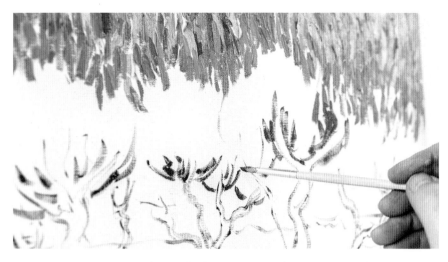

10 Put some more of the darker green colours where the branches are and keep 'growing' those trees, or painting those leaves. Try also to imagine where the shadows would be, in order to show the shapes of the trees.

11 Use a thicker brush for wider strokes of colour.

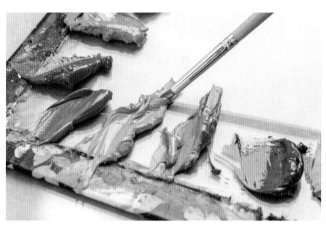

12 Go back in with a finer/smaller brush to fill in more of the gaps. Try adding a few strokes of yellow that will optically mix on the canvas – don't forget that blue and yellow make green, and that you have lots of different blues and yellows to play with.

13 The green leaves should meet the sky and weave together in vertical lines.

Sarah says

You can try to explain in words how to do something but there really is no substitute for doing it yourself, so dive in and have a go. When you are emulating another artist's style, you don't have to worry about the idea or the composition; they have done that for you. Just practise getting the paint onto the canvas!

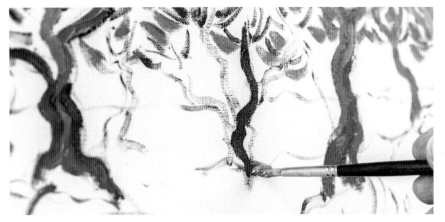

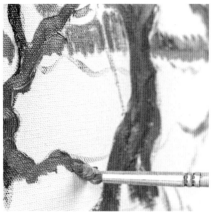

14 Paint the purple tree trunks next; make longer marks twisting down the trunks. The purple will look great alongside the yellow grasses you will add at step 17. For me, purple is the colour of shadows in Provence.

15 Start to fill in the grasses and the foliage. Mark some green so that the trees actually root into the ground.

16 Paint darker green leaves at the base of the trees' crowns; the foliage is thick here, and does not let through much light, so appears darker.

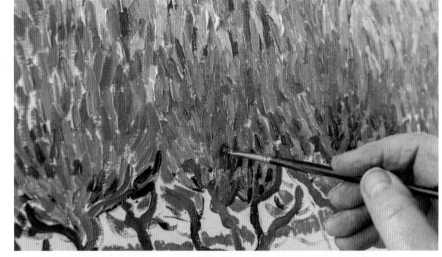

17 Now get some of the yellows in on the ground. Use a flat brush on its side, in a similar way to how you've painted the sky and the leaves. Make short strokes of colour, sculpting the way that the grass is growing, and sit the different shades of yellow next to each other to indicate that this ground isn't smooth.

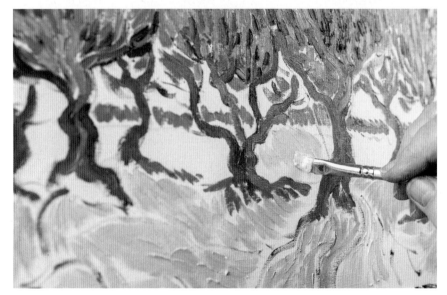

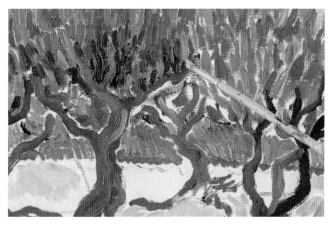

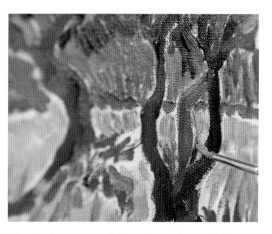

18 Add some short strokes of green and yellow to fill the gaps between the trees and the ground.

19 Take a small brush and get rid of any white peeping through, with yellows and oranges.

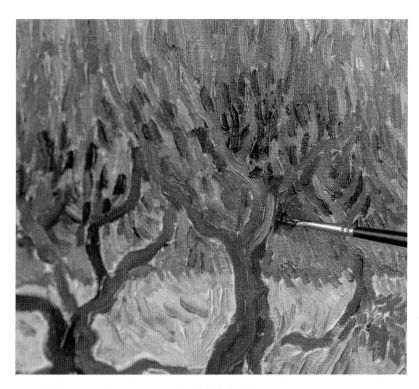

20 Pop a few strokes of green into the grass. Don't think about painting each blade – your brush is too big for that. Simply paint marks to show the general direction of the grass.

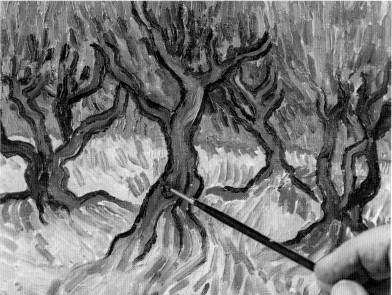

21 Load a small round brush with your darkest purple (a mix of Prussian blue and Alizarin crimson), then twist on the outlines of the trunks of the gnarly olive trees. This is the final flourish and will finish off your painting, bringing it all into focus!

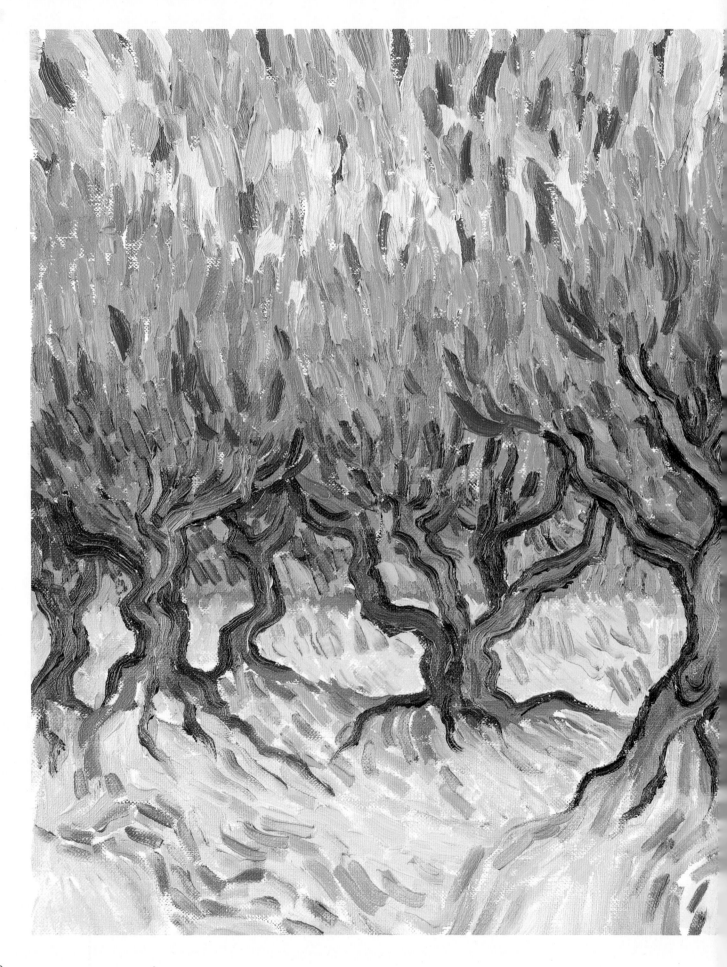

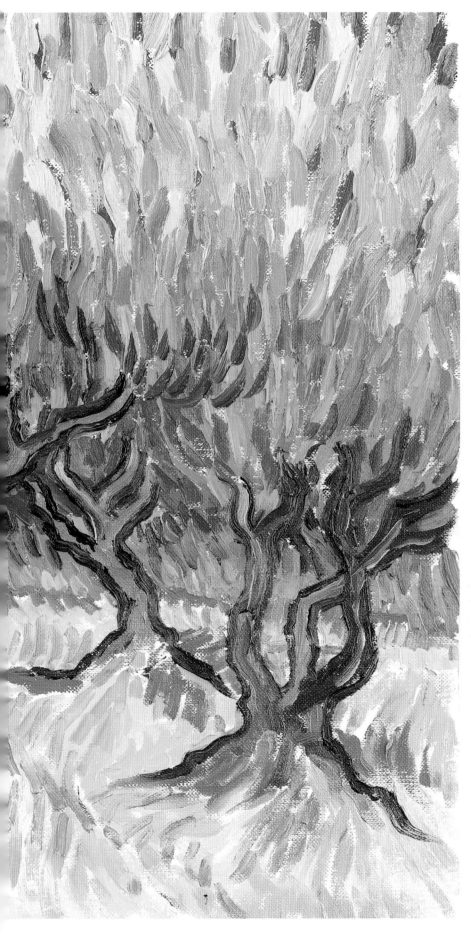

After Van Gogh's 'Olive Orchard'

40 × 30cm (15¾ × 11¾in)

See how the brushmarks echo each other. The blue brushmarks in the sky are very similar in shape to the green brushmarks of the leaves, giving you the feeling that there is shimmering heat on this day in the olive orchard.

2 Painting from a photo

Painting from a photo is very useful when you are first learning to paint; the subject won't move, the light won't change, and everything is already two-dimensional!

But there are some provisos to working in this way: you are creating a painting, so don't slavishly copy every single blade of grass or leaf – don't make an exact copy of the photo or feel bad if it isn't a replica. It's your painting, you are an artist, and if you want to paint the sky pink, you can – you are the boss!

I deliberately take bad, out-of-focus photographs to paint from, as I want them to be an *aide memoire*, not to trick me into copying the scene exactly.

YOU WILL NEED:

Surface:

- ○ MDF board, primed: 21 × 30cm (8¼ × 11¾in)

Colours:

- ○ All the colours in the capsule palette (see pages 30–31)

Brushes and additional tools:

- ○ Flat brushes, small and medium
- ○ Filberts (round brushes), small and medium
- ○ Palette knives (for mixing colours)

YOU WILL LEARN...

- how to ignore elements from source photographs
- different techniques for laying down paint
- the difference between the distance and the foreground
- how to mix different greens.

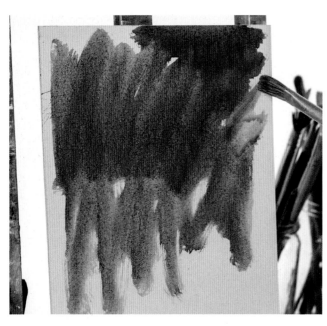

1 Make a watery mix of Ultramarine blue and Burnt sienna oil paint for the underpainting and apply it freely to the whole surface of the board.

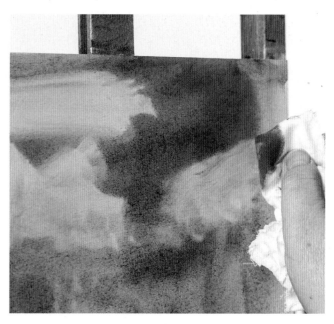

2 Use a cloth to lift out clouds and the horizon line.

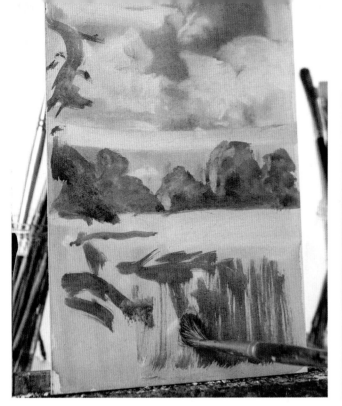

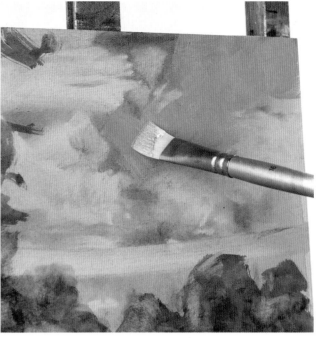

3 Paint in the big shapes that you can see when you squint your eyes (the treeline and the foreground). Once this is done, go and make a cup of tea and let it dry!

4 Start with the sky; refer to a colour version of the photo. Use primarily Cerulean blue with a touch of Ultramarine blue to spice it up, and Titanium white, to make the sky colour. Apply quite smoothly with a big brush: you want the texture to be in the foreground of your painting, so your sky should not be too textural.

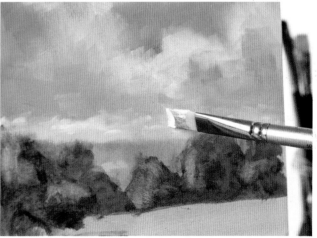

5 Clouds are not completely white, so add a tiny fleck of Ultramarine to Titanium white and then brush in your clouds.

6 Add a bit more Ultramarine blue and a tiny speck of Burnt sienna into the sky mix to make a warm bluey-grey for the clouds on the horizon. Don't forget that the clouds further away, closer to the horizon line, will appear smaller.

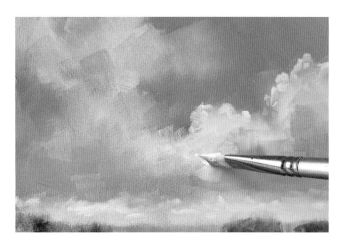

7 Put some more white on the corner of your big brush and tip off the clouds with highlights where they are catching the light.

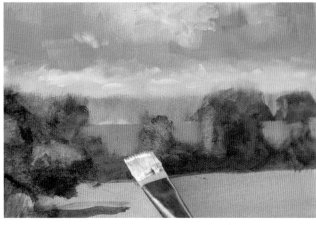

8 Paint in the little bit of river visible through the trees, using the sky mix again.

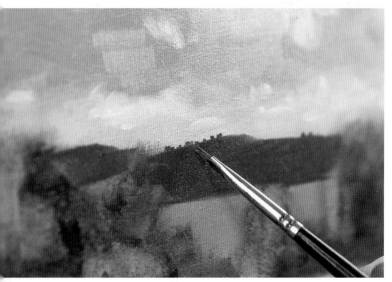

9 Don't clean your brush completely before putting in the distant hills. You want these to be a bluey-green, so mix that on your palette. Paint the first layer of hills and break up the horizon with little dots, which represent trees. Don't try to paint everything that you think is there, or that you can see on the photograph, just a hint.

Sarah says

Worth thinking about when you're doing this is what you want to talk about in your painting. For me, it's the slash of yellow of the barley field and the texture of all the summer flowers – that's what I saw when I chose the source photograph, and what I'm trying to achieve in the painting.

Tip

Try to think of your painting as a stage set: you are working from the back coming forwards.

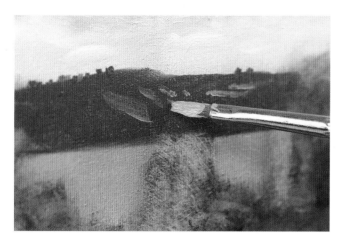

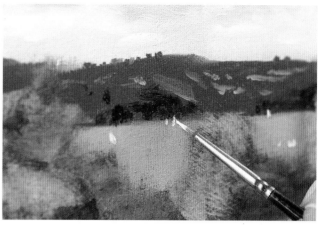

10 Use a tiny, softish flattish brush with a pale green on it to pop in slashes of distant fields, applying just a touch of paint.

11 Put in a darker area of blue, as the trees going down to the water are in shadow. They also provide a good foil for these specks of white, which represent boats. Use a tiny bit of pale Yellow ochre for the foreshore.

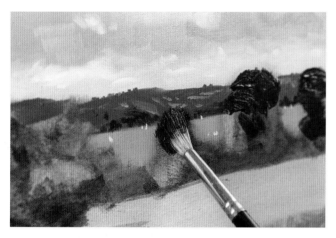

Top Tip

When you're painting distant objects, you need only give a clue as to what you're looking at. People will make their own connections and make their minds up about what they're seeing, so you don't need to draw in every detail.

12 Move in and do the next layer, the trees. Take up a medium round brush (make sure the brush is dry). It is important to change brushes, to help move the viewer forwards through the painting, and avoid the midground looking too similar to the background. Push the paint on rather than painting it on, using a really dark green mix (add Prussian blue and Alizarin crimson to your basic green).

Sarah says

When painting from your photographs, really try to remember what the place sounds like, the feeling of the place, the weather and bird song; all these memories will help with your painting. It is always worth making little notes and tiny sketches while you are out as well as taking the photo.

A NOTE ON *NŌTAN*

Nōtan is a Japanese term that means 'light–dark harmony'. You can apply *nōtan* to your painting to arrange different elements of light and dark without having the distraction of the other elements i.e. colour, finer details or texture.

See page 44 for a further explanation of *nōtan*.

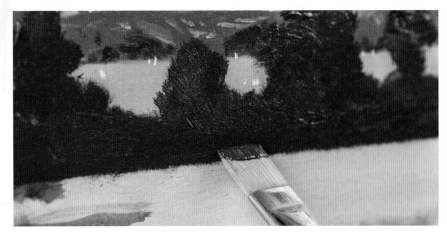

13 Paint in the large shape of the midground trees. Try to see the whole shape, not the details. Take care with the edge that visually 'hits' the water (which has the water behind it). Now paint down to the edge that will eventually act as a backdrop and contrast for the yellow-green barley that you will add later. This dark green mix comprises Sap green with Prussian blue and Alizarin crimson. Use a flat brush here.

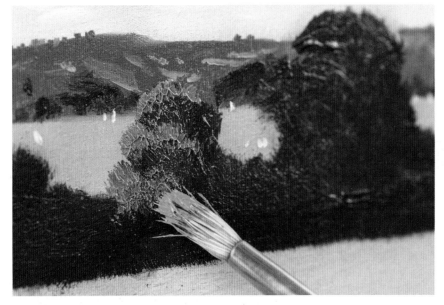

14 Finish off the midground before you attempt the foreground. You will need a lighter blue-green for the light on the trees – not too bright but certainly lighter than the inky dark green that you have on the midground trees. Use an old brush at this stage: make sure that it is clean and dry before loading it up with the lighter green (made up of the warm yellow with a touch of Cyan blue). Then push the lighter green into place; let the 'scrubby' bristles do the work for you.

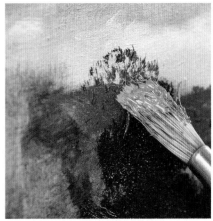

15 This is where you can experiment with different ways to put the paint on; touch the canvas really gently and just leave small marks with your brush. When people paint, they tend to think they need to make long horizontal or vertical strokes, but there are a lot of other marks you can make. Touch the brush very gently along the treetops in the midground.

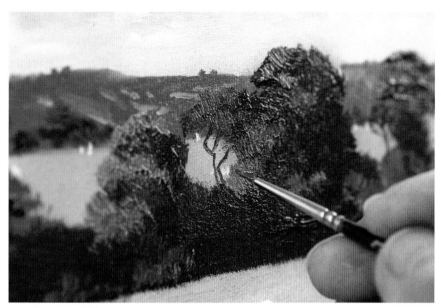

16 Now put some highlight on the pine trees. Make sure that the 'light' that you are painting onto the trees is coming from the same direction. Put in the Scots pine tree trunks as a couple of wiggling lines; don't scrub, just paint in one stroke and lay the colour on top of the pale water behind.

17 With a very light green mix, mainly Lemon yellow, paint the far edge of the barley field first. Use a medium flat brush for this.

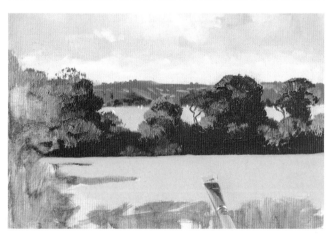

18 Once the edge is in, make sure that the rest of your brushstrokes move vertically, up and down, mimicking how the barley grows.

Sarah says

Paint from your own photos whenever possible. When you paint from other people's photos, you don't get quite the same idea or feeling of the place. Do as much sketching or record-keeping of how you feel as you can – this is crucial preparation for painting.

19 With a bluey-emerald green, paint in some horizontal slashes to break up the yellow, which is a sliver of light falling across the field. The emerald green is the shadow of trees at the edge of the field. Use the edge of your brush for these marks.

20 Use the edge of your brush again to pull a darker version of the emerald green downwards in vertical brushstrokes. Put some super-dark green into the depths of the shadows. This is the edge of the path running alongside the field.

21 With a medium brush loaded with the lightest barley colour (Lemon yellow with the meanest speck of Cyan blue), touch the very edge of the field where the trees meet the barley. Give the impression of stalks sticking up; make tiny marks to soften and break up the straight line.

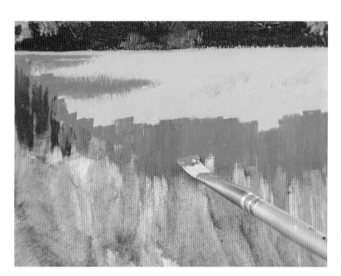

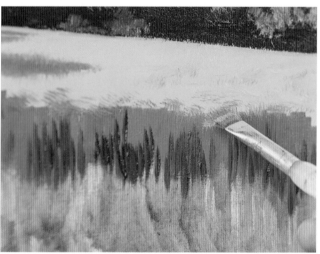

22 Dip your brush into the emerald mix again and begin to build up the lower edge of the field in downward strokes. Always take your colour further than needed when building your 'stage set'.

23 Paint the darker green into the bottom edge of the field, again making vertical marks with the edge of your brush to break up any unnatural lines.

24 With a tiny, old, thin paintbrush, add a few little 'humpback bridge' marks of barley at the closest edge of the field. You don't need to paint in a lot; a few will suffice.

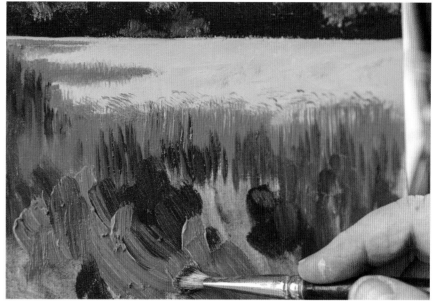

25 With a stiff hog hair brush, begin work on the very foreground; this is the area for interesting brushstrokes. Work with a variety of greens, wiping – not washing – the brush between colours.

26 With a paint shaper (or the edge of a credit card), press dark stalks into this area, breaking into the yellow of the field. Use the really dark green mix for this.

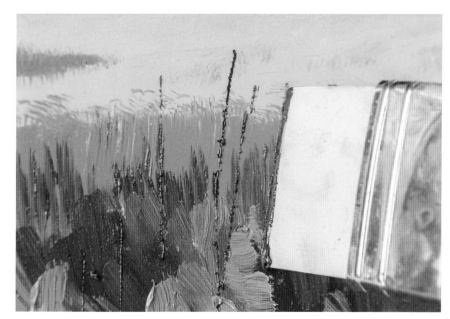

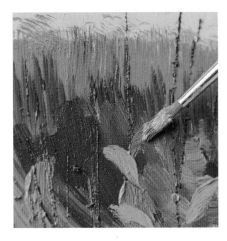 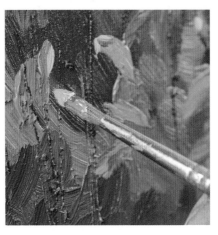

27 Paint in more leaves, varying the green as you go; choose more blue-green colours for the shadows. Load the brush and twist the paint off, letting the brush make the shape of the leaves.

28 Use bright yellow here and there to add highlights.

29 For the cow parsley, add little curved shapes with a loaded, soft brush. Then add shadows among the grasses. Things that you know to be white but are in shadow, paint with a pale purple-blue: Ultramarine with white and a touch of emerald green works well.

30 Add dots of seed heads to complete the scene.

BEFORE YOU FINISH

Now is the time to sit back and take a critical look at your work. Check it in a mirror and ask yourself whether it looks as you want it to. Have you missed anything out? Is the path working? Maybe add a few more dots of colour for flowers.

Opposite

Painting from a Photo

21 × 30cm (8¼ × 11¾in)

This scene depicts an idyllic summer's day in Cornwall; a footpath runs beside a barley field with a river beyond.

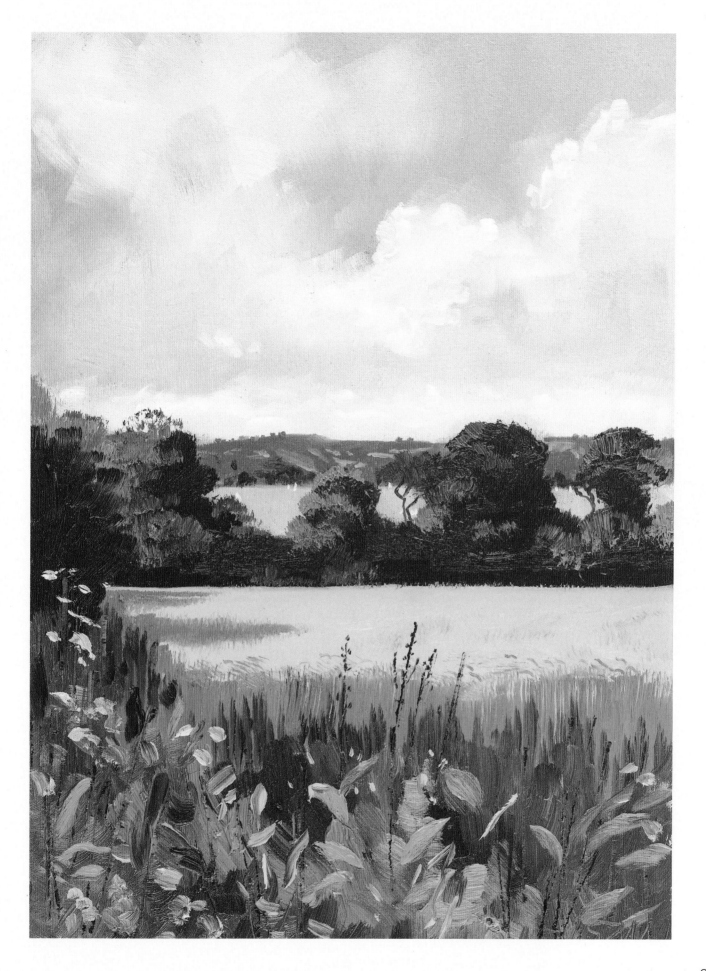

3 Painting an abstract

Give yourself permission to play. When you let yourself experiment with different ways of applying paint, using your brushes and tools and creating textures, you are learning.

Let's paint an abstract and really learn to enjoy this wonderful medium.

YOU WILL NEED:

Surface:

○ MDF board, primed: 42 × 30cm (16¾ × 11¾in)

Colours:

○ All the colours in the capsule palette (see pages 30–31)

Additional paints:

○ Acrylic paint in Ultramarine blue

Brushes and additional tools:

○ Flat brushes, small and medium

○ Filberts (round brushes), small and medium

○ Palette knives (for mixing colours)

YOU WILL LEARN:

• brushmark-making

• colour mixing

• the different things your tools can do

• a new way to loosen up and experiment!

1 Using a diluted acrylic colour first, make some very basic composition decisions. You could divide your canvas roughly into thirds, which is a very good framework for any composition. Here I have painted an L-shape using the Rule of Thirds (below) as a guide, and a circle shape on one of the intersections of the L-shape.

Tip: Applying the Rule of Thirds

Divide up your paper or canvas into thirds, then place important features, like a tree or the horizon, on one of the lines or at the intersections. It's a very basic but useful composition trick.

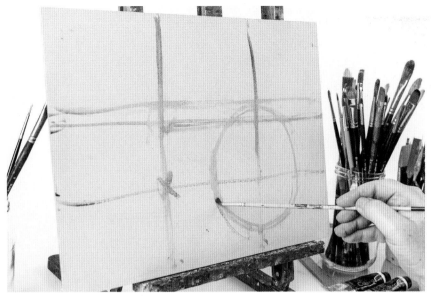

2 Once you have a very rough composition marked out, clean the acrylic paint off your palette and begin with the water-mixable oil paints.

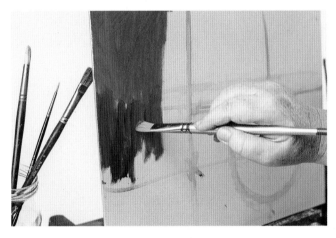

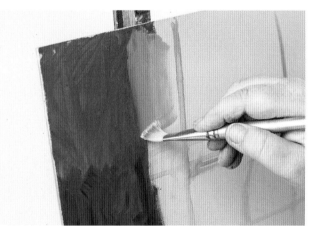

3 Begin in the top-left corner with Cyan blue, then add some Ultramarine blue and mix them together on the board. The paint will stay wet and workable for ages, so you can take your time blending and 'worrying' the two blues together. However, there should be a transition of the blues so they should not be thoroughly mixed together.

4 Add some Titanium white and mix it in with the Cyan, using an old, ragged brush to make marks in the paint. Adding the white will make the difference between the two blues very noticeable.

BEGINNING WITH ABSTRACTS

Allowing yourself to paint abstracts is a brilliant warm-up exercise. You can relax and listen to music and let your mood influence your painting – you can't really go wrong!

Artists starting out often have preconceived ideas about what they should be painting and indeed whether they can paint at all.

I once taught a 68-year-old man who hadn't painted since he was eight years old because his teacher had told him that he couldn't. Sixty years of missed painting time later, he was actually very good and, more importantly, he enjoyed it!

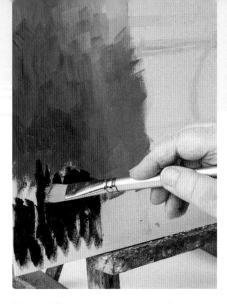

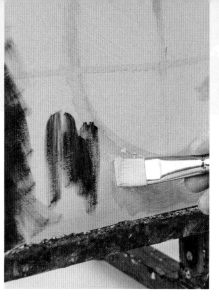

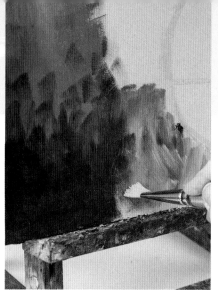

5 Add some Prussian blue at the bottom of the canvas. When I want to add some 'weight' at the bottom of the painting, I add darker colours as they always seem heavier to me!

6 Come in now with a new, flat brush and a warm yellow: Cadmium yellow medium. Paint from the right-hand side towards the bottom centre, adding some Lemon yellow as you move towards the middle of the canvas.

7 'Squish' the paint off the brush and add some more, this time bringing the Lemon yellow across the canvas to mix with the blue and make a rough yellow-green.

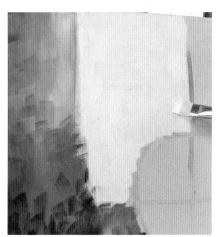

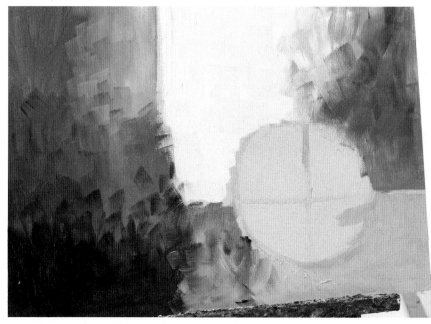

8 With a clean and very dry flat brush, apply Titanium white in the top centre of the composition.

9 Mix Cyan and Ultramarine blue quite roughly with the Titanium white and apply to the top-right corner, using quite visible brushstrokes.

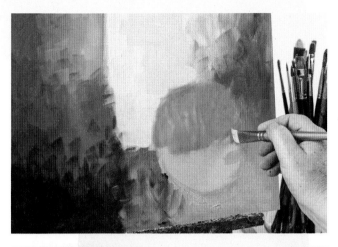

10 Make different, directional brushstrokes, and try out different blue and yellow combinations for numerous greens inside the circle.

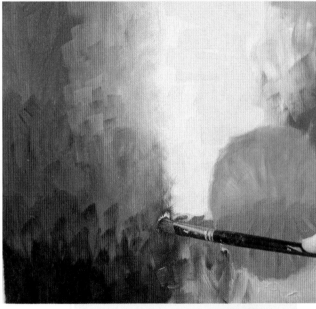

11 Use a soft, pointed brush to blend some areas together.

12 Tap the brush into the areas of white and blue; simply play with the marks that you can make with your brushes.

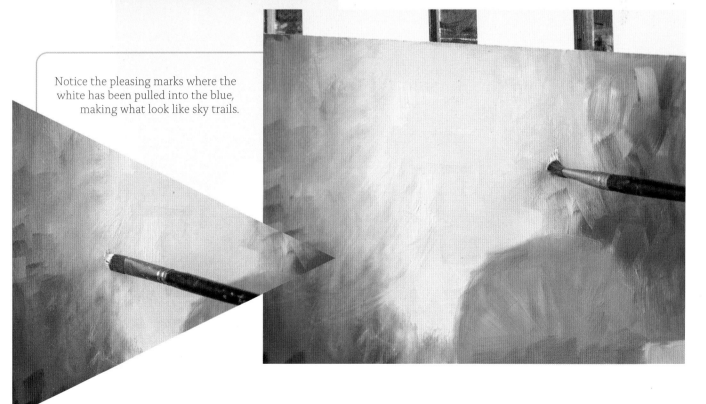

Notice the pleasing marks where the white has been pulled into the blue, making what look like sky trails.

13 Having done lots of mark-making with brushes, now you can start to use some of your other tools. The palette knife is interesting to apply paint with; it requires a bit of practice to get used to using it, so this is the perfect project for that. Make a strong hard edge of Cadmium yellow against the blue.

14 Apply the paint by loading the knife with colour. Imagine that you are spreading butter onto toast – don't work the paint in, lay it on. The resulting textures, in the yellow-on-yellow area, will be very interesting to see.

Sarah says

Something that seems to happen after you have allowed yourself the freedom to paint a few abstracts is that you will begin to look at other artists' work with a keener eye. You will begin to notice interesting brushstrokes, how the paint has been applied and other physical aspects of the painting, not just the subject matter.

15 Make the most of the edge of the knife to make definite or strong edges.

Top Tip

One of the advantages of painting in oils is that you can manipulate the paint for much longer than with, for example, acrylics.

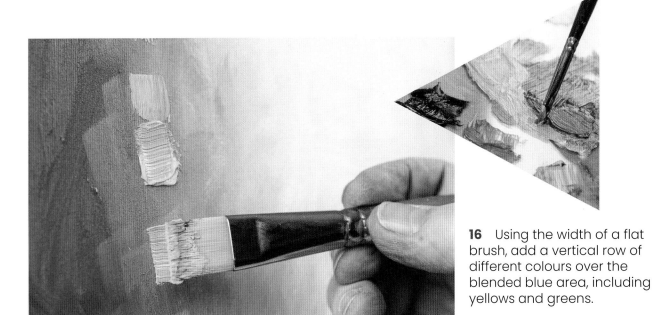

16 Using the width of a flat brush, add a vertical row of different colours over the blended blue area, including yellows and greens.

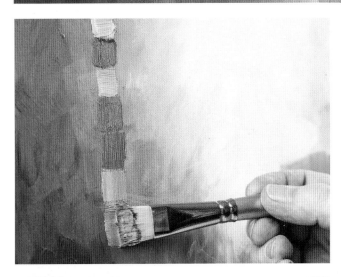

17 Try to lay the colour gently but firmly, in one definitive brushmark each time: this is the best way to apply colours on top of other colours without getting 'mud'.

18 Try the same thing with your palette knife.

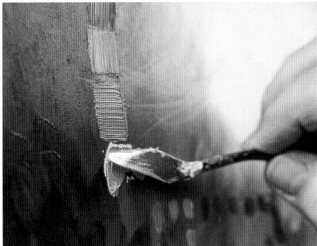

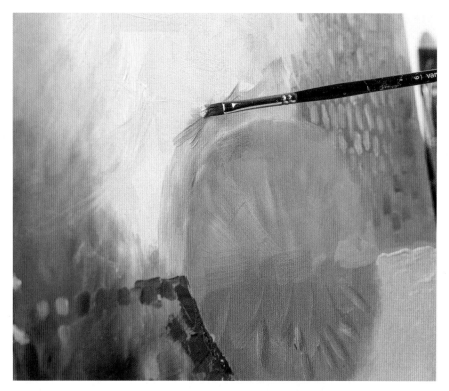

19 After all that careful colour placement, loosen everything up again! Apply some Yellow ochre with a small brush and deliberately mix it into the colour already on the surface, around the edge of the central circle – just for fun!

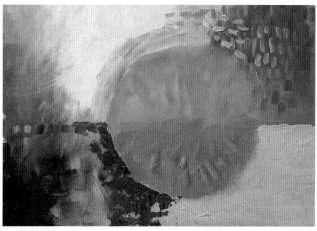

20 Now you have a selection of different textures, colours and marks around the outside of the green circle.

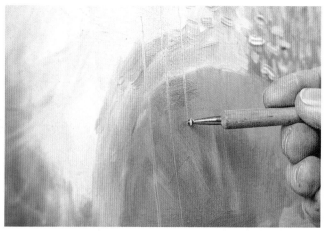

21 Inside the green circle, use a nail varnish tool to scratch lines into the still-wet paint.

 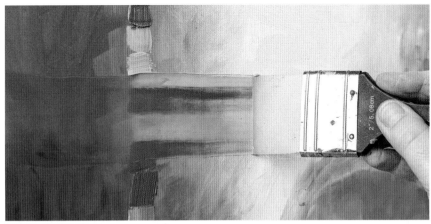

22 Then use a small paint-moving tool (paint shaper) with a flexible silicone tip to move the paint around and work squiggly marks into the wet paint.

23 Switch to a large, flat paint shaper and pull the 'blade' through the paint to draw it. This painting makes me think of a formal garden on a summer's day; the patterns and textures remind me of flowers, grass, and even the flight paths of insects.

The blue and white marks in the bottom corner could represent a fountain.

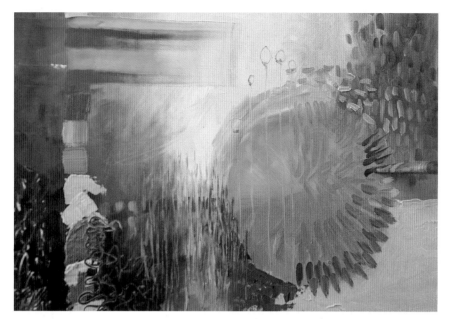

24 Add some more green paint with a small brush and break up the edge of the green circle.

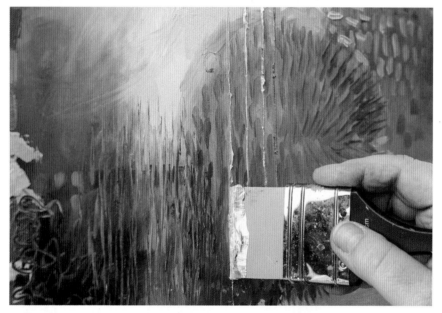

25 Emphasize some of the marks to make them look a bit like tall plants: stamp in some seed heads and plants using the large paint shaper and a mix of Yellow ochre and Titanium white; this makes a pale earthy yellow, reminiscent of dried grasses.

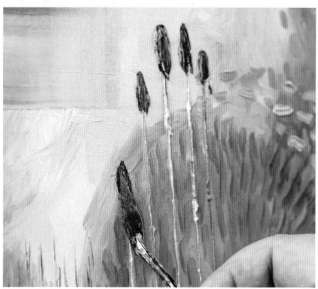

26 Add some Burnt sienna as a dash of contrast for reed heads; again, press the colour on and try not to let it mix with the colour beneath.

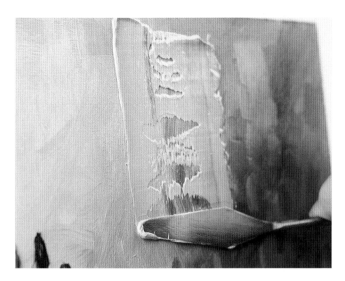

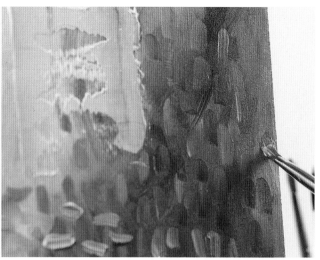

27 Using the palette knife, add some Titanium white paint and drag it down the painting.

28 With a stiff little brush, make marks into the paint that look like rain. These will appear behind the paint you dragged down with the palette knife at step 27.

29 Turn the painting upside down, and run some dribbles of clean water down the canvas. These random drips will move the paint. When the water hits a thicker paint mark, it will run around it. Try things out, take risks, experiment and see what happens... this is something that you should try to do with every painting.

30 Turn the painting the right way up again, and put it somewhere safe to dry – this may take several months!

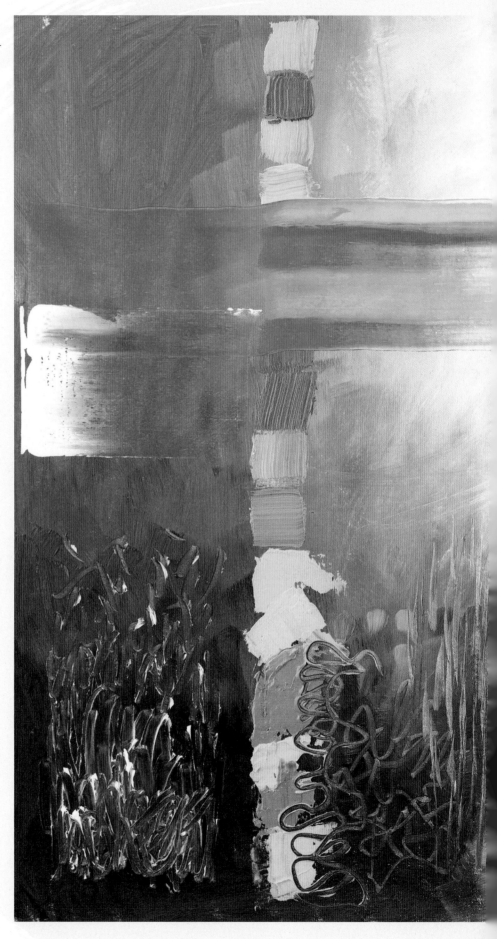

Listen to the Bees
42 × 30cm (16¾ × 11¾in)
Oil on board.

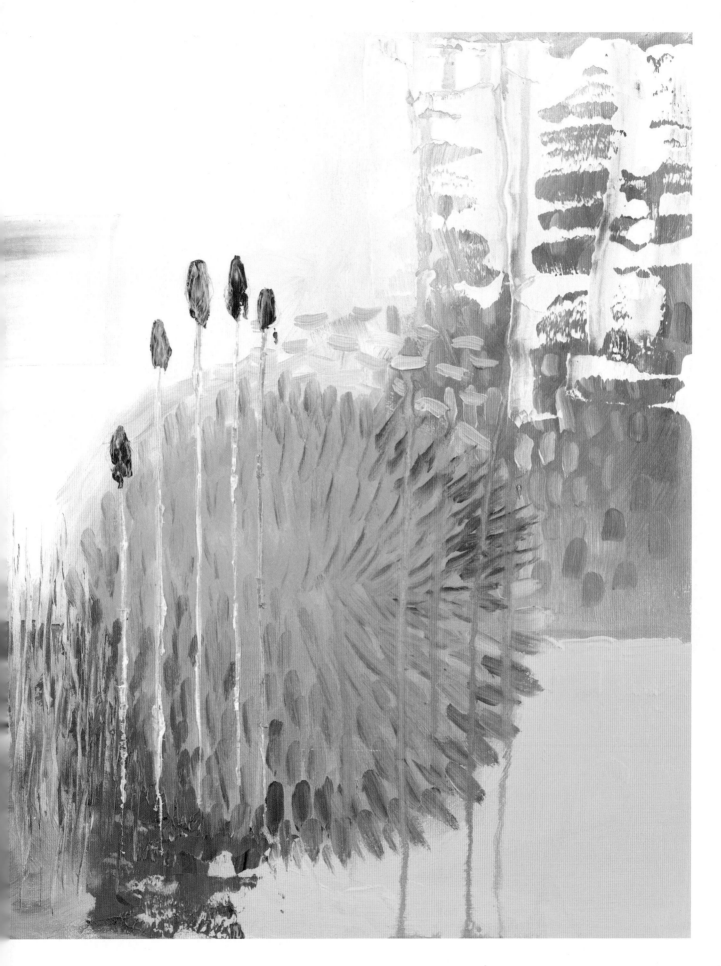

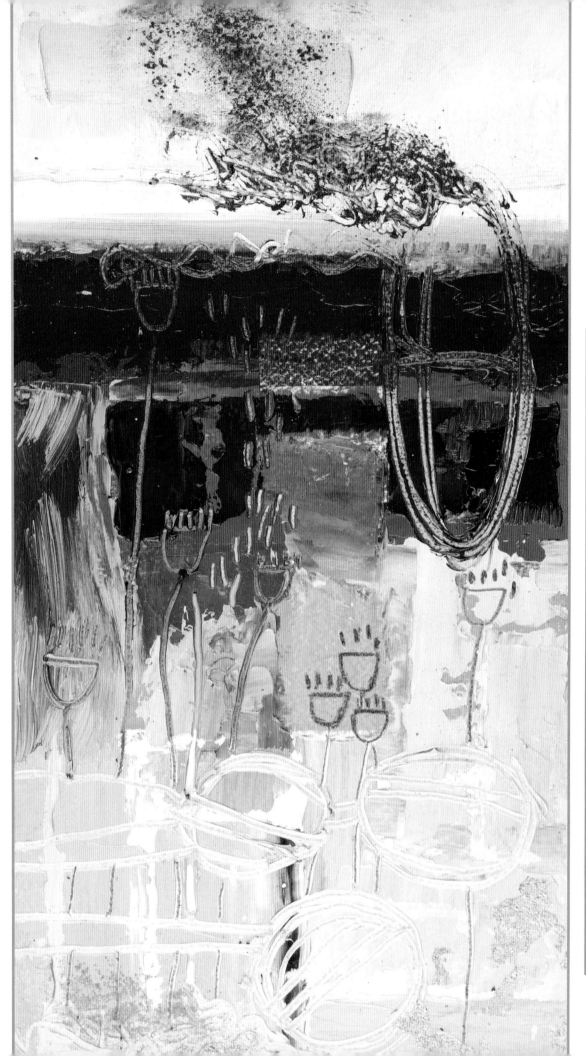

Opposite

Daydreaming, Creekside

16 × 29cm (6¼ × 11½in)
An abstract with a very seasonal feel:
with hints of seed heads and the colours
of autumn.

Moroccan Garden

30 × 40cm (11¾ × 15¾in)
With its exotic plants, vivid yellows and
blues, hot white walls and the suggestion
of some water trickling, it's easy to see
where this title came from.

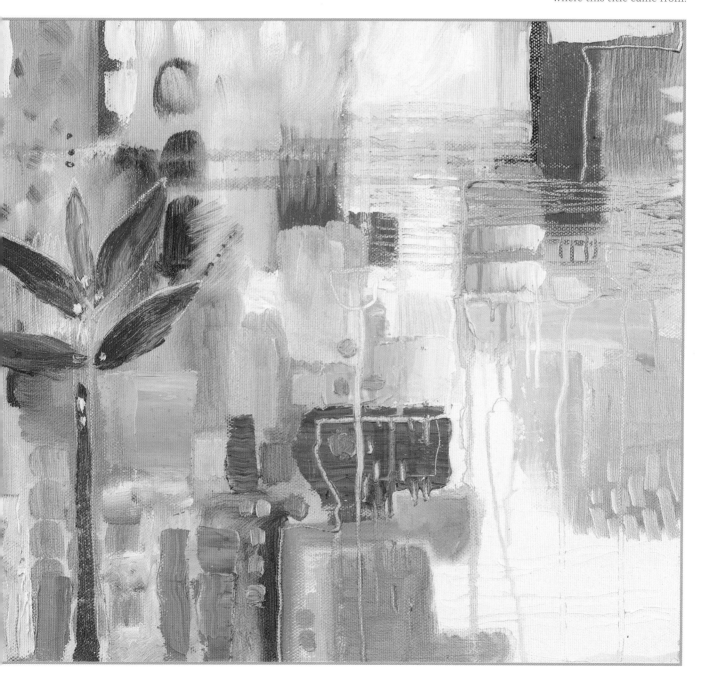

4 Still life

While you are painting a still life, you will be looking very closely at the shapes and their relationship to each other. You will also be trying to mix colours that match what you can see and noticing how the light changes those colours.

You can take anything as your subject: I have used a mug and a bowl of fruit. Group them in a pleasing arrangement; try to avoid anything too regimental and have some shapes overlapping.

YOU WILL NEED:

Surface:

○ MDF board, primed: 42 × 30cm (16¾ × 11¾in)

Colours:

○ All the colours in the capsule palette (see pages 30–31) – especially the earth colours

Brushes and additional tools:

○ Flat brushes, small and medium

○ Filberts (round brushes), small and medium

○ Palette knives (for moving the paint onto the palette)

YOU WILL LEARN:

• how to look and then paint what you see

• how to see the spaces between objects

• ways of blending paint and softening edges

• how to paint detail using layers.

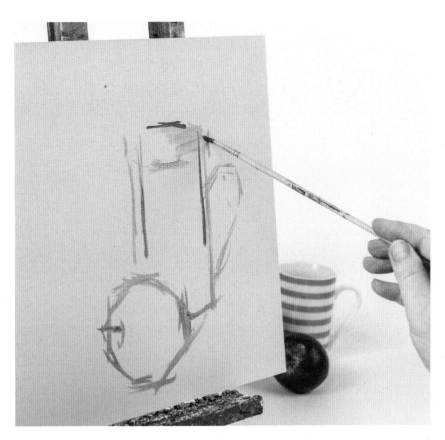

1 Sketch your arrangement using some watered-down acrylic paint (I've used Ultramarine, but you can use any colour). Don't panic about this drawing; it will be covered up as you paint. Just try to get everything in the correct place on your canvas.

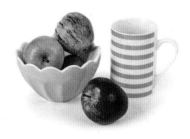

The still-life set-up.

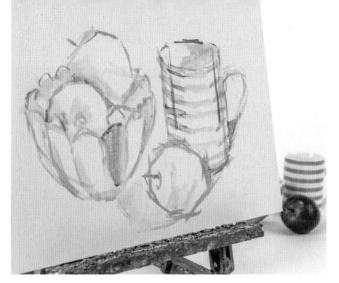

2 At this stage you are making visual notes – an *aide memoire* – of details that you don't want to forget as you paint. You'd be surprised at how easy it is to forget the things that you first noticed, so make visual notes of where the shadows fall, and so on.

3 With the initial drawing done and dry, it's time to start painting, or blocking in the colour. Mix some colour: I wanted to achieve a '1950s blue', a basic colour that I could adjust throughout the painting. To mix this blue, I used Cerulean with Titanium white and a touch of Yellow ochre for a green-blue, then I 'knocked it back' a bit by adding a speck of Burnt sienna. Start the painting with a medium flat synthetic brush. Paint in the shape of the bowl in a fairly blocky way, and adjust the colour by adding a little Prussian blue as the light changes around the bowl.

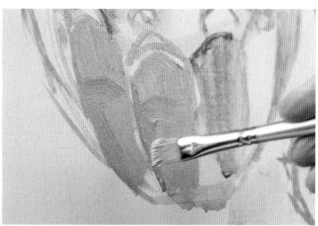

4 Take the same blue over to start the mug, use the same blocky brushstrokes and adjust the colour according to the light on the mug. Look at the way that the colour of the apple 'changes' the colour on the mug.

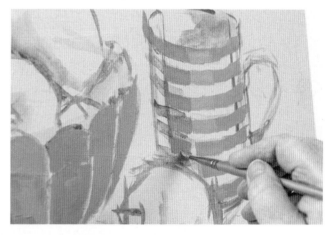

MAPPING WITH DIRECTIONAL MARKS

If you look at other artists' paintings, you will see that the direction of the marks made often give you clues to the shape of things that have been painted. Van Gogh's work is a fantastic example of this: the direction and angle of brushmarks tell us so much about the structure and form of things.

I like to imagine that, if my paintings were sent to another planet, aliens could build something three-dimensional from my two-dimensional image by using it as a map. You need to get that much information into your work – without words!

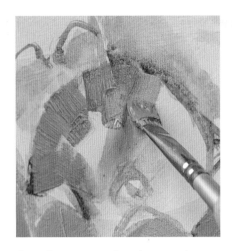

5 Mix a green for the apple from Lemon yellow with Cerulean, a hint of white, a pop of Yellow ochre and a speck of Burnt sienna again, to knock it back if it becomes too bright. Don't think too much about these mixes; they will become instinctive and easier, the more you paint.

6 Use another, clean flat brush for the yellow-red striped apple. First, paint the 'under-colour': make a dirty yellow mix of Lemon yellow and a hint of Yellow ochre. In the shadow areas, try adding a touch of blue.

7 Paint up to the edge of the green apple but try not to touch it with your brush. Add some white to the yellow mix and a tiny touch of Scarlet lake, the warm bright red, to turn the other side of the apple rosy-pink.

Sarah says

Try to look 'underneath' the surface decoration of the stripy yellow-red apple, beyond the obvious pattern, to ascertain what the base colour is. Think of the apple as a stage in a theatre. You are painting the set: the backdrop is the furthest away from the front of the stage – this colour is the base colour of the apple. You will add the rest later.

8 Touch in a little flash of orange (from the satsuma) underneath the apples. To make the orange colour, mix the warm yellow, Cadmium yellow, and warm red, Scarlet lake. Paint this into the middle of the satsuma, then, for the edges, 'mucky it up' with the addition of a tiny bit of Burnt sienna and Ultramarine blue.

9 After mixing colours and doing a bit of painting, you will need to do some housekeeping: tidy up your palette, scrape colours together into neat piles, and scrape excess paint off your brushes with a palette knife. If you own several similar brushes, keep some for applying dark colours and others for light colours. Note that you don't need to wash your brushes yet; just wipe them clean for now.

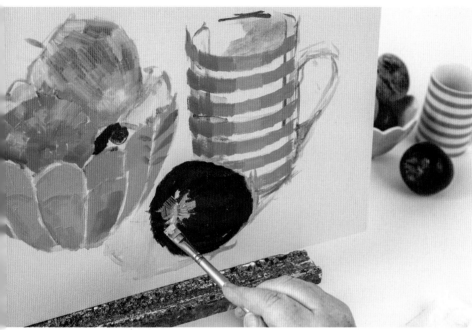

10 For the red apple, use a mix of the cool red, Alizarin crimson; Burnt sienna, and a little Ultramarine blue, which will make the colour move towards purple. Paint the apple following the direction of the stripes on the skin. Vary the red as you paint, adding a few stripes of Scarlet lake. Use a little of the dirty yellow mix (from step 6) to add highlights near the stalk.

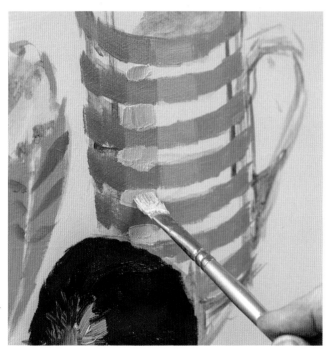

11 Use a clean brush to paint some of the white stripes on the mug: Add a tiny bit of blue to a larger blob of white paint to suggest shadows and the shape of the mug.

Tip

Remember, always add dark colours, in small amounts, to a larger amount of light colour. It is easier to adjust the colours that way round.

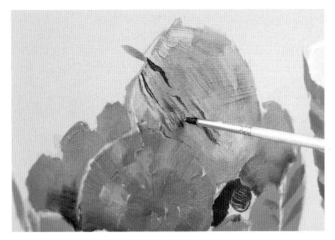

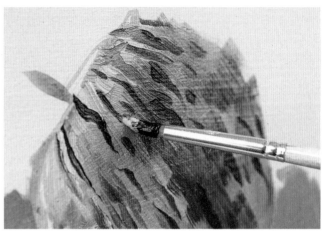

12 Next, start painting the areas around the arrangement. To make the shadow colour inside the bowl, make a nice warm grey by mixing Ultramarine blue, Burnt sienna and white. The edges of the bowl are also shown in white. Add red stripes to the yellow apple with a small pointed brush; twist the brush between your fingers as you apply the paint, as this will give you a very natural-looking wobbly line.

13 Stipple in a bit more of the red: make only three or four brushmarks before reloading the brush.

Tip

Avoid using your brush as if it is a marker pen with an endless supply of colour; it is a vehicle to get the paint from the palette to your canvas and it will need reloading.

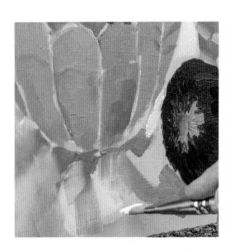

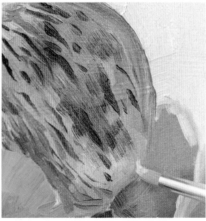

14 Break up the shadow of the bowl with a pale mix of white with a little Yellow ochre. Use this mixture as the background of the painting; adding the yellow will make the whites on the mug and bowl look brighter.

15 Paint the very edges of the apples in the warm yellow with a tiny touch of Yellow ochre mixed in. Notice how the apple appears dark against the light background and light against the shadow area.

16 Paint a stalk on the green apple in a dark mix of Ultramarine blue and Burnt sienna. Then soften the furthest edges of the apple with a soft brush, making it appear almost out of focus.

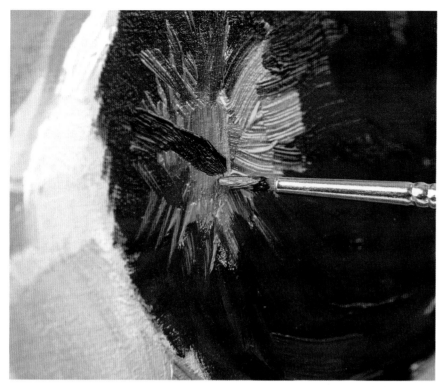

17 Use a small brush to push an orange mix around to fill the space around the stalk of the red apple. Paint the stalk itself with the mix from step 16; load the brush, press it down, then 'twist' it off the painting. Fill in any little gaps with the small brush.

18 With the dirty yellow mix add a highlight to the stalk. Pull the paint down the centre of the stalk, effectively leaving a small, dark outline.

19 Blur the edges of the red apple as you did with the green apple at step 16.

20 Join up and cover over any gaps on the bowl by pushing the paint around a little, with a small brush.

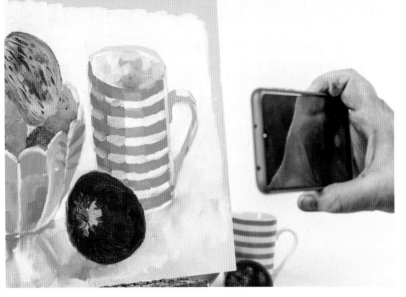

21 At this point, take a photograph of the painting to see if any adjustments are needed.

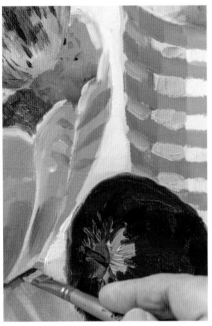

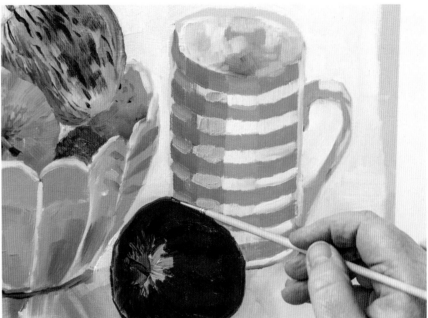

22 Put some red into the bowl to suggest the reflection of the red apple.

23 Make the painting a little Cézanne-like by exaggerating the colours and, using a small brush, draw around some of the objects, especially under the bowl and under the mug using Prussian blue with some of the cool red.

Sarah says

Right before you finish the painting you may feel disheartened by it, but then you make a couple of tweaks that solve a lot of problems, like a flash of bright white as a highlight, or another tiny line to emphasize an outline, or soften an edge as it recedes. Even if you've been painting for a long time, you can lose confidence, but keep carrying on until you reach a point whereby you can make those tweaks.

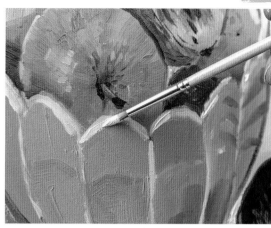

24 With a small, round brush loaded with white, paint the edge of the mug: roll the brush between your fingers to move the paint from the brush to the canvas.

25 Soften and blend the paint inside the mug with a soft, flat brush, to give the effect of smooth glazed china.

26 Do the same for the highlights on the bowl as in step 24: roll white paint off a small brush onto the canvas.

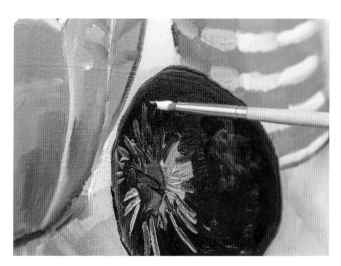

27 Finally, dot in a few highlights on the red apple. Use either the lightest red you can mix or even a dot of white, straight from the tube.

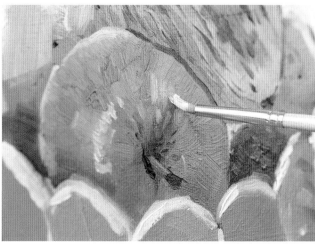

28 Apply the same treatment to the green apple (using the lightest green you can mix, or a dot of white). Your still life is complete!

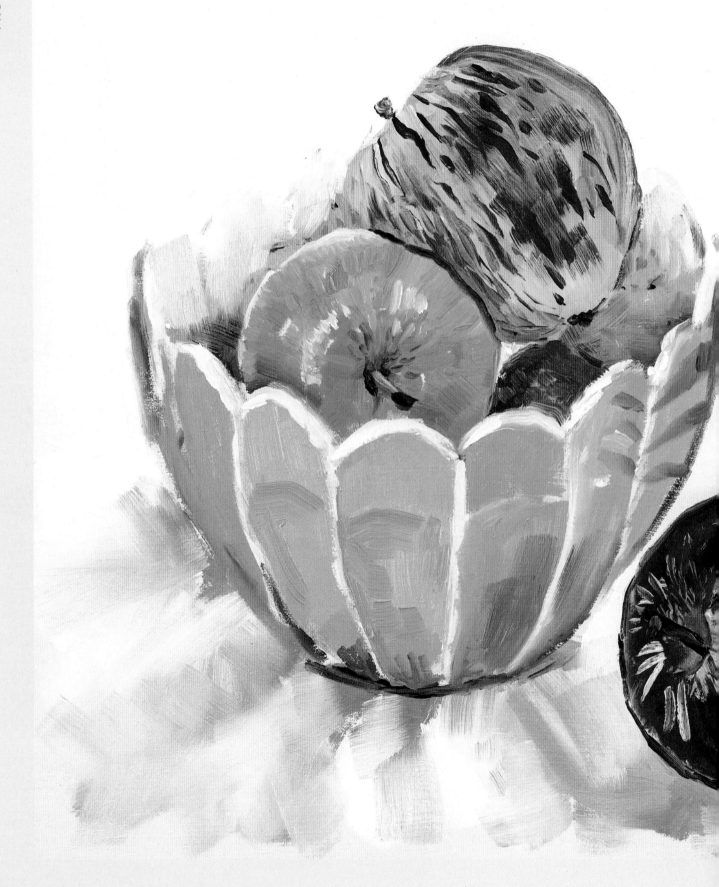

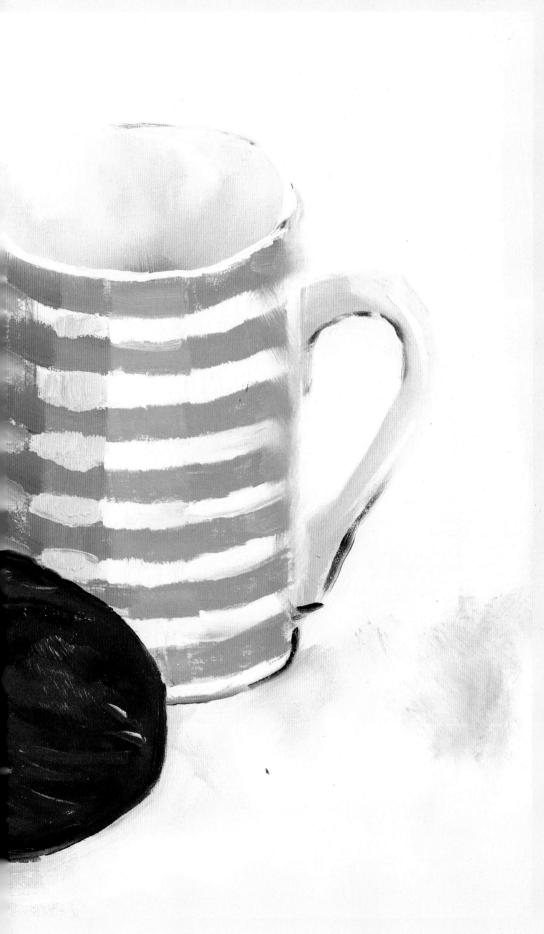

*Still Life with
Three Apples*

*42 × 30cm
(16¾ × 11¾in)*
This is a simple still life of
objects from the kitchen,
with a little emphasis on
brushmarks and some
outlining to enhance the
colours of the fruits.

Little Ted

15 × 21cm (6 × 8¼in)
Anything can be a subject for a still life. Old toys are
a great subject as they always seem to hold a story or
convey a sense of history.

Sake cups

15 × 21cm (6 × 8¼in)
Sometimes you don't need to arrange still-lifes at
all for a pleasing composition; collections of objects
often lend themselves naturally. I call these 'found'
still lifes.

Landscape

I love painting landscapes in water-mixable oils; I always find plenty of opportunity to introduce textures and different ways of applying the paint.

As you tackle this project, remember that you are creating a painting, not a photograph; and that oil paint is very forgiving – you can scrape back any mistakes and paint again.

YOU WILL NEED:

Surface:
- MDF board, primed: 42 × 30cm (16¾ × 11¾in)

Colours:
- All the colours in the capsule palette (see pages 30–31)

Brushes and additional tools:
- Flat brushes, small and medium
- Filberts (round brushes), small and medium
- Old fan brush
- Old brush with stiff bristles
- Palette knives
- Plastic card
- Nail tool

YOU WILL LEARN:
- how to ensure your horizons are correct
- how to use different tools for mark-making
- about *sgraffito* – scratching through the paint
- how to lay a colour on top of another.

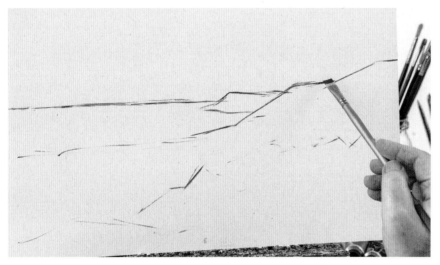

1 Sketch out the composition, using undiluted water-mixable oils. Put in a few markers to show where everything is. I always make sure that the sea horizon is straight – I don't want the sea to appear to run out of my painting, so I measure two points up from the bottom edge of the canvas and join these up for a straight line.

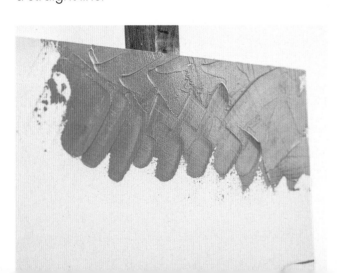

2 Make a good sky mix of Ultramarine blue and Cerulean blue, together with a bit of Titanium white. Sometimes, this colour can look a bit unnatural, so to knock it back a little, add a speck of colour from the opposite side of the colour wheel: that is, orange.

90

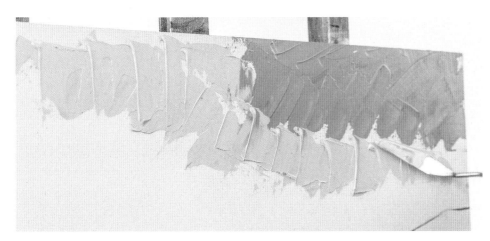

3 Apply the sky with a palette knife. Start in the top-right and gradually make the mix lighter as you come down and across the painting.

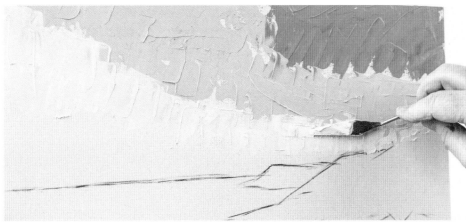

4 Add more white to make the blue paler; mix it with the palette knife. Scoop up the paint onto the knife and apply it to the canvas.

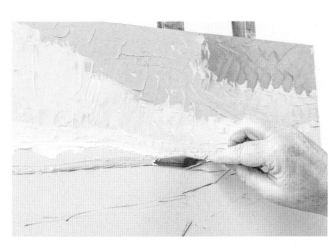

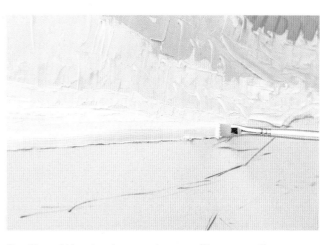

5 There is a little bit of cloud on the horizon with yellow in it, so mix up some white with Lemon yellow and run this in first. Add a little blue mix to the pale yellow for this cloud line. The result should be a pale greenish-grey. Apply all of this with your palette knife.

6 Blend the horizon colours with a small flat brush.

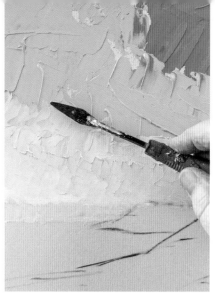

7 Blend the sky colours gently with a small palette knife. The knife will pick up the paint on the canvas so don't forget to wipe it clean between strokes.

8 Don't lose all the knife marks in the process of blending; the sky should look painterly. Overlap the sky colours slightly around the cliff area.

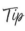

Tip

Using the palette knife to put the colours into the sky is a quick way to cover the canvas; it also makes some very interesting textures. Notice how the different sky colours are beginning to appear in the image to the right.

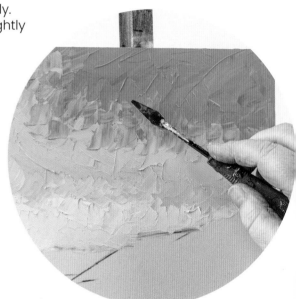

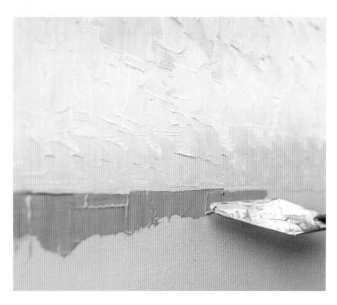

9 For the sea, use the same blue mix as for the sky as a basis; add some more Yellow ochre and a touch of Prussian blue to make it greener and a bit 'murky'.

Sarah says

You don't always need to choose a brush to apply paint: there are other ways! The tool that you choose can be really helpful in creating the end result – for example, when you paint the sea using a palette knife, it can make little horizontal ridges in the paint, like waves.

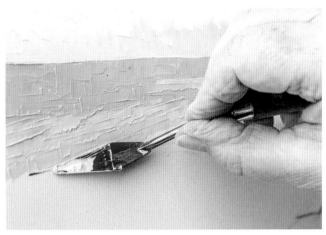

10 Slowly make the lines in the sea curve round to reflect the shape of the coast line.

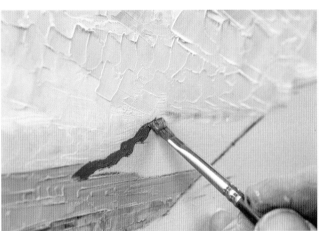

11 Now paint the cliffs. The further away the land is, the softer and cooler the colour should be, so mix a soft blue-green from Cyan blue with a little Lemon yellow, a touch of Alizarin crimson and Titanium white. Lay the colour over the sky; don't scrub the paint on. Lay it down gently and get a good edge.

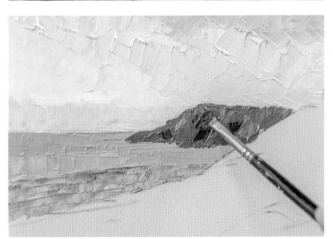

12 Add some Yellow ochre to the brush and put in some areas of sunlight on the cliffs. Add strokes of darker green too, for shadow areas.

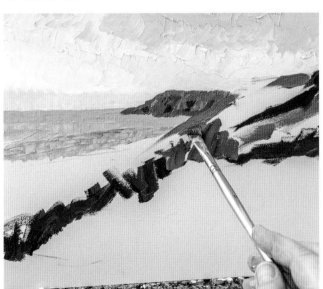

13 Paint the cliffs in the foreground with slightly darker versions of the mix of greens in step 11: add more Burnt sienna, Sap green and Ultramarine blue.

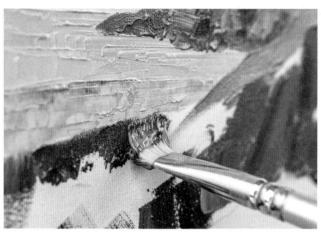

14 Using an older, flat brush, push the paint upwards, towards the sea; splay out the bristles to give you a ragged edge.

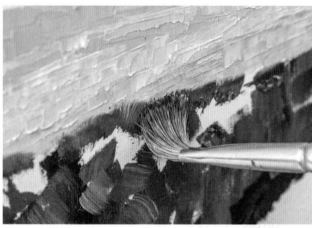

15 Where the foreground tree will go, make sure that the colour that you are painting is a midtone – not too dark and not too light. Remember that this is rough ground, so don't make it too neat.

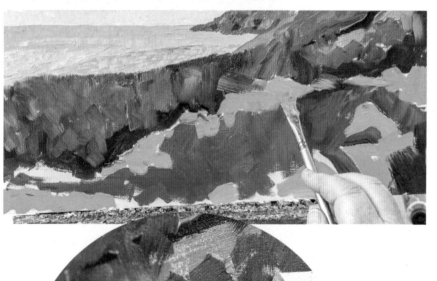

16 Paint in the green foreground, as well as the shadow of the tree that will be added at step 23. With your eyes partly shut, try to 'name' the shape of the shadow to make it easier to fill in: I think it looks a bit like a horse! Paint this with a darker green mix, then fill in the lighter green spaces.

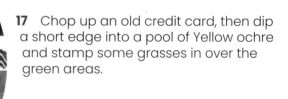

17 Chop up an old credit card, then dip a short edge into a pool of Yellow ochre and stamp some grasses in over the green areas.

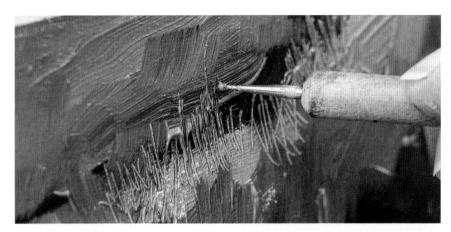

18 Scratch through the still-wet paint with various tools for a *sgraffito* effect. This nail tool is ideal for adding textural grasses that are further away.

19 Use an old fan brush with bristles that are stiff from old paint to make more grassy textures on the cliff tops; although the tree will be painted over some of this, it is still important to get texture all over the area.

20 Pull up the green-grass paint with the stiff-bristled brush. At this stage, your tools are doing a lot of the work for you.

21 Use a tiny old brush with stiff bristles to scratch in some seed heads – let happy accidents happen!

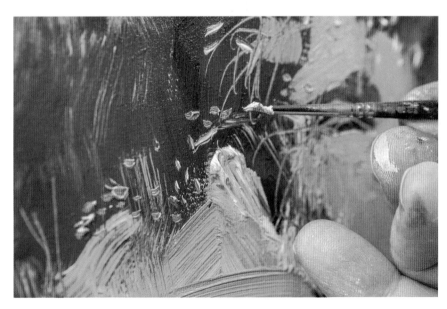

22 Using 'artistic licence', add some sea pinks to break up the grassy-green foreground. This mix of white with a tiny bit of Alizarin crimson will give the painting a magic pop of pink.

23 With a dark mix of Ultramarine blue, Burnt sienna, Sap green and some Prussian blue, apply the foreground tree trunk with a round brush. Use the twisting technique shown on page 82, step 12 to apply the colour. Keep an eye on the brush and, as it twists, ensure that no sky colour transfers onto the brush. If it does, stop, reload the brush with the trunk colour and carry on. Paint in some branches coming out of the trunk.

Tip

When you are painting details such as branches, you might find supporting your painting wrist with your free hand (right) will give you more control over the brushstrokes.

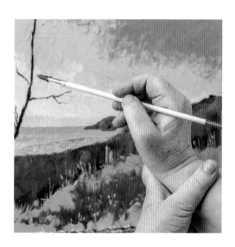

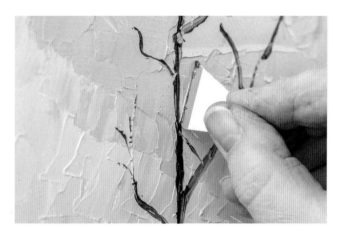

24 Apply the same dark mix from step 23 to the straight edge of a small piece of chopped-up plastic card, and stamp in some twigs.

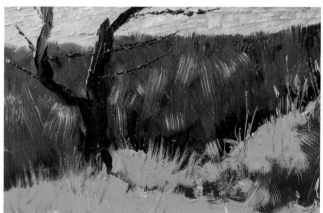

25 Mark in some lighter grasses by the trunk in a mix of Sap green, Yellow ochre and a hint of Titanium white. Add a speck of bright red if the mix looks too chemical or vivid.

26 Mix some dark greens for the foreground pine tree foliage. The first brushmarks you make are the backdrop for the pine needles so use a medium-size flat brush. Draw the paint down gently to make the pine fronds. Get a couple of strokes out of each brushful of paint; make one stroke, turn the brush over, make another stroke then reload the brush.

27 Mix a paler green by adding Yellow ochre to the dark green mix. Apply pine needles with a spiky, old brush – draw the bristles upwards and let the bristles do the work.

28 Add a little bit of sunlight to the left side of the trunk in Yellow ochre.

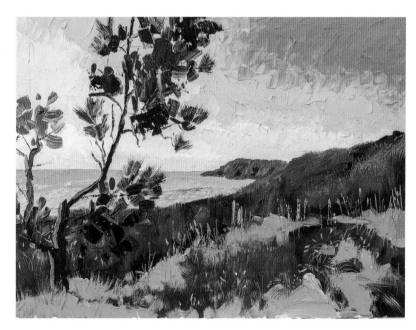

29 If you need to add a few dots of sky among the green pine foliage then do so; you should still have the sky-blue on your palette.

30 Finally, scratch your signature into the paint.

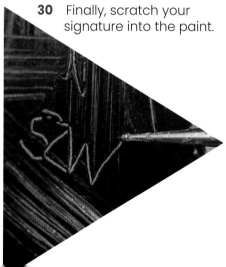

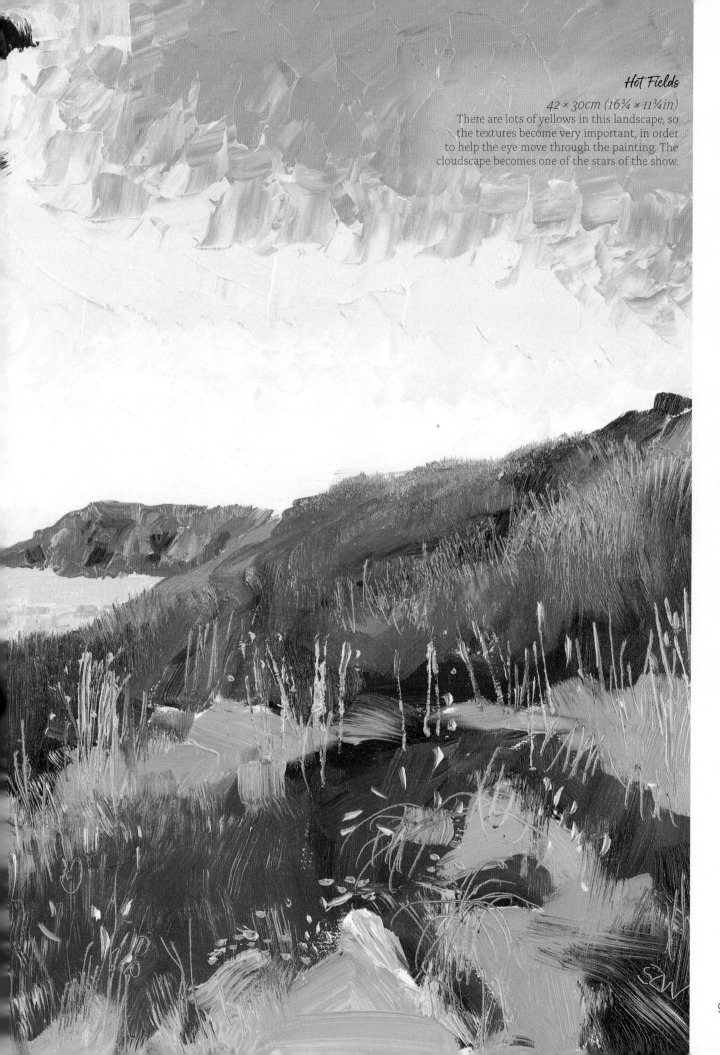

Hot Fields

42 × 30cm (16¾ × 11¾in)
There are lots of yellows in this landscape, so
the textures become very important, in order
to help the eye move through the painting. The
cloudscape becomes one of the stars of the show.

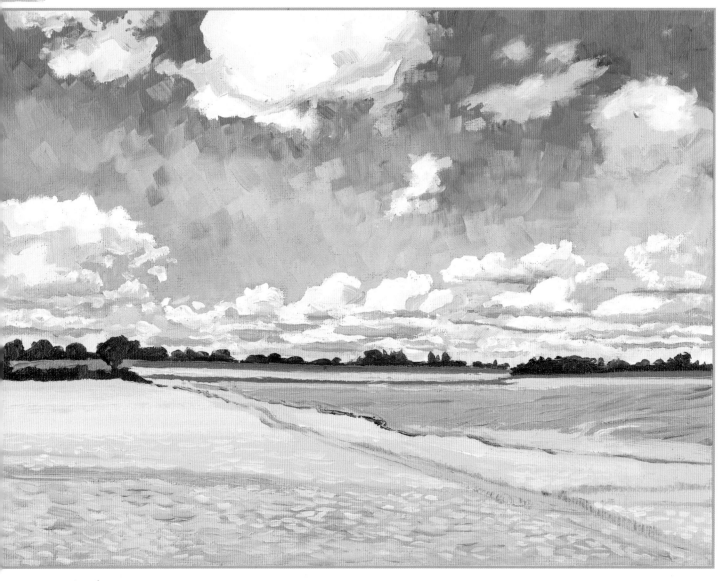

Landscape

40 × 30cm (15¾ × 11¾in)
There are lots of textures in the
wheatfields, and a strong contrast with
the dark trees in the distance.

Opposite
French Fields

30 × 40cm (11¾ × 15¾in)
This landscape in France is painted in
the style of van Gogh.

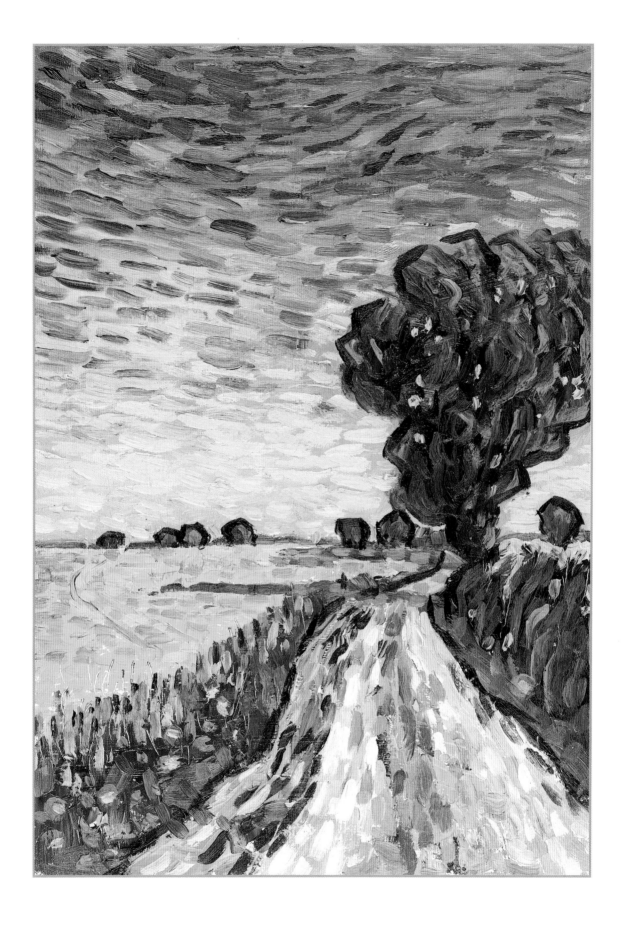

PROJECT

6 Buildings

I like painting buildings; who doesn't? The varied architecture, the light on the walls, especially on a trip abroad, is all waiting to be recorded in paint.

This is the beautiful Provençal village of Roussillon, which is located in the very heart of the biggest ochre deposits in the world, and, as such, is distinguished by a wide palette of flamboyant colours.

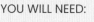
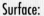

YOU WILL NEED:

Surface:

○ MDF board, primed: 30 × 42cm (11¾ × 16¾in)

Colours:

○ All the colours in the capsule palette (see pages 30–31)

Additional paints:

○ Acrylic paint in Ultramarine

Brushes and additional tools:

○ Flat brushes, small and medium

○ Filberts (round brushes), small and medium

○ Palette knives

○ Plastic card

○ Sharp pencil

YOU WILL LEARN:

• how to paint negative space for complex shapes

• how to use thin tools for fine lines

• how to use flat brushes for straight lines

• about painting into the shadows.

1 First, sketch out the position of the building with diluted Ultramarine acrylic paint. Once the shapes are right then the shadows and darkest areas can be blocked in. To see these, squint or half-close your eyes (see page 44) to see the main areas, or shapes, of light and dark. Ignore all the details at this stage.

2 Make a good green-blue sky mix from Cyan blue and Ultramarine blue. Mix in a little Titanium white and Lemon yellow, and a speck of Burnt sienna.

102

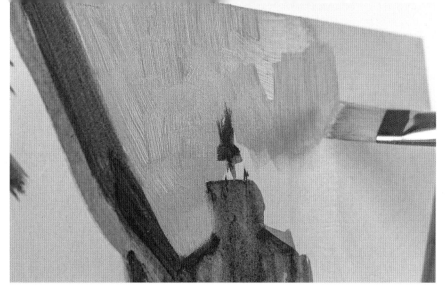

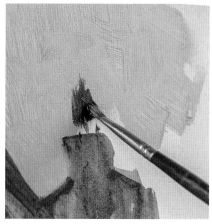

3 Use a large flat brush to paint the top-third of the sky.

Tip

When you are trying to get the right colour, take up some of the mix on your palette knife and hold it up against your source image to check the colour and tone. I find it easier to close one eye to do this.

4 The top of the bell tower is a complicated metal structure with lots of little shapes within, so tackle this next. Paint its overall shape with a dark mix of Ultramarine blue, Alizarin crimson and a bit of Sap green. You will add the sky through the bell tower later.

5 Continue painting the sky; notice how the blue gets lighter as it moves down towards the buildings. Add some Titanium white to the sky mix to achieve this.

6 Once the sky is filled in, take a soft brush and gently blend the blues together, avoiding the bell tower.

7 Add a wispy cloud with some titanium white...

8 ...then blend it in with a soft brush, until it is almost gone.

9 Fill in the sky holes on the bell tower; carefully load a small, pointed brush with the sky-blue mix and shape it into a nice point on the palette. Make only a couple of marks before you reload the brush with paint.

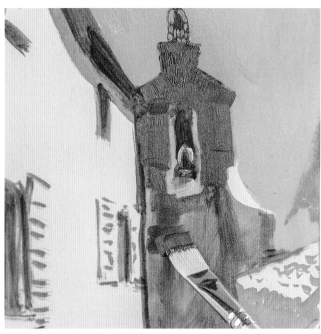

10 Next, paint the darker walls on the buildings with a mix of Burnt sienna and Yellow ochre with a bit of Titanium white. Darken the mix with a bit of Ultramarine blue. Use a big, flat brush to put in the straight edges of the buildings.

11 Make up a shadow colour by adding some more Ultramarine blue to the mix from step 10. Using the really dark mix, block in the darkest areas of the painting. Try to 'look into' the shadows and see what is there and make the brushstrokes follow and describe shapes accordingly. You can vary the colour slightly as well; use Ultramarine blue on its own for objects deep in the shadows.

12 With the edge of the flat brush, paint the dark mix into the windows, arches, frames and at the edge of the roof on the left-hand building.

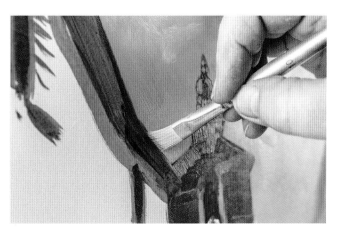

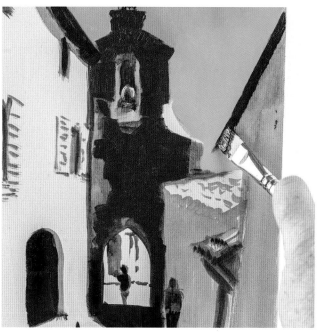

13 Clean the flat brush, and sharpen the roof edges but leave a tiny gap between the sky and the roof edge. Put the edge of the clean brush into this gap and pull it downwards; the brush will pull the two areas of paint together.

14 Paint the edge of the opposite roof in the same way. Work on the dark areas first – when you have the paint spread quite thinly on the canvas, it is easier to add lighter colours to dark, as you will have more control. Paint the dark shape of the arch beneath the bell, and paint inside the bell tower itself in the same mix.

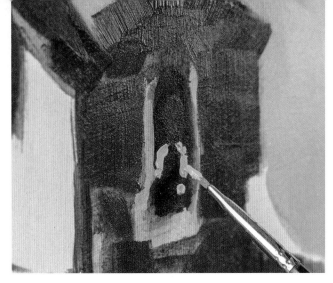

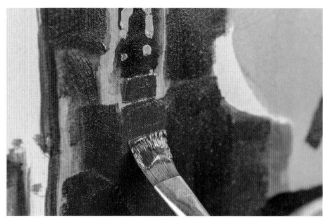

15 To reinstate the bell in the tower, choose a pale sky mix that matches the colour of the sky behind that section of tower. Then, with a loaded brush, paint the space around the bell: this is the negative space. Focus on the shapes of the space rather than trying to draw in a bell shape.

16 Make a lighter shadow mix by adding some Cyan blue to Yellow ochre. With a smaller flat brush, paint the bricks around the arch, and the clock on the tower.

17 With this lighter shadow mix, paint the side of the right-hand building. There are dark shadows underneath the roof, and the wall gets gradually lighter with the reflected light from across the road.

18 Block in the lighter areas of the roof tiles and the tower and then put in a few details with dark paint and a small brush. Make a good dark mix with Sap green, Prussian blue and Alizarin crimson: this should be your go-to black. It gives a great nuanced dark, and will lighten interestingly when a little yellow or white is added.

19 Mix Yellow ochre and Burnt sienna. Add some Titanium white and Lemon yellow to 'zing' it up a bit; this mix is for the walls that are in full sun. Don't mix it up too much; you want variations in the colour to suggest the rough texture of the wall.

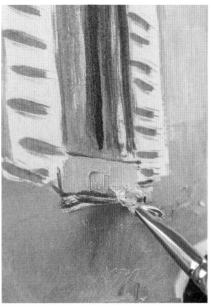

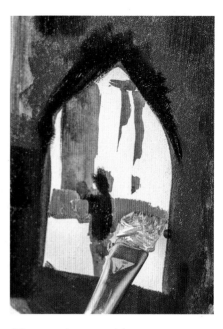

20 Imagine the texture of the uneven wall as you paint – this will help the process. Paint around the window ledges for now; you will fill those in at the next step.

21 Dip your dirty brush into some white paint and let it mix on the canvas to paint in the window ledges.

22 For the sunshine underneath the arch, use a brightened version of the mix from step 19, plus a nice orange mix of Yellow ochre, Alizarin crimson and Titanium white, and some brighter (Lemon) yellow.

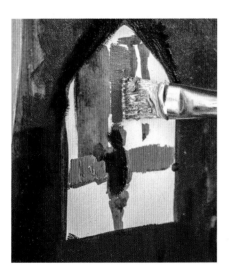

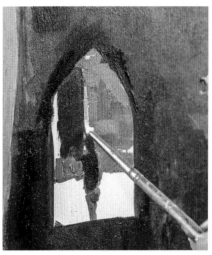

23 There are several figures beneath the arch in the source photograph, but I only want to include one. Block in the figure with a few strokes in the dark mix from step 18. Remember that heads are a lot smaller than you will naturally paint them; imagine a wobbly carrot shape as you paint the figure – it works, honestly!

24 With a tiny brush, put in a few highlights into the scene beyond the arch; use the lightened mix from step 22.

25 Keep working on getting the colours right on this little section of the painting. You need to imagine the walls and the road surface, so you are thinking in blocks of colour. The area will look naturally bright because of the contrast of the dark archway.

26 Run in a dark line underneath the wall in the distance, then use a pale mix of Titanium white and Lemon yellow, with a touch of Yellow ochre, to paint the path below.

27 Bring the paint up to the edge of the figure and do the same on the other side of it.

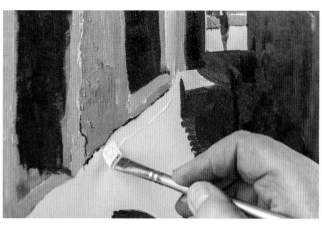

28 Use Burnt sienna and Ultramarine blue again for the corner of the building. Paint a 'twiddly' line for the uneven edges.

29 Paint the bright slash of sunshine that is hitting the road, using the bright mix that you used beyond the arch in steps 26 and 27. Be really careful as you paint near the shadows; you don't want to accidentally pick up any of the dark paint on the brush. Clean or wipe off the brush if necessary.

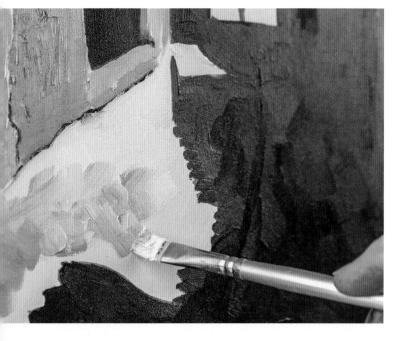

30 Come forwards in the painting as you paint the sunlight, adding Yellow ochre and letting it mix on the canvas: the road's surface will get darker and more textural towards the foreground. Leave a tiny gap by the shadows; fill the space with a dry brush as you want the shadow shape to be sharp.

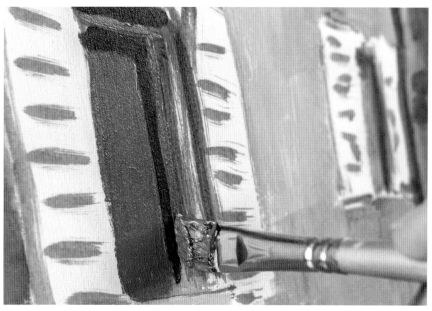

31 Paint sunshine into the doorway in a wedge shape. You will add the decorative railings later.

32 Mix a soft, warm, mid-tone grey from Ultramarine blue, Burnt sienna and white. Paint inside the window frames; use the edge of a small, flat brush for thinner lines. Let the shape of the brush do some of the work for you.

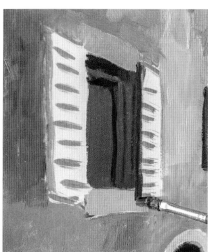

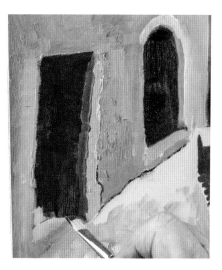

33 Make a purple mix for the shadows on the walls, under the eaves and down the sides of the shutters. Add a little Alizarin crimson to Ultramarine blue, then add a touch of Burnt sienna.

34 Paint the sides of the shutters and beneath the window ledges.

35 There is a rosy glow of reflected light inside the door frame: paint this in using Burnt sienna with some Alizarin crimson mixed in.

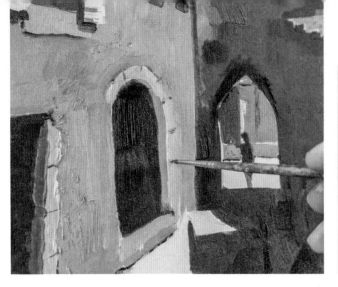

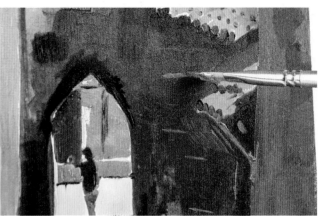

36 Paint tiny lines in Burnt sienna with Yellow ochre for the bricks around the door frame and the arched windows.

37 Add in some paler bricks; put in a few marks to remind you of how the perspective should be, as you want this wall to look convincing. Work from the angle of the roof, gradually moving towards the angle of the road. Use a flat brush to add a few bricks in slightly differing tones of the mix at step 36, with a little more Yellow ochre or Titanium white to lighten.

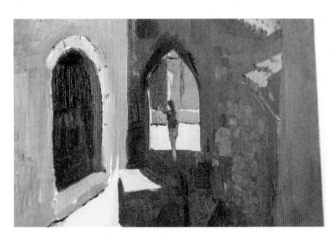

38 Give the figure in the shadow by the wall a blue jacket and the figure under the arch some pale trousers.

39 Paint the shutters in the pale blue sky mix, toning it down slightly with a tiny bit of Burnt sienna.

40 Scratch out the slats on the shutters with a sharp pencil through the wet paint.

41 Paint in the green climbing plant; make one green using Lemon yellow and Cyan, and another with Ultramarine blue and Yellow ochre. Use a yellow mix to dot in a few leaves on top. Use shaky, twisting, wiggling brushstrokes to make the plant look organic in contrast to the buildings.

42 For the railings, use an old credit card cut to size and dipped in a pale olive colour mixed from Cyan and Yellow ochre. Press on the vertical bars first, using the card as a stamp...

43 ...then the horizontal bars.

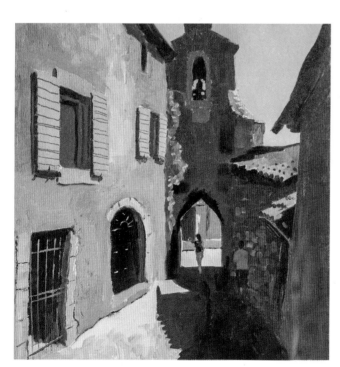

44 There is a bit of ironmongery in the arched window: try not to paint every bar but rather suggest where they are by painting a few squiggles in the right places to suggest shapes.

45 Add the details to the clock – again, just a few suggestions (refer to the finished painting on page 113). Finally, add a super white highlight along the top of the wall beyond the archway as a final flourish.

Two more views of the painting

If you tilt the painting slightly, you can see the textures in the paint, and how the tiny, dark lines really help to set the shutters into the building. Tiny details, sparingly used, really make a difference.

Opposite

Clock Tower in Provence

30 × 42cm (11¾ × 16¾in)
Here is the finished painting; you can apply the same technique to a picture of your own. Work from a photograph or from sketches that you might have.

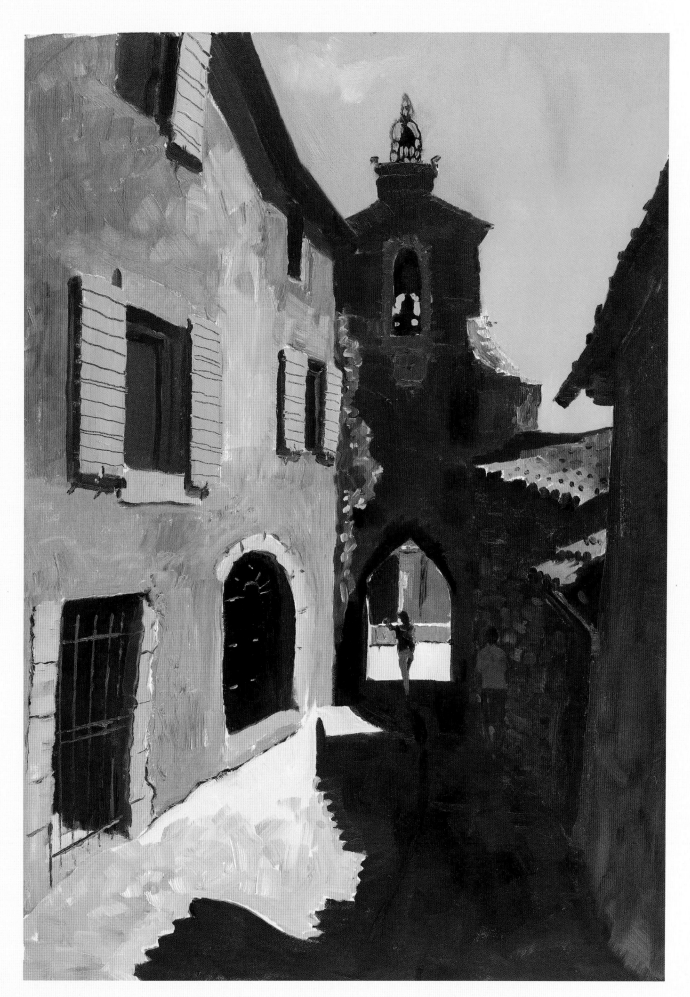

WIMPERIS

Tractor Shed in Provence

21 × 15cm (8¼ × 6in)
A small *plein-air* painting, which clearly
shows the use of *sgraffito* (scratching
through the paint). Notice how useful the
brushstrokes are in telling the story of the
wind in the trees, and the old stone walls.

Troubleshooting

The fabulous thing about working in water-mixable oil paints is that when things don't turn out as you want, you can simply scrape back and repaint – it's as simple as that!

Here are a few techniques to try.

TONKING

This technique can be used to remove 'too much' paint from a painting.

Blot the area with absorbent paper; press the paper, flat, onto the area that you want to change, where the paint has become too thick or the consistency is wrong and needs to be corrected.

With the painting on the right, I decided that there was far too much paint on the bristles of the far-right brush: I wanted it to be sparer, spikier and 'scratchy', as it is an old, dried-out brush.

This was the perfect opportunity to apply a technique known as 'tonking'; named after Henry Tonks (1862–1937) who pioneered the technique, it enables the artist to effectively turn back the clock.

The original painting, before the troubleshooting techniques have been applied.

1 Press some absorbent paper – newspaper or kitchen towel – flat over the area that you want to rework. Rub gently on the paper so that it absorbs the excess oil paint.

2 When you peel back the paper, you will see the impression of the paint; the paper will have also left the 'ghost' of what you had painted on your board or canvas, enabling you to rework the area with less paint second time around.

SCRAPING OFF

If anything goes wrong, or if you dislike an area of your painting on reflection, you can simply scrape off the offending mark or marks using a palette knife.

Within the painting below, I decided that I wanted to move the plant and pot from the foreground as they didn't look quite right there.

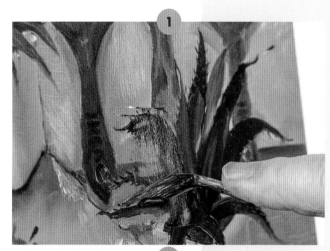

1 Scrape the knife down the painting, collecting the paint on the blade as you go.

2 Wipe the paint off the knife onto your palette or a cloth, and repeat until it's all gone from the area. *The process is continued overleaf.*

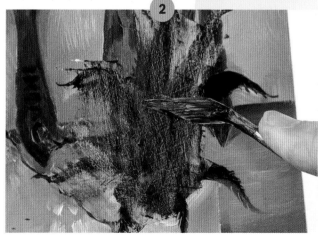

RUBBING OUT

With a cloth or rag, wipe away the rest of the area that you don't want, leaving a pale area in place to paint over.

1 Once all the paint is gone, take a cloth or kitchen towel, dip it in a clean water and squeeze it out so it's damp; and rub away the rest of the unwanted paint.

2 Dry the area and 'polish' it with a clean cloth.

3 Now you are ready to repaint the offending pot plant where you want it to belong.

Above, the painting, rescued and reworked.

Aftercare

Water-mixable oil paints take the same amount of time to dry as traditional oil paints – this depends of course on the thickness of the paint applied, as well as the colours – for example, white seems to take longer to dry than other colours. Drying time is also dependent on the weather: in a cold, damp climate, paintings can take a couple of weeks to dry, whereas in hot, dry climes, they can be dry in a matter of days.

You can give your painting a light coat of retouching varnish once it is dry to the touch, after two weeks, and you can then frame your work.

If you want to use a proper varnish, then you should wait for six months before applying it. However, your paintings should be dry enough to handle and prop gently against one another within a week. Touch the surface very lightly with your finger to test for dryness.

STORING YOUR PAINTINGS

It's a good idea to have a designated place in which you can put newly finished work in plain sight, as, after a few days you may well notice elements that need changing or improving.

You need somewhere that you can prop your work out of the way of the cat's tail or sticky little fingers. If you prefer to work on canvas, find some narrow shelves on which you can prop finished, or half-finished, works to dry. You can customize the shelves by adding a lip to the front to stop the paintings falling off.

I also keep a shallow box in the airing cupboard, in which I lay my paintings if I want them to dry faster.

If you have a cork noticeboard on the wall, attach small shelves to this, on which to prop up your paintings; alternatively, you can fix your paintings to the board with mapping pins. Another option is to use a repurposed drying-up rack to prop up your drying paintings.

TRANSPORTING YOUR PAINTINGS

USING MAPPING PINS

To transport your paintings while wet (if you're taking home paintings created on holiday, for example), stick mapping pins into the edges of the stretched canvas (as shown below, **a**), and balance another canvas on top (**b**). The pins will keep the surfaces apart so there will be no smudging or transferring of the paint.

Tape the canvases together in the middle of each of the four edges using any wide tape, such as parcel tape. Wrap the tape around to encompass both canvases; this stops them slipping off the pins. Then run the tape all around the edges to seal the two canvases so that no dust or dirt can get in (**c**).

I once took three large van Gogh–style demo paintings (think thick, impasto paint) on a 12-hour train trip like this and not a drop of paint was spilled!

Afterwards, take the pins out and fill the holes with fresh paint.

USING MATCHSTICKS

If you are making your own boards or using canvas boards or oil painting card, stick matchsticks on the back, stack the paintings back to back, and tape them together to transport them. This will give you a little bit of space between each painting, enabling you to gently stack them; run some tape round the edges to stop them slipping.

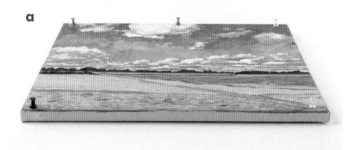
a

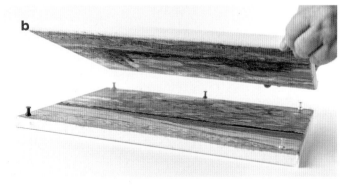
b

c

USING A MOUNT TO CROP YOUR PAINTINGS

Using a card mount with your paintings, even as a temporary measure, can be really helpful. You don't need a mount to frame an oil painting, but it can help you gain a different perspective on your work by isolating areas so you can see them properly. You can see if the painting looks better cropped, get a different view on it – maybe even glean two paintings from one!

The other benefit to painting on board is that, if you are not happy with your painting, once it is dry you can crop it with a mount, find a portion of the painting that you do like, then isolate it with a ruler and a sharp knife. *Voila!* A new painting!

You can use the same trick with a painting on canvas; you just need to be prepared to paste it onto a board after you crop it. To do this, cut the crop slightly larger than your board. Take some PVA glue and paint over the back of the canvas; fold the edges of the canvas over the board and put some heavy books on top until everything is stuck down.

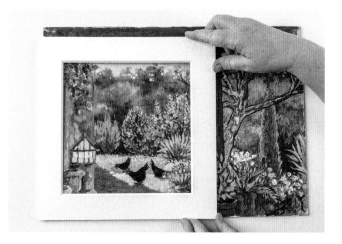

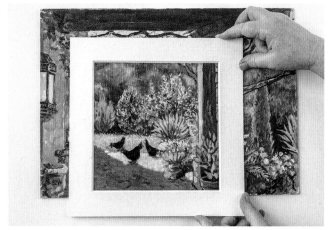

CHOOSING YOUR CROP

Portrait mount

The side edges of a portrait mount are longer than the top and bottom edges. (Incidentally, a portrait mount has nothing to do with it being used to frame a portrait painting!)

Looking at a different slice of your painting through a portrait mount can really change the composition, especially if the original painting is in landscape format, as shown on the right.

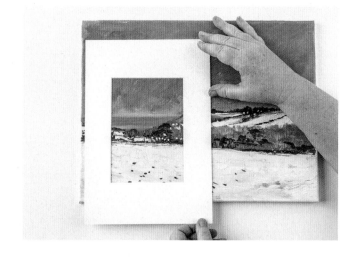

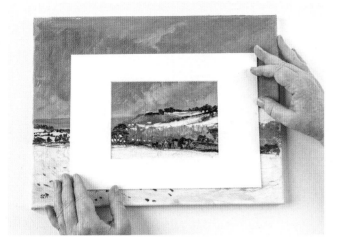

Landscape mount

The top and bottom edges of a landscape mount are longer than the sides.

Use a landscape mount to see whether your (landscape) painting looks better cropped with the focus on a particular detail; you could chop the painting up into two, or paint a similar scene with a different aspect.

FRAMES

Whatever you paint, finish it off with a frame – it really makes a huge difference. You can find simple frames in many places including large homeware shops.

I always think that a wooden frame is better than a plastic one. I recommend that you try to find wooden frames that are well made: look at the joints in the corners and choose those that fit together well with no gaps.

A thin frame can make a painting look as if it has been framed as an afterthought and can look cheap, especially on a smaller artwork – opt for a thicker frame, ideally one that is bevelled, to draw the eye in.

For landscape paintings, try to avoid frames with too many lines on them. Go for something curved instead that leads the eye into the picture, rather than something flat. My failsafe frame is a simple white wooden frame. A decent, not-too-thin wooden frame can go around any painting, and you can change the colour with wax or paint to suit the painting inside.

All that said, each individual artist should find their own style of frame for their paintings. There is no need for a mount and glass for a painting in water-mixable oils. As long as the painting is dry, you can simply place it into the frame.

Try different styles and see what suits. It can really change the way you see your painting, making it look truly polished. It is the final flourish: like wrapping a present, you have spent such a long time on the work, so do it justice with a pleasing frame.

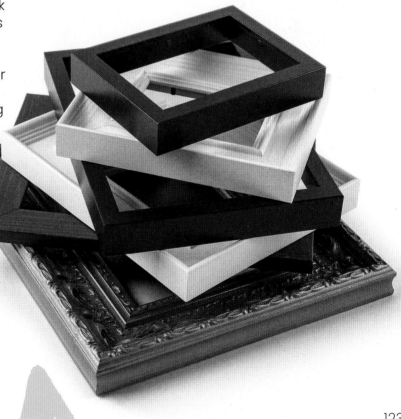

FRAMING YOUR PAINTING

When dry, water-mixable oil paints behave just like regular oil paints, and oil paintings do not need glazing. People used to glaze them when there was more smog in the air, and smoky fires. These days, we are far more hermetically sealed, and people do not smoke as much, so it's no longer necessary to glaze the finished paintings.

You will need to take out the glass if there is any. Place the painting into the back of the frame; if there are tabs on the reverse, fold them down over the painting to hold it in place. If there are none, then gently tap some painter's points into the frame, not the painting.

Your painting is framed and ready to hang.

A modern still life is lifted with a simple, contemporary black frame.

A very ornate frame suits this van-Gogh-style landscape, making it look even more like the work of an Old Master!

SIGNING OFF YOUR WORK

One day in the future someone might want to find out about the artist of their oil painting – that's you, so make it easy for them by signing it!

I usually sign and date the back of my paintings, using an indelible pen; I also apply a stamp with my name and website details on.

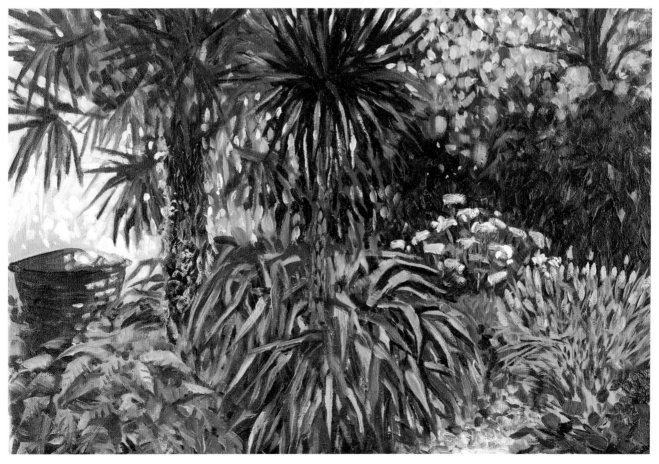

Glossary

Here is where I explain all the arty terms that I have used in the book! You don't need to know them but it does help, in order to navigate the world of 'art speak'!

Canvas
a term to describe whatever surface you are painting on. (It doesn't have to be canvas!)

Coloured ground
a thin layer of paint, applied to a support to make it ready for painting; it can be white but I prefer to use a coloured ground.

Gesso
traditional oil gesso is a mixture of glue (usually from rabbit skin), water, and chalk (calcium carbonate) used to create a flexible, yet absorbent surface for the oil paint to be applied onto.

Grisaille
(pronounced: 'griz-zai') a monochromatic oil painting which is often used in underpaintings or as a black-and-white painting technique.

Hue
the labelling on a paint tube that denotes a combination of less expensive pigments that closely imitates the mass tone of a more expensive pigment. Not to be confused with hue in the context of describing colours (as in the perceived colour of an object – such as, 'the lemon has a yellow hue' – see page 33).

Impasto
the texture created in a painted surface by the movement of the brush. Impasto usually implies thick, heavy brushwork, but the term also refers to the crisp, delicate textures found in smoother paint surfaces.

Medium
the mixture that you add to your paint to dilute it, or to change consistency, drying time and working properties.

Monochrome
a painting created in a range of tints and tones of a single colour.

Nōtan
a drawing with flat areas of light and dark – see page 44.

Plein air –
(pronounced: 'plen-air') a painting created outside rather than in a studio. The term comes from the French 'en plein air' meaning 'in the open air'.

Sgraffito
scratching through wet paint.

Scraping back
removing paint from the surface with a palette knife.

Scumbling
a very thin layer of opaque or semi-opaque paint that partially hides the underlayer. Scumbling is the painting technique wherein one thin or broken layer of colour is brushed over another so that patches of the colour beneath show through. It can be done with a dry brush, or by removing bits of paint with a cloth.

Tonking
the process of blotting off paint (see pages 116–117).

Value
the lightness or darkness of a colour, rather than the actual colour.

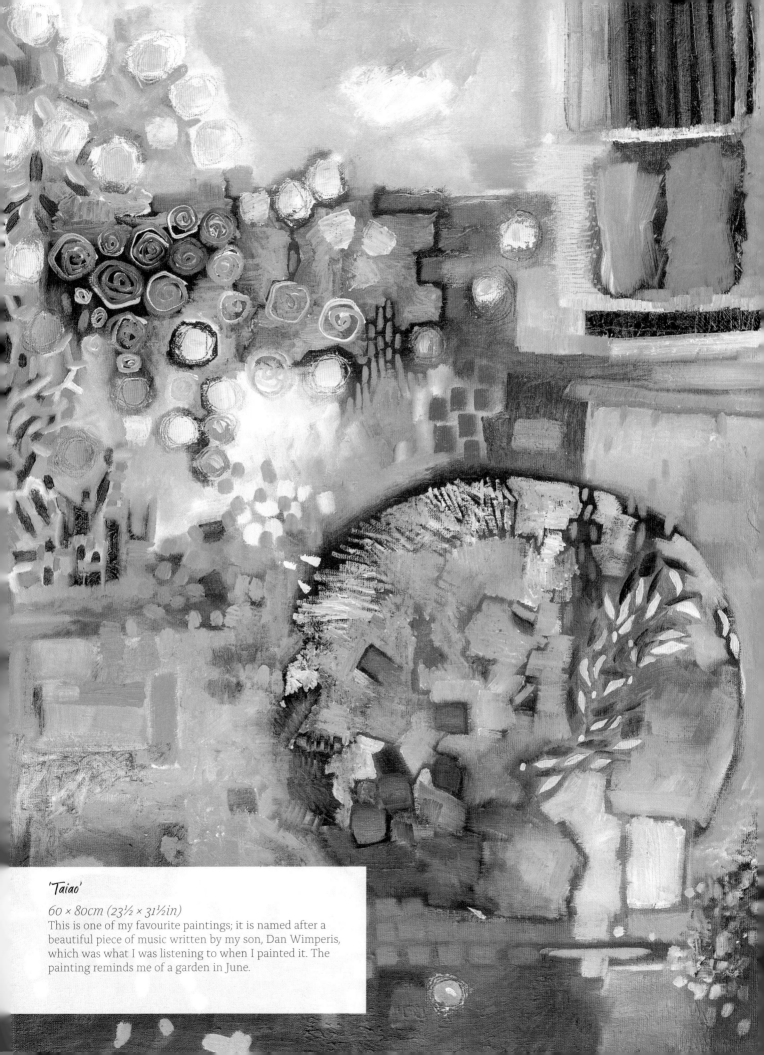

'Taiao'

60 × 80cm (23½ × 31½in)
This is one of my favourite paintings; it is named after a
beautiful piece of music written by my son, Dan Wimperis,
which was what I was listening to when I painted it. The
painting reminds me of a garden in June.

Index

A
abstract(s) 30, 64–77
apron 25, 29

B
bespoke painting surfaces 18
black-and-white 33, 44–45, 126
buildings 102–115

C
canvas board 16–17, 121
choosing your crop 122–123
colour(s)
 complementary 33, 38–39
 cool 30–31, 81, 84, 93
 temperature 30
 warm 30–31, 55, 58, 66, 80, 82, 109
colour, exploring 46–53
colour, terminology of 33
colour wheel 32–33, 38, 90
coloured ground, *see also*: gesso 126
composition 44, 49, 64–66, 89, 90, 122
craft knife 25

D
directional marks 67, 79
 mapping with 79
Doré, Gustave 48

E
easel(s) 21, 22–23
emulsion 18

F
frames 123–124
 framing your painting 120, 122–124

G
gesso 16–18, 126
grisaille 126

H
horizon 54–56, 58, 64, 90, 91

I
impasto 47, 121, 126

L
landscape(s) 30, 90–101, 124
layers, layering 42, 56–57, 78, 126

M
Manet, Édouard 48
mark-making 40–42, 64, 68, 90
MDF (or hardboard) 16–18, 54, 64, 78, 90, 102
medium 18, 24, 64, 126
monochrome 126
music 65, 127

N
nail tool(s) 15, 42, 90, 95
negative painting 102, 106
nōtan 43, 44, 58, 126

O
oil(s), conventional 12, 16, 21, 34, 40, 120, 124
oil paper 16–17, 46
other artists' work 48, 68, 79
outline(s) 51, 83, 84

P
paint shaper(s) 15, 42, 61, 71, 72
paint(s)
 acrylic 12, 24, 40, 41, 46, 47, 64, 65, 68, 78, 102
 blending 12, 41, 65, 67, 69, 78, 85, 91, 92, 103, 104
 mixing 15, 24, 28, 32–38, 42, 46, 54, 64, 81, 82
 watercolour 21
paintbrushes 12–13, 15, 16, 21, 22, 24, 26–27, 29, 34, 40–42, 46 *and every project*, 126
 brights 40
 fan, fan-shape 12, 41, 90, 95
 filbert 13, 41, 46, 54, 64, 78, 90, 102
 flats 40, 46, 50, 54, 58–59, 64, 66, 69, 78, 80, 85, 90–91, 94, 97, 102–106, 109, 110
 holding 34
 household 13, 41
 synthetic bristle 12–13, 79
palette (colour), capsule 10, 30–31, 46, 54, 64, 78, 90, 102
palette (mixing) 21, 24, 28, 34, 35, 36, 37, 42, 46, 56, 65, 78, 81, 82, 97, 104, 117
palette knife, knives 15, 24, 34–38, 42, 46, 54, 64, 68–69, 73, 78, 81, 90–92, 102–103, 117, 126
 using as a palette 42
paper sizes 17, 19
phone 24, 45, 84
photograph(s) 43, 44, 45, 54–63, 84, 90, 107, 112
 painting from 54–63
 seeing your painting as 45
plastic card(s) 15, 90, 96, 102
plein air 22, 115, 126
precutting your boards 19
problem-solving 84

R
red glass, plastic 24, 45
rubbing out 118
Rule of Thirds 64

S
scraping back, scraping off 90, 116–117, 126
scumbling 126
sgraffito 90, 95, 115, 126
shadow(s) 49, 50, 57, 60, 62, 79, 80–82, 93, 94, 102, 105, 106, 108–110
signing off your work 125
sketchbook(s) 21, 24
sketch(es), sketching 43, 44, 59, 78, 90, 102
squinting your eyes 44, 55, 102
still life 21, 78–89, 124
stretched canvas 16–17, 19, 121
studio 21, 23, 24, 28, 126

T
tonking 116, 126

U
using a mirror 43, 62

V
van Gogh, Vincent 46–53, 79, 100, 121, 124

W
wooden panel 16–17
workspace 21, 26

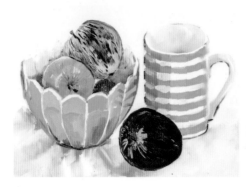

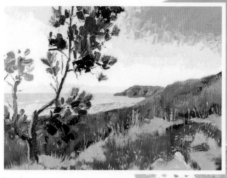

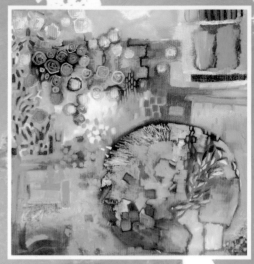

DISCOVER THE JOY OF WORKING WITH WATER-MIXABLE OIL PAINTS IN THIS COLOURFUL, ACCESSIBLE GUIDE.

Water-mixable oils offer all the qualities of traditional oils – rich pigments, a buttery consistency, long drying times, and the potential to evolve your style of painting. There is one big difference, of course: there is no need for solvents! Once you've finished painting, all you need is soap and water to clean your brushes, and you're ready to go again!

Expert artist Sarah Wimperis guides you through working with this vibrant medium, from priming your painting surface and mark-making to mixing dynamic colours from a capsule palette and troubleshooting any potential pitfalls.

Apply what you've learned to 6 beginner-friendly projects, including a striking coastal landscape, a stunning still life, and a masterpiece inspired by Vincent van Gogh.

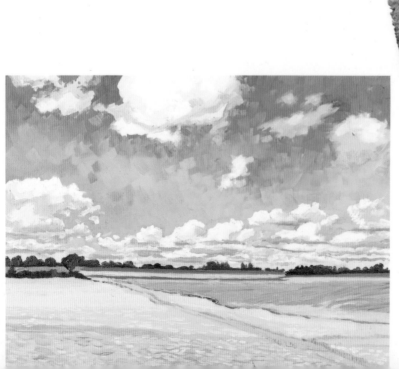

50
The world's finest art and craft books
www.searchpress.com

UK £14.99/US $23.95/CAN $28.95
ISBN 978-1-78221-857-9

EAN

5 2 3 9 5>

9 781782 218579

illustrators

ISBN 978-1-907081-41-5

UK £18

ISSUE NINETEEN

Cover Image: James Gurney
Illustrators
The Book Palace
Jubilee House
Bedwardine Road
Crystal Palace
London SE19 3AP
Email: IQ@bookpalace.com
Web: www.bookpalace.com
Contact GW: gw@bookpalace.com
Tel: 020 8768 0022
(From overseas +44 20 8768 0022)
Publisher: Geoff West
Editor & Art Director: Peter Richardson
Deputy Editor: Diego Cordoba
Layouts for JOB and Erik Kriek features
by Diego Cordoba
Consultant Editors: David Ashford, Norman Boyd
Featured Writers:Thomas Kintner, Diego Cordoba
Website: Paul Tanner
Subscriptions & Distribution: David Howarth
Advertising: IQ@bookpalace.com

illustrators IISBN 978-1-907081-41-5
ISSN 2052-6520
Issue Number 19 Published Summer 2017
Copyright © 2017 by The Book Palace Ltd.
All text and artwork copyright is vested with the
respective creators and publishers. None of the
material within these pages may be reproduced
without the written consent of ***illustrators*** or
the aforementioned copyright holders. The
images reproduced within these pages are for
research purposes and all efforts have been
made to ensure their historical accuracy.

Illustrators is published quarterly
Back issues £20 each plus postage
4 issue subscriptions
UK £55 POST FREE includes 4 free
digital issues
EU/USA £70 POST FREE includes 4
free digital issues
ROW £75 POST FREE includes 4 free
digital issues
Available in the USA from **budplant.com**
Trade Orders: IQ@bookpalace.com

Printed in China by Prolong Press Ltd

illustrators

ISSUE NINETEEN

CONTENTS

2 James Gurney
The legendary creator of 'Dinotopia' is studied in-depth by ḥ. Kintner.

34 Erik Kriek
Punchy graphics and edgy subject matter—Diego Cordoba visits one of Holland's finest artists.

62 J.O.B.
Diego Cordoba turns the spotlight on one of the pioneers of the illustrated book.

81 Arturo Del Castillo
Scanned from the original art-boards, Del Castillo's interpretation of Dumas' 'Three Musketeers'.

94 The Bookshelf *Gats, Bats and Big Cats!*

96 From The Inside *Weird and wonderful illustration stories.*

EDITORIAL

James Gurney's work has been in our collective consciousness for well over twenty years, since his phenomenally successful series of 'Dinotopia' books first burst on the scene. His work is steeped in the mists of antiquity but offset with a powerful immediacy, which manifests itself in his ability to create characters who look real, as opposed to romanticised, inhabiting worlds that are governed by the laws of physics, which make his giant reptiles seem all the more awe-inspiring. Thomas Kintner will tell you more in this fascinating feature which leads off our latest issue.

The ever resourceful Diego Cordoba has produced two features spanning the centuries as he takes a look at the work of the artist Erik Kriek, whose gutsy, comic-styled artwork is wowing art directors and fans far beyond the shores of his home based in the Netherlands.

Diego's second feature delves deep into the story of the artist who signed himself J.O.B. Jacques Onfroy de Bréville's work epitomises the full-on majesty and pomp of Imperial France. The fact that illustration wasn't Job's first choice as a career in the arts adds, rather than subtracts from the magnificence of his achievement, as Diego explains in this fascinating feature.

The comics that appeared throughout Europe and the UK in the latter half of the 20th century were enriched by the work of many fine draughtsmen recruited by illustration agencies and studios catering to an international market. In what was a very competitive arena the work of Arturo Del Castillo shone out like a beacon of brightness. We are privileged to share with you a remarkable series of pages that he created for a comic strip adaptation of Dumas' 'The Three Musketeers'.

To round off this issue we have the first in a series of delightful and, oft times, ironic glimpses into the fickle world of illustration, as Diego Cordoba reveals some of the perverse twists of fate which have attended the creation of some of the most memorable illustrations over the last two centuries.

Finally, our apologies for the non-appearance of the Philip Mendoza feature, which we had to set aside due to space (or lack of) considerations. Rest assured, it will be appearing in a later issue.

The opinions expressed in illustrators are those of the writers, and are not necessarily those of the editor and publishers. The accuracy of the authentication of all images is the responsibility of the contributors.

James Gurney

Making fantasy a reality has been the hallmark of this extraordinary artist's work, as Thomas Kintner discovered in a journey to the Syn Studio *Gathering of Masters*.

It's EARLY AFTERNOON on a July Saturday in Montreal, and if Olindo Gratton's 13 saints have any sympathy for the plight of those below, they betray no sign. Traffic heads nowhere fast on Boulevard René-Lévesque, as motorists probe desperately for an escape route that does not exist, and gaze enviously at pedestrians who ease past the barricades that cause these idling engines. Here are the outskirts of the world's largest jazz festival, mere blocks from swathes of trumpet and saxophone that intertwine in the midday breeze, but for the 13 bronze statues atop the façade of Cathédrale Marie-Reine-du-Monde, the only horns in the wind are played by motorists maddened at a snail's progress.

Follow the sidewalk two blocks north-west, hang a right onto Rue Sainte-Catherine, and it's an easy stroll to the cluster of venues that do the event's

ABOVE: A superb example of Gurney's art; *Dinosaur Boulevard*, from 'Dinotopia: A Land Apart From Time', published 1992. The artwork measures an imposing 24 x 52 inches and was rendered in oils.

ABOVE: *Attack on a Convoy* from 'Dinotopia: The World Beneath', published in 1995. Gurney's skill at meshing fantasy and reality hooked generations of readers, who were propelled into a world where the co-existence of dinosaurs and humans seemed entirely plausible.
FACING PAGE: *Garden of Hope*, another piece from 'Dinotopia: The World Beneath'. The painting was featured on the cover of the first *Spectrum* annual in 1994.

heavy lifting. Along the way are restaurants, shops and one venue not on any festival map, but which arguably belongs.

In a fifth-floor studio space of a brick building whose lobby conveys only nondescript utility, wild ideas roam. 'The Syn Studio 2016 *Gathering of Masters*' is underway, an interactive three-day programme at a school that specializes in concept art training, in a city that is home to thriving video-game and entertainment industries. Among the programme's highlights are a session covering 'open world game' design led by Ubisoft veteran Raphael Lacoste, and contemplation of fantastical creatures with Terryl Whitlatch, whose signature design work on the likes of Pixar's *Brave* and the *Star Wars* film series gives her profound credibility with students, faculty and enthusiasts.

A couple of hours before musicians take the stage just over a block away, a performer with somewhat less sartorial flair dons a headset microphone at Syn Studio. Pacing the well-worn hardwood floor in a red plaid work shirt and jeans, James Gurney unravels the transformation of the everyday into the impossible.

To an audience populated by artists for whom computers are their primary means of expression, Gurney provides a compelling argument for paper, pencils and paint. Tangible form is a trait common to both his work and its inspiration, which eschews reference culled from the internet and other

ABOVE: A photograph of the framed original for *Dinosaur Parade*, which served as the cover for 'Dinotopia: A Land Apart From Time'. The international best-seller captured many awards, including a Hugo, and melded the influence of Victorian classicists such as Alma-Tadema with Gurney's love of dinosaurs and superb storytelling abilities.
FACING PAGE: *Ride to Atlantis*, 1989. This hauntingly beautiful oil painting was prompted by imagining how a mermaid would ride a sea creature. The resultant piece was based on a succession of life studies and James' observations of how skin tones react to light when underwater.

media sources in favour of first-hand observation of the physical world.

His signature achievement is a feat of world building; the 'Dinotopia' series for which his four picture books form the foundation of a fanciful history in which dinosaurs avoid extinction and coexist with humans shipwrecked on an island over a span of centuries. The paintings that accompany the narrative are characterized by what Gurney terms "imaginative realism," in which fantasy elements are extrapolated from the everyday, a methodology that achieves a verisimilitude as charming as it is impossible.

Gurney recalls a long-ago conversation with the late Ian Ballantine, who published the works of J.R.R. Tolkien in paperback, and was a staunch early supporter of 'Dinotopia'. "One of the things Ian said about Tolkien," Gurney remembers, "is that 'The Lord of the Rings' includes a lot of throwaway details that add to the feeling of reality. The stories allude to heroes and battles and locations that are tangential to the main story but that add texture, as if the imagined world has a vast history and geography going on outside the frame. Tolkien was a linguist, so much of his back-story development took the form of names and languages. As an artist, I realized that I could achieve the same thing visually by showing cutaway views, maps, and incidental details."

The 'Dinotopia' books luxuriate in narrative-anchoring specifics,

ABOVE: A scene from 'Dinotopia: The World Beneath'. *Small Wonder* depicts two children looking after dinosaur hatchlings and is painted direct from life—with James' son Dan and a friend as the models, and a neighbour's tulip garden serving as background.
FACING PAGE: *Song in the Garden*. This beautiful painting was created for 'Dinotopia: Journey to Chandara'. Painted in 2007, it combines portraiture (the children were the daughters of friends), a dinosaur model, photographs and other elements that Gurney constructed.

merging the fantastical with the lived-in. Gurney drew inspiration from all points on the map, recalling, "I travelled to Italy, Israel, and Jordan on assignment for *National Geographic* to research paintings of Etruscan and Roman life. I explored newly opened tombs and freshly uncovered archaeological sites, consulting with experts every step of the way. My job was to reconstruct what those sites looked like hundreds, or even thousands of years ago. Photographs aren't much help for reference because everything looks different at those places now, and there often aren't many artefacts or architectural remains to build on."

"We had the same challenge when reconstructing dinosaurs. I had to

ABOVE: A superb example of Gurney's mastery of landscape in this painting from 'Dinotopia: Journey to Chandara'.
FACING PAGE TOP: *Mud Trap*, an illustration for *Scientific American*, illustrating the discovery of a group of dinosaur fossils in a muddy lake. James created as reference a muddy maquette, which he baked in an oven to achieve the right degree of cracking in the prehistoric mud.
FACING PAGE BOTTOM: One of the inspirational touchstones for 'Dinotopia'—*Waterfall City* was painted in 1988, some four years before the first of the books was published. The developmental work that went into this ground-breaking project was all-encompassing.

imagine a whole world from just a few scraps of direct evidence, using lateral thinking and educated guesswork. Bringing to life scenes from history or prehistory means creating a realistic painting of something that can't be photographed. 'Dinotopia' was the outgrowth of all this work, because I was accustomed to imagining entire cities out of whole cloth, and I had been exposed to all the glories of the ancient world."

His approach was forged of lifelong passions. Born in June 1958, Gurney grew up with an abiding interest in past civilizations. He remembers, "I was aware of archaeology as soon as I was able to read, because some of my favourite things were old copies of *National Geographic*. They told the stories of explorers in South America discovering Machu Picchu and other lost cities. Growing up in Palo Alto, California, I knew I couldn't find King Tut or a tyrannosaur by digging in my backyard, but by the time I arrived at college in UC Berkeley, I had a chance to participate on some local digs for Pleistocene fossils and Gold-Rush-era archaeological sites. I majored in archaeology, and some of the scientists noticed my artwork and asked me

ABOVE: *Kill Stealer,* from a 2015 feature in *Scientific American* on tyrannosaurs. The tyrannosaur depicted is the Yutyrannus, which is about to steal a kill from a group of Dilong. All the tyrannosaurs depicted are feathered. His procedure was documented by the artist on YouTube. FACING PAGE: Another epic painting from 'Dinotopia: A Land Apart From Time'. This image is also available as a print, and has become a favourite amongst Gurney enthusiasts.

to do accurate scratch-board drawings of the artefacts. One of my jobs was copying hieroglyphs on Egyptian scarab beetle carvings. I did my work in the catacombs of the Kroeber Museum, which was full of mummies, grass skirts, and ceremonial objects that really electrified my imagination."

After graduating from Berkeley in 1979, he headed south to the Los Angeles area, where he enrolled at the ArtCenter College of Design, and met a fellow student named Jeanette who later became his wife. While most students utilized photographs as reference for an assignment on railroads, the two of them visited downtown freight yards to sketch from real trains and to interview workers there. Few teachers shared Gurney's interest in animal drawing, multi-figure composition, and painting outdoors, so he left the school and taught himself by studying old painting manuals and making daily trips to the zoo and the natural history museum. With Jeanette still in school, Gurney took responsibility for the young couple's support, and that meant finding work.

His side of the bargain was easier said than done. He struck out with major

Text continues on page 21

ABOVE: *Market Square*, an image from 'Dinotopia: Journey to Chandara'. As with many of his images, the artist built a maquette, complete with arch and plastic dinosaurs, so that he could create accurate lighting for the painting.

ABOVE: The cover to 'Dinotopia: Journey to Chandara'. Titled *Desert Crossing*, the image draws on the poet Shelley, as well as Michelangelo, for inspiration. The runic writing on the foreground rubble reflects on the transitory nature of all civilizations with its ironic phrase, 'Everlasting Dominion'.

LEFT. The artist on a trip to the Roman ruins at Dougga, Tunisia.

LEFT: A view of Chandara, from 'Dinotopia: Journey to Chandara'.

A surreal moment: *Incident at Kelly Street*. Note the masterful handling of light. By contrast, the source photo was very evenly lit. The car was based on a model that the artist bought and assembled.

Text continued from page 12

animation players such as Walt Disney Studios and Don Bluth Productions, but did get a bite from a smaller enterprise. The boutique studio run by Ralph Bakshi was working on a fantasy-adventure film written by a pair of comic book veterans, and grounded in an ethos inspired by legendary monsters-and-muscle fantasy artist (and the film's co-producer) Frank Frazetta. What would become 1983's *Fire and Ice* needed painters for scene backgrounds. Alongside his friend Thomas Kinkade (with whom he would co-author the 1982 book 'The Artist's Guide to Sketching', and who Gurney recalls in those pre-'Painter of Light' days as an artist focused on "urban streetscapes and offbeat surrealism"), sought out the Bakshi studio.

"We knocked on the door and said we're a background painting team," Gurney recalls. "'We can take care of the whole background department for you.' We had no idea what we were talking about. Ralph hired us, and that's where I really learned to paint. We had to paint eleven paintings a week. The production backgrounds were about eight by ten inches, nine by twelve

FACING PAGE: Discovered in Uruguay in 1987, *Josephoartigasia Monesi* was scientifically modelled in 2008, using computer technology to model its skull. Gurney shepherded the next stage of the reconstruction for *National Geographic* with his painting of this giant mammal in action.
ABOVE: *Mountain Man*, from 'Dinotopia: Journey to Chandara'. The use of side lighting enhances form and emphasises the character's rugged qualities.

SWAMP ALONG RUTSEN RD.

maybe, in cel vinyl acrylic, an opaque paint."

Frazetta's paperback covers were works of genre-defining power, so it's little surprise that his example inspired the young Gurney to pursue another direction for his burgeoning career. "I always loved science fiction, but I had never even thought of painting the covers for paperbacks before. And so I prepared samples and sent copies to publishers in New York. I started getting assignments in the science fiction and fantasy genre. I loved the range of subjects, everything from dragons to castles, heroes, monsters, and spaceships. Some of my paperback covers were ambitious wraparound paintings, with entire space-ports chock full of bright-coloured aliens. I even developed a way to create flip-book animation sequences printed in the corners of the pages, something no one had tried before."

His work appeared regularly in *National Geographic* beginning in 1985, as he travelled the world and painted reconstructions of subjects that included Etruscan civilization and the Ulysses voyages. Circa 1990, Gurney made a radical shift, committing to a two-and-a-half-year plan to create a series of limited-edition prints of lost-world panoramas. From those paintings emerged the idea of a long-form picture book in the mode of Rien Poortvliet's 'Gnomes' or Brian Froud and Alan Lee's 'Faeries'. His initial task was the organization of the time he had available. "I did a series of time charts with the goal of producing ten book pages of artwork per

FACING PAGE: A truly disconcerting painting of a prehistoric crocodile succumbing to the deadly embrace of the Titanoboa, which, at over forty feet long, was a truly impressive creature. To achieve a convincing lighting effect, the artist created a maquette out of modelling clay and lit it with a theatre spotlight.
ABOVE: *Rutsen Swamp*, **a recent painting created on location, with the artist employing a mixture of gouache and coloured pencils.**

ABOVE: A portrait study of Al, a recently retired policeman, working at a forge at Old Sturbridge Village, and a portrait of James' son Frank working as a glass-blower.
FACING PAGE: A painting of gum-ball machines. The artist had three hours to kill, and devoted them to creating this fabulous painting from life at a local laundromat.

month. I did a fifteen-page outline of the story first, and then worked up a storyboard. I sketched the storyboards in pencil on pre-printed card stock, and then displayed them all up on a big wall, where I could see how the continuity would flow from section to another. All through the development of the final artwork, I changed out sequences that weren't working and put new sequences in. Friends of mine who are storyboard artists say that you know your storyboard is starting to work when your discard pile is higher than the pile that's actually in the story."

The result was 1992's million-selling 'Dinotopia: A Land Apart from Time'. Winner of numerous honours including the World Fantasy and Hugo awards, and a dominant presence on best-seller charts following its release, the book became the start of its own industry, which has included Gurney's three follow-ups, a series of books set in the same universe by other authors, and multiple television series.

Along the way, Gurney has maintained a practical approach to fantasy. With examples illustrating his point, projected onto a pair of screens behind him in the filled-to-capacity studio, he notes that the real world often provides moments of "strange illumination" that can be re-purposed to characterize the most alien of landscapes. It also provides other raw material. "Sometimes, when I do a study on location, it helps me generate ideas that

25¢

GURNEY

RED HOOK - MARKET ST.

A HEN'S LIFE

ABOVE TOP: Spring comes to the Hudson, as James illustrates in this painting of Market Street in Redhook. ABOVE: Studies of hens. FACING PAGE: A page from the artist's sketchbook depicts a utility post, with annotations and notes acting as guides for future paintings.

I can later adapt to a studio painting. For example I painted a bridge in Toledo, Spain that I used as a prototype for a more fantastical bridge in my book 'Dinotopia: Journey to Chandara'. I learned a lot by studying the way the piers of the bridge cast shadows over the murky water and the way the reflections cut across the shadows, something that I would never have been able to observe in a photograph."

Gurney regularly utilizes small-scale models in external settings to help conceptualization, particularly in the context of lighting, posing and the geometry of a scene. Simple sculptures and maquettes became part of his process early in his creative life. He recalls, "I liked building models more than drawing because I had a hard time working out the perspective. I didn't grow up in a family of artists, and never did much painting in oil until I was almost 20. As a kid, drawing mainly meant designing things from an engineer's perspective, and what I loved doing most was building three-dimensional models in the workshop, such as powered tugboats and radio-controlled gliders that I built from scratch."

Making the unreal seem plausible can boil down to something as simple as having fictitious characters treat their surroundings no better than people in the real world treat theirs. "Whenever you think about future technology, future vehicles," he suggests, "it's tempting to think of brand new, shiny, off-the-showroom kinds of vehicles, but they really get interesting when

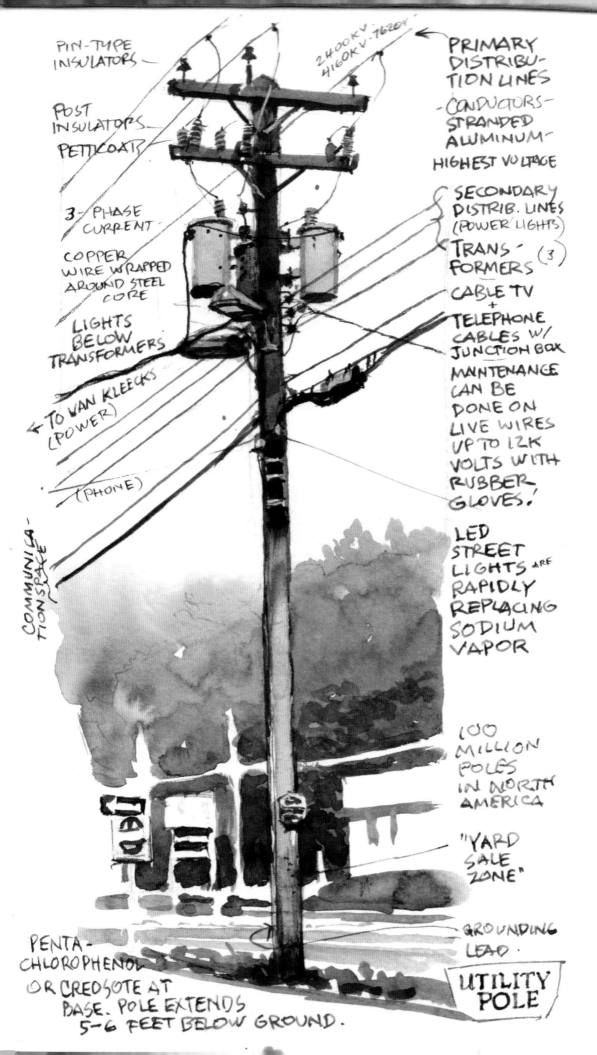

PIN-TYPE
INSULATORS

POST
INSULATORS

PETTICOATS

3- PHASE
CURRENT

COPPER
WIRE WRAPPED
AROUND STEEL
CORE

LIGHTS
BELOW
TRANSFORMERS

← TO VAN KLEECKS
(POWER)

(PHONE)

COMMUNICA-
TION SPACE

2400 KV
4160 KV - 7620V

PRIMARY
DISTRIBU-
TION LINES

- CONDUCTORS-
STRANDED
ALUMINUM -

HIGHEST VOLTAGE

SECONDARY
DISTRIB. LINES
(POWER/LIGHTS)

TRANS- (3)
FORMERS

CABLE TV
+
TELEPHONE
CABLES W/
JUNCTION BOX

MAINTENANCE
CAN BE
DONE ON
LIVE WIRES
UP TO 12K
VOLTS WITH
RUBBER
GLOVES!

LED
STREET
LIGHTS ARE
RAPIDLY
REPLACING
SODIUM
VAPOR

100
MILLION
POLES
IN NORTH
AMERICA

"YARD
SALE
ZONE"

GROUNDING
LEAD

PENTA-
CHLOROPHENOL
OR CREOSOTE AT
BASE. POLE EXTENDS
5-6 FEET BELOW GROUND.

UTILITY
POLE

they get worn and broken, and that's what we see in our own world. One time I was sketching the chassis of an old truck, and I started playing with this idea. I imagined it as if it belonged to a sort of skimmer vehicle, an old one that's still floating around in the desert with its anti-gravity system still working."

He proposes another advantage of translating ideas from the physical world: "You can take a form and manipulate it as if it were made of rubber, the way an animator would, where everything can be squashed or stretched. Let's say you want to sketch a car coming to life. If you're on location, you can get down on your hands and knees and look under the bumper. That way you can see the form from a lot of different angles, which makes it much easier to do this kind of transformation."

If Gurney's philosophy can be boiled down to a one-liner, it is that imagination grows best when planted in the rich soil of empirical observation. "Imaginative realism means making the impossible seem inevitable. That only happens when I leave myself open to the weird magic of the everyday world."

He recalls a letter from a young reader that recounted a dispute with his

BELOW: A study by the artist of an aircraft at Los Angeles International airport. The plane departed midway through the painting. Much to the artist's relief, another identical aeroplane took its place and the painting was completed.
FACING PAGE: Another study at an airport—this time Madrid. The artwork is tiny, 4 x 5 inches, but conveys a majestic sense of scale in its details.

Madrid Airport -
Gate A6 Iberia Flight 6251
to New York -

ABOVE & RIGHT:
From maquette
to final art, the
evolution of a Gurney
painting—*Aftermath*.
ABOVE: James at Syn
Studio, with *Aftermath*
alongside.

brother. "He says 'Dinotopia' is made up," read the letter, "and I say it is real. Please tell us who is right…and don't lie." Gurney laughs at the memory, and remembers, "I sweated over this one for a long time, and I said, 'Well, your brother is right, because I'm an artist, I drew these pictures, and I wrote the story. But the more I've written it, the more real it seems to me, and I think the things that are most important to us, the things we really believe in, the things that inspire us, our religions, our folklore, it's all stuff we can't see. And maybe they're more real than we are, because they'll outlast us. The rest of us will turn to dust, but those shining ideas are what will live on, so maybe you're right, as well as your brother.'"

With that, Gurney adjourns his Gathering of Masters workshop, remaining.to mingle with audience members, talk shop and sign books. On display nearby are a maquette made of wire and foam, representing a sentient robot, the finished painting for which it was used. They are the endpoints of the journey from practical observation to a realized work of imagination, with the points between mapped by his muse.

Just down the street, Saturday's music begins. Fresh from a deconstruction of creative technique, performers' explorations have added resonance.

ABOVE: The artist visited by a wild macaque on Gibraltar.

Some of them are craft elegant diversions, others clever interpretations, and not a few offer straightforward displays of proficiency. Listen as they unfold in real time: collaboration cultivates ideas—ideas spark improvisation, and those permutations shape living art. Ideas, to improvisation, to art. It's jazz all over town; on the stage here, and five floors up in a venue that didn't make the festival map. ●

ABOVE TOP: Painting of 16th century knights inspired by a trip to the Higgins Armory in Worcester, Massachusetts. ABOVE: The artist with *Dinosaur Parade.*

● *Four of the original paintings shown in this article (Dinosaur Parade, Waterfall City, Dinosaur Boulevard, and Desert Crossing) are featured in an exhibition at the Barbican Centre in London from 3 June to 1 September, 2017. The exhibition will continue at Brandts Museum of Art & Visual Culture, Denmark, and Onassis Cultural Centre, Greece. It will be staged at both venues before embarking on an international tour. For more information, visit:* **http://blog.barbican.org.uk/2017/01/into-the-unknown-a-journey-through-science-fiction-2/**
For more examples of James' work check out his site at: **http://jamesgurney.com/**
He also runs a highly-recommended blog where he shares techniques and insights into the creative process: **gurneyjourney.blogspot.com**
In addition, James also hosts a YouTube channel at: **https://www.youtube.com/user/gurneyjourney**
For information on the courses and events offered by the Syn Studio, check out their website at: **https://synstudio.ca/**

Erik Kriek

The Dutch master with a quirky sense of humour has made a big splash in the horror comics genre, as well as being one of the funniest cartoonists in the Netherlands. Let's follow Diego Cordoba and make his acquaintance.

YOU MAY BE SURPRISED TO DISCOVER that behind this big bear of a man, looking more like a lumberjack, lies a soft-spoken artist with a tender heart. Physical attributes aside, Dutch artist Erik Kriek is relatively unknown beyond the confines of his homeland, the Netherlands. However, his work is truly international and is seen in many magazines both in his native country and abroad. His comic books, whether humorous or in the horror genre, have garnered him a cult following amongst graphic novel enthusiasts.

Born in Amsterdam in 1966, Erik grew up, like many Dutch children, reading: "*Tintin, Lucky Luke, Asterix*, you know, classic French and Belgian comics." To which he added, "I read everything from *Donald Duck* to *Spirou*. I also had these cheaply printed *Prince Valiant* comics. I think they came free as a promotion from our local supermarket. I devoured that stuff. Me and my brother (and my dad) read classic Dutch comic magazines *Sjors* [*Dutch version of the American Winnie Winkle strip, appearing in his own magazine along with a Dutch-created character Sjimmie, an African boy who was part of a visiting circus and Pep [another weekly*

Erik's artwork is done with brush and ink on paper, and coloured with *Photoshop*, except where noted.
FACING PAGE: *Gutsman and Tigra Riding on a Bike*, cover for *Amsterdam Weekly*, a free English-language cultural paper from Amsterdam, 2005. Here we see the main characters of Kriek's ongoing comic series *Gutsman*.
LEFT: *Aces High*, unpublished work, 2009.
TOP RIGHT: *Self-Portrait*, 2012.

children's comics magazine published between 1962-1975]. In the late seventies they merged into *Eppo* as sales figures were declining dramatically. Those were great magazines, featuring comics like the *Trigan Empire* by Don Lawrence and *Storm*, a comic he made for the Dutch market. Powerful stuff!"

Erik took to drawing at an early age because "I had two older sisters who took up a lot of space in the house. So I was always left to my own devices, mostly because I was always looking out for my kid brother—four years my junior, playing and drawing together." While his

Kriek's eclectic taste covers many different genres, among them country music and bluegrass.
FACING PAGE: *Banjo Bess*, unpublished work, 2009.
ABOVE: *Blue Grass Boogieman*, promotional band artwork, 2009. Perhaps one of the best bluegrass bands in the world, and they're from the Netherlands.
LEFT: *Johnny Cash*, poster, 2016.

sisters were out dancing, Erik was left at home playing with *Star Wars* toys with his kid brother. "I continued playing with him even when I was fourteen years old," Erik continued, bursting out with laughter.

Although he can't remember precisely at what age he began drawing, he remembered he was very competitive at an early age, "trying to be better than my classmates… and succeeding!"

Once out of high school, and putting his *Star Wars* toys back in the closet, Erik studied illustration and graphic arts at the Rietveld Academy for Art and Design in Amsterdam. His ambition had always been to draw historical battle-scenes or sword and sorcery-themed pictures. "In my art school days, comics were a swear-word. One teacher told me: 'Watch out you don't turn into a comic-book artist! It would be such a waste, because you draw so well.'" Nonetheless, he had a tremendous time in art school, learning a lot by going against the grain, and graduating with a folio crammed with comics-related art.

"Although I always considered myself as too lightweight an artist to have the necessary discipline and the virtuosity to draw comics."

"Nevertheless", Erik later added with a sigh, "I think over the last four decades, or so, the attitudes in art education have changed a lot. Students don't learn any technical skills anymore. I help many art students, and most of them have never drawn from a live model. Mind-boggling…"

Around Europe Kriek is known primarily for his horror comics. A big fan of the horror genre, Erik has been doing a series of one-page comics examining genre/cult cinema for the Dutch genre fanzine *Schokkend Nieuws* (*Shocking News*). Here we can see some of the samples he has created for the fanzine throughout the years.
TOP LEFT: *Klaus Kinski*, **from the film 'Nosferatu', 2010.**
BOTTOM LEFT: *The Day The Earth Stood Still*, **2008.**
FACING PAGE: *Dagon*, **cover, 2012.**

However, it was during his art school days that he discovered *Raw* magazine (edited by Art Spiegelman and his wife Françoise Mouly). "Here were artists who were using comics in a completely different and free sort of way. The emphasis wasn't on technical expertise but on personal expression. It inspired me to find my own voice in comics."

Ever the toiler, Erik began experimenting with brush-inking, a technique that takes many years to master fully, as a brush behaves very differently from a pen, but the results obtained are unlike any other method, giving an elegant, sensual line that is at once thin and thick.

At first glance, Erik's drawings might seem a bit old-fashioned (some critics have called it a 'retro-style'), but in reality it's the result you get from working with a brush.

"I have been fascinated by that brush-style for a long while. It's true what they say, that it takes a long time to master. I'm still learning every single day. The brush is just so versatile. As for working in a 'retro' style: I don't know. I look a lot at old masters and time-honed techniques, so I guess that stuff rubs off somehow. I don't concern myself with 'style' that much, I just draw things the way I like to draw them. It is an intuitive process."

A large portion of his work consists of editorial illustrations done for magazines and newspapers, both

**FACING PAGE: *Sarah Palin*, editorial illustration for the Dutch national newspaper *de Volkskrant* (*the People's Paper*), 2008. Sarah Palin is an American politician who served as governor of Alaska and vice-presidential candidate. She also advocated the hunting of wolves from helicopters and claimed to have hunted bears herself.
ABOVE: *100 Comics That Should be on Your Bookshelf*, book cover, 2005. See how many comic book characters from both European and American comics you can spot here!**

in the Netherlands and abroad. He has also designed and illustrated theatrical and movie posters, book covers, CD sleeves, commercial logotypes, t-shirts, postcards, skateboards and snowboards.

In 1994 Erik decided to go ahead and work on a series of comic books. He created the superhero parody *Gutsman*, drawn in a style bringing to mind the work of Mike Allred's *Madman* and the art of Charles Burns. Unlike most of his Dutch comic book counterparts who draw mostly in the ligne-claire (clear line) style of

TOP LEFT: *All Women Are Hunters*, editorial illustration for *Starstyle Magazine*, 2003.
TOP RIGHT: *Queen of the Stone Age*, unpublished work, 2009.
FACING PAGE: *Guitar Chick*, unpublished work, 2009.

Tintin creator Hergé (consisting only of outlines for both characters and objects, with no shadows or spotting), Erik douses his brush with the blackest ink and swathes his drawings with heavy shadows, bringing to mind the work of artists such as Matt Baker and Al Feldstein.

The series *Gutsman* is about an ordinary bloke dressed like a superhero, whose girlfriend named *Tigra* dresses like *Catwoman* and is as sexy as *Betty Page*, but whose entire family (also dressed in feline suits) doesn't approve of her relationship with *Gutsman*. Even so, most of the stories feature *Gutsman* and *Tigra* quarrelling with each other and confronting their own problems as a couple at home, making it more of a soap opera, and less about superheroes fending off evil villains. It's entirely drawn in black and white, and has no dialogue, with the word balloons consisting of drawings expressing the feelings of the various characters.

The name *Gutsman* comes from the Dutch word

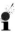

"guts" meaning gouge, the tool used for carving wood and doing linoleum cuts. "Gutsman was my nickname when I was in art school. I was always busy making woodcuts, and block prints, so the name stuck somehow. A sketch in my sketchbook saw Gutsman as a Batman-type superhero with two "guts" in his utility belt. Later he developed from a superhero spoof into a sort of silent soap opera."

TOP LEFT: *London After Midnight*, unpublished work, 2010. Featuring the great silent movie actor Lon Chaney, 'the man of a thousand faces'.
TOP RIGHT: *Rondo Hatton*, comic page for *Schokkend Nieuws*, 2011. Hatton suffered from acromegaly, an excess of the growth hormone by the pituitary gland, which gave him that grotesque look, perfect for horror movies.
FACING PAGE: *The Living Dead*, again from *Schokkend Nieuws*, 2011.

Although dealing with superhero characters, Erik wasn't at all interested in them. "No, I was never into superheroes. I mean, I like the early ones and the phenomenon generally, but I never really got into them. The whole self-importance the genre has garnered boggles me. I mean, come on, a guy in tights? It's silly!" Nevertheless, *Gutsman* was made into a one-hour play in 2006.

After having drawn ten issues of the series (the last appearing in 2007), Erik then decided to change genres, and adapted the work of H. P. Lovecraft into comic books. "Lovecraft's stories have a timelessness about them, so I could have easily situated them in modern times. [*But*] I decided early on to stay true to the original tales. I also wanted to have a pulp-era feel to them. There weren't many comics in HPL's day, but we know he went to the cinema often. I wanted the stories to look like matinee shows from the 1920s. The original Dutch version is printed in a PMS black, with a brownish tinge, to give it a silent-movie feel."

The book was published in 2012, and was designed

CREEKSPEAK®
SCHOKKEND NIEUWS PRESENTEERT:
1999 GEÏLLUSTREERDE BLIK OP DE GRUWELFILM
TEKST: BART 'THE BOAT CAN LEAVE NOW' VAN DER PUT
BEELD: ERIK 'SHOOT 'EM IN THE HEAD' KRIEK

LEVENDE LIJKEN

Een kleine 2000 jaar na de wonderbaarlijke herrijzenis van *JEZUS* van *NAZARETH* doet een *WEDEROPSTANDING* nauwelijks wenkbrauwen fronsen. sinds *GEORGE ROMERO* in 1968 de doden uit hun graf liet opstaan behoren *ZOMBIES* tot de *ONVERWOESTBARE* monsters van het horrorgenre. de *HONGERIGE HORDEN* uit romero's *NIGHT OF THE LIVING DEAD* keerden terug in *DAWN OF THE DEAD* (1979) en *DAY OF THE DEAD* (1985), en kregen destijds gezelschap van een bonte stoet italiaanse kadavers, waarbij lucio fulci met *ZOMBI 2* (1979), *CITY OF THE LIVING DEAD* (1980) en *THE BEYOND* (1981) de toon zette. de meeste zombies zijn *ENG*, sommigen zijn te *ZOT* voor woorden...

DE ZOMBIE EN HET SCHOOTHONDJE

De *30TH ANNIVERSARY EDITION* van *NIGHT OF THE LIVING DEAD* eindigt met de introductie van een *SCHOOTHONDJE* dat de mensheid tegen een nieuwe *ZOMBIEPLAAG* zal beschermen. coproducent *JOHN RUSSO* dacht de klassieker hiermee te *VERBETEREN*. hij krijgt daarom de *POEDELPRIJS*.

DE ZOMBIE EN DE SIGARET

De italiaan *JOE D'AMATO* sloeg met *SEXY NIGHTS OF THE LIVING DEAD* een gammele brug tussen *HORROR* en *PORNO*. wie goed oplet ziet in de climax van de *HORNOFILM* een *ZOMBIE* met een rokende *SIGARET* rondlopen. roken is *DODELIJK*...voor de *LACHSPIEREN*.

DE ZOMBIE EN DE TEPEL

In het kostelijk idiote *ZOMBI 3: NIGHTS OF TERROR* probeert een *ARCHEOLOOG* een aanval van *ETRUSKISCHE* zombies af te slaan met de onsterfelijke woorden: *"WACHT, IK BEN JULLIE VRIEND!"* later besluit een ontriefde moeder haar *ONDODE* zoontje de borst te geven. hij hapt *GRETIG* toe...

DE ZOMBIE OP ZEVENMIJLSLAARZEN

Na *28 DAYS LATER* blijken *ZOMBIES* in de remake van *DAWN OF THE DEAD* ook niet door *RIGOR MORTIS* gehinderd te worden. de strompelende lijken van weleer beschikken tegenwoordig over zevenmijls-laarzen.kan *KLEIN DUIMPJE* daar niet iets tegen ondernemen..?

BILL HINZMAN 1968 1998

FACING PAGE: *Dread Cthulhu*, cover for *Schokkend Nieuws*, a Lovecraft-themed issue, 2006.
LEFT: *Medical Data Registration*, editorial piece for the newspaper *de Volkskrant*, 2007.
BOTTOM LEFT: *Zombie Face*, unpublished work, 2011.
BOTTOM RIGHT: *Morten Storm*, editorial piece for *de Volkskrant*, 2014. Talk about a horror story: Storm, a Danish biker and former agent of the Danish Security and Intelligence Service (PET) turned into an Al Qaeda terrorist! Sometimes real-life stories are way more horrific than any by Lovecraft.

by Borinka Beeke. It proved to be a great success in Europe, being translated into seven different languages, and established Erik as a major force in the horror genre. Following Lovecraft's stories very closely, it is maybe the best-ever comic book adaptation ever done of his work. The artwork consisted of heavy shadows with bold brush strokes and grey tones, accompanied by some very disturbing drawings, which seem destined to visit sleepless nights on unwary readers.

It goes without saying that Erik is a big fan of the horror genre. "I have been a horror-fan most of my life. I love Lovecraft, naturally. I'm a big Stephen King fan,

well, of his earlier novels. And his short stories! I think that is where his main strength lies. I also like old *Creepy* and *Eerie* magazines, really powerful stuff! And movies! Man, where to start? I'm a huge fan of Italian horror movies from the '70s and '80s; Argento, Fulci, Bava, that sort of stuff. Wow, there's so much going 'round." Recently, he discovered *It Follows* (a 2014 American supernatural psychological horror film written and directed by David Robert Mitchell). "That was the best new movie and the scariest one I've seen in a long time! Really good!"

Although the graphic style of the Lovecraft book might

TOP LEFT: *Skater Girl*, unpublished work, 2007.
TOP RIGHT: *Longboard Baby*,
unpublished work, 2012.
BOTTOM RIGHT: *Gutsman and Tigra*,
unpublished work, 2007.
FACING PAGE: *Two-Fisted Sales*, illustration
commemorating the 40th anniversary (1968-
2008) of legendary comics shop (the oldest on
the planet) Lambiek, in Amsterdam, 2008.

LAMBIEK, 40 YEARS OF
TWO-FISTED
SALES

KRIEK · EK ENTERPRISES · GUTSMAN

FEATURING:

THE *VAULT KEEPER*

THE *FOSSIL*

THE *DUDE*

...WHAT DO YOU *MEAN* 'THEY THREW YOU *OUT*?!

...I JUST WANTED TO KNOW IF THEY SOLD ANY *REAL* BOOKS.. ...YOU KNOW, WITHOUT *PICTURES* IN THEM. I GUESS THESE GUYS TAKE SELLING *COMIC-BOOKS* *VERY* SERIOUSLY..

remind some readers of the old *EC* comics, Erik wasn't aware of their existence for a long while. "I discovered them pretty late actually. They weren't around when I grew up. For me, they are the blueprint of what a comic-book should be. These guys invented the medium as far as I'm concerned. For us today it is so easy. You *Google* up some old stuff that you can steal from, but these guys, they had no example, they just made it up as they went along. And without any artistic invention. Fantastic!"

After the Lovecraft book, Erik decided to change genres and adapt the so-called 'murder ballads' from American folk-songs for his next project 'In The Pines'. These songs about murders and murderers have been around since the sixteenth century, and some have been

Text continues on page 54

LEFT: *The Cramps*, centrefold-spread for *Schokkend Nieuws*, 2013.
ABOVE: *Undead Rebels*, unpublished work, 2007.
FACING PAGE: *That 7,000,000 Year Itch*, magazine illustration for *PIM* magazine, 2002.
FOLLOWING PAGES LEFT: *Mantis Attack*, promotional poster artwork for Free Comic Book Day, 2013.
FOLLOWING PAGES RIGHT: *Queen Beatrix 70*, editorial piece commemorating the 70th birthday of the former queen, 2008. "The piece was vetoed at the last minute by the editor-in-chief, as deemed too disrespectful to the head of state."

Text continued from page 50

adapted into country songs by such diverse artists as Johnny Cash, Sandy Denny, Judy Collins, Ronnie Sparks (the female voice from the Handsome Family), and even more contemporary musicians such as The Band, Steve Earle and Nick Cave. Graphically speaking, Erik adopted a slightly different style from his previous book: gone are the bold brush-strokes delineating the outlines of his figures. In fact, this time around the drawings consisted only of light and shadows, the outlines of the figures and panels being delineated by a single colour tone that varies from one story to the next, and sometimes within the same story as to express a change in mood.

TOP LEFT: *From Beyond*, cover for *Zone 5300*, Holland's last remaining avant-garde comics magazine, 2008. "This issue ran a story from my Lovecraft anthology."
TOP RIGHT: *Zombie Girl*, unpublished work, 2009.
FACING PAGE: *Zombie Killer*, unbelievably, it's an unpublished work, 2009.

Also gone are the accompanying boxes of text that were so carefully used in the Lovecraft book, leaving us here only word balloons with dialogue, on what are primarily almost wordless stories.

The mood with which Erik expresses a series of stories situated in the back-door of the American depression era is simply uncanny. You actually get a feeling of the era, and his drawings of abandoned wooden shacks and the forbidding forests bring forth a sense of unease and a feeling that takes us back to the world of H.P. Lovecraft.

"As of June 2017, 'In the Pines' is published in the US by *Fantagraphics Books*. It is currently selling well in Europe, especially in Germany, where it won the Rudolph Dirks Award in December 2015." The design of the book was done by Erik's studio-mate; Rob Westendrop, and it features real hand-lettering by Frits Jonker, one of the few remaining letterers left in the Netherlands (the *Fantagraphics* book also features Jonker's lettering).

It is difficult to pinpoint any particular influence on

Text continues on page 59

LEFT: *The Great Baby Swindle*, commissioned piece for *NRC Next*, a national Dutch newspaper, 2008. "This autobiographical piece explores the costs involved when having your first child."
ABOVE: *Saint Obama*, editorial piece for *de Volkskrant*, 2008. "At the time of his election, Obama was thought to be the world's saviour."
FACING PAGE: *Taneytown*, limited art-print accompanying the luxury edition of 'In The Pines', 2016.

TOP LEFT: *Boris Karloff*, personal work, scraper-board, 2007.
TOP RIGHT: *RIP*, movie poster for the short film *RIP 2002*.
BOTTOM LEFT: *Mission Uruzgan*, editorial piece (in a series of five) for *de Volkskrant*, 2007. Personal stories from the Dutch military forces stationed in Afghanistan. "I made the illustrations appear to be torn out of a comic book so as to emphasize the fragmented, grittiness of the stories."

ABOVE: *Evil Big Bird*, editorial
piece for *de Volkskrant*,
illustrating an article about the
influence TV-violence has on
young children.
RIGHT: *Vincent Price*, scraper-
board, 2006.

Text continued from page 54

Erik's artwork, as it varies so much from one book to the other. As to his actual influences, he confessed: "They are too many to name. I love Frans Masereel and James Ensor. Max Beckmann, Kokosjka, David Hockney, Van Gogh, Picasso, Edvard Munch…and Charles Burns, Daniel Clowes, Will Eisner, Wally Wood, Alex Toth… There are so many. And I discover new geniuses every week just browsing the web!"

Unlike many modern comic book artists, Erik still works the old-fashioned way of drawing and inking on paper. "I always base my drawings on a black line. I start sketching on paper using blue Col-Erase pencils and Palomino Blackwing pencils, transferring sketches to a

light-pad (LEDs are a great improvement on those old light bulb-powered light boxes of yore), sometimes two or three times to get the composition right and to clean up the line work. Final inking is done on Schoellerhammer 4G paper (there is NO alternative as far as I'm concerned) using a Winsor & Newton No. 2 sable brush, and India ink. I also use Tombow, Kuretake pens a lot lately, they have a lovely soft brush-like tip. They don't last very long, so I buy them by the dozen. Corrections are done with bleed-proof gouache, preferably Dr. Martin's Pro White (very hard to get nowadays because of its toxicity and ever-expanding EU regulations, I guess)."

"The finished drawing is then scanned (using a Mustek A3 scanner) into Photoshop and colouring and effects are added using a 21" *Cintiq* tablet and a *Mac*."

As to his future projects, he let's us know, "I'm currently working on a new graphic novel that is set around the year 900 AD. Working title is 'Viking-Western' but there is not much to tell yet. I've just started on this project, and I hope it will be finished before 2020."

Erik Kriek lives and works in Amsterdam, the Netherlands, with his girlfriend Stans and their son Clovis, and an ever expanding collection of toys. ●

● *Check Erik's website at **www.gutsmancomics.com** for more samples or commissions of his work.*

ABOVE: *Wishful Thinking*, editorial illustration for a piece on climate change having an effect on our winters, 2007. 'Is Ice-Skating Becoming a Thing of the Past?'
LEFT: *Water Nymph*, personal work, 2007.

IN THE NEXT ISSUE

ISSUE TWENTY

In issue 20 we're getting into a Russian theme, with the work of the amazing Franz Roubaud as our cover feature, and a host of other turn of the last century Russian realists, to transport you to distant times and distant climes.

Work by Ilya Repin, Vasily Polenov, Victor Vasnetsov, Ivan Shiskin and Konstantin Makovsky (to name but a few) will astound your senses. We also delve deep into the fairytale world of Ivan Bilibin, whose art continues to captivate young readers.

Ilya Repin

Ivan Bilibin

Konstantin Makovsky

Job (Jacques Onfroy de Bréville)

ABOVE: Napoleon Bonaparte and his troops in the desert during the Egyptian Campaign, illustration for 'Bonaparte' (1908), written by Georges Montorgueil.
FACING PAGE: *Reichshoffen*, illustration for 'Allons, Enfants De La Patrie' (1920), a series of poems based on historical French events written by Jean Richepin.

Diego Cordoba revisits the life and times of one of the greatest historical artists, whose majestic artistry and love of history spearheaded a revolution in children's illustrated books.

ALTHOUGH TODAY HE IS ALMOST FORGOTTEN, Jacques Onfroy de Bréville was one of the premier illustrators of children's books at the turn of the last century. Using the initials of his name he signed his work as 'Job'. Born in Bar-le-duc, in the Lorraine region (of France) on the 25th November 1858, Jacques was fascinated by drawing and the graphic arts from a tender age. He illustrated a variety of plays inspired mostly by military feats and famous battles. In 1868 his family moved to Paris and he entered L'École Bossuet and later pursued his scholarship at the College Stanislas. Simultaneously he wrote a variety of plays with his younger brother Pierre, who went on to become a famous musician. Jacques' forté, however, was his ability as a caricaturist, and in 1876 he signed a 'Petite Définition', drawing comparisons with Victor Hugo's support for the 'Communards' [*The Communards were members of the Paris Commune, part of an insurrection against the government that lasted for two months, as a reaction to the defeat of the French during the Franco-Prussian war of 1870 and the capitulation of Paris*]. Art became his most important interest, though when he wanted to go to the École des Beaux Arts he was stopped by his father, so he chose a career in the army instead. For five years, he remained in the newly-formed republican army. Thereafter, he harboured a certain fondness for those days, which shaped his love of weaponry, uniforms and military history.

In 1882 he returned to Paris, and finally went to the École des Beaux Arts, studying under the painters Carolus Duran, Ernest Meissonier, Édouard Detaille

ABOVE LEFT: Original art to the narrative 'Un Rêve Agité', pen and ink.
ABOVE RIGHT: 'Un Rêve Agité', printed page and in colour for a series of one-sheet children's stories published by Quantin (1886). Some critics believe this could have been one of the early inspirations for Winsor McCay's *Little Nemo*.
BELOW: 'Le Grand Napoléon des Petits Enfants', cover of the book written by J. de Marthold (1893). Job's first masterpiece.

and Évariste-Vital Luminais. He had a classical training and was decidedly underwhelmed by the contemporary art scene such as the Impressionists and later in life, the Modern Art movements from the early part of the 20th century. Since his paintings didn't meet with much success, he veered towards caricatures and newspaper cartoons. Reader response to these drawings was enthusiastic, and Job finally found his niche, feeling at ease working on either political journals or women's magazines. He also did a series of sequential drawings creating a narrative, usually humorous, and a page long, a format which was a forerunner to today's comic strips. One of them, about a boy called Lucien who goes to bed, and discovers his wooden horse has come to life, prefigures Winsor McCay's *Little Nemo* right down to the concluding panel.

He also collaborated with different journals: *Le Monde Parisien*, *La Caricature*, *La Nouvelle Lune*, etc., generating caricatures and satirical social and political drawings, in the style of Caran D'Ache, a contemporary satirist and political cartoonist (sometimes hailed as one

of the progenitors of comic strips, and known for his cartoons of family dinners at which the news items of the times are heatedly discussed among the guests).

Aside from Job's caricatures and cartoons, he illustrated children's books. However, his political and intellectual inclinations drove him into illustrating historical works, which soon beacme very popular.

Job became renowned for his illustrations in historical books, over thirty among them, mostly written by Georges Montorgueil. These books were considered masterpieces of their genre. They tell stories, aimed at children, about great moments in France's history, or the life of the great and glorious French heroes, with a definite bias towards the Napoleonic era. Of the 37 books he illustrated, 16 concerned the Emperor [*Napoleon*] himself, the Great Army or were simple collections of the military uniforms of the First Empire.

Beginning in 1888 with 'Histoire D'un Bonnet à Poil' ('Story of a Bearskin') written by J. De Matrthold and finishing in 1931 before his death with 'Quand Le Grand Napoléon Était Petit' ('When the Great Napoleon was Young') written by E. Hinzelin, the texts are steeped in the 'Third Republic' (which commenced right after the fall of the Second Empire and the suppression of the Paris Commune, establishing a regime based on parliamentary

supremacy). Delving into heroism, honour and courage, the text and images were there to exalt the glory and grandeur of France, and the historical events, depicted so sumptuously by Job, provided much fodder for their youthful readership. The anecdotes were numerous and perfectly illustrated by Job. It's through these books that the French youth learnt about Bayard and its bridge, Guesclin and his hogs, Roland and his olifant—whether historical or just legendary, every aspect of France was vividly illustrated and even caricatured, as in the case of Louis XI. Job perfectly captured the latter's sinister air, visiting cardinal de La Balue's young daughter—whom he visited only at night—in a dark dungeon, but wearing a red silk robe, or the same Louis XI walking through

BOTTOM LEFT: *Napoleon being approached by a nervous lieutenant during a parade at Schönbrunn,* illustration for 'Napoleon' (1921), written by Georges Montorgueil.
BOTTOM RIGHT: *Napoleon at St Helena, guarded by the British,* illustration for 'Jouons a L'Histoire' (1908), written by Georges Montorgueil. All the figures are represented as wooden toys, hence the title of the book, 'Let's Play at History'. Notice the army in silhouette in the background above the clouds, a device Job would frequently introduce into his illustrations.

Bibliothèque nationale de France

Bibliothèque nationale de France

Bibliothèque nationale de France

ABOVE: Three illustrations from 'Le Grand Napoléon des Petits Enfants' (1893). These three samples shows Job's use of symbolism (the sun shining behind Napoleon creating a halo), colour used to form silhouettes, and use of dark shadows to enhance a certain feeling, all techniques Job would use later in his work.

his garden at Plessis, which was the scene of many an execution ordered by the king.

Job was a very precise illustrator: he paid close attention to detail (buttons, coats, boots and ornaments, all were drawn in their right place), as well as every aspect of the battles and wars he depicted. However the faces he drew sometimes bordered on caricature: his heroes tended to be stereotypically handsome, while his villains were irredeemably ugly. Job was an illustrator of action scenes and high drama, rather than someone who merely contemplated scenery. He was less interested in the landscapes or the colours of the skies he painted: his attention was focused on the ruggedness of the veteran soldier, the suffering of the mess girl in the Russian plains or the satisfaction of the Great Mademoiselle giving the order to fire the cannons of the Bastille against the Royal troops. The summit of his art was attained with his depiction of Napoleon: stoic in his efforts, generous

Text continues on page 70

BELOW: *Chariot de Thespis* (1913), interior llustration for the booklet of the play of the same name written by J. Dessaint.
FACING PAGE: *Le Faucheur De Bouvines*, illustration for 'Allons, Enfants De La Patrie' (1920). When attacked by the Teutons, the French used their scythes to cut down the legs of their attacker's horses. This is quite a violent illustration for a children's history book.
FOLLOWING PAGES: *Battle of Waterloo*, illustration for 'Napoleon' (1921). One of Job's great panoramic views.

Text continued from page 66

with the afflicted, pitiless in the face of cowardice, and reflective when contemplating his past victories on top of his favourite rock at Saint-Helena.

His most famous books, though, were 'Murat', 'Le Grand Napoleon des Petits Enfants' ('The Great Napoleon of the Little Children'), 'Louis XI', 'Bonaparte' and 'Les Gourmandises de Charlotte' ('Charlotte's Gluttony')—whoever read that last book will never forget it: Charlotte will only eat sweets. She becomes so small that she lives in a matchbox and becomes servant to a rat. Wanting to grow to her natural size she starts eating anything she has in front of her, and gets fatter and fatter. The moral

TOP LEFT: *Battle of Fleurus with Balloon*, illustration for 'Jouons a L'Histoire' (1908).
TOP RIGHT: *La Croisade Des Enfants*, illustration for 'Allons, Enfants De La Patrie' (1920).
FACING PAGE: Napoleon Bonaparte and Josephine de Beauharnais reviewing a model during preparations for their coronation, illustration for 'Bonaparte' (1908).

to the story being that a well-balanced diet will give you a normal-sized body. He also illustrated the life of George Washington, which introduced his work to a new readership in the United States.

However, his first successful book was 'Le Grand Napoléon des Petits Enfants', released in 1893, which many critics consider a masterpiece. The fourth book commission that Job undertook, it was laid out with an illustration taking up most of the space on each page and a couple of lines of text underneath. The book recounted the life of the Emperor in a rather exaggerated and whimsical manner. It reads almost like a comic book. Although drawn in a rather naïve and simplistic way (Job was at the beginning of his career as an illustrator), it does establish both the subject matter and treatment by which he would become known by his readers: galloping horses, battle scenes, bold framing, panoramic views with hundreds of soldiers, and assured illustrations rendered with light and shade. Although some of the images veer towards the ludicrous as, for example, a dog on its hind legs lifting a paw to salute the Emperor as he

FACING PAGE: *Napoleon at the Battle of Austerlitz*, illustration for 'Bonaparte' (1908). This scene is totally invented, Napoleon was never there to help his soldiers out of the icy water, but it is nonetheless a very powerful image. Take note that Job didn't use any photographic reference but, instead, relied on his imagination.
LEFT: *Napoleon Bonaparte at Marengo, near the city of Alessandria, in Piedmont, Italy, 1800,* illustration for 'Bonaparte' (1920). Even when illustrating a rather static scene like this, you can see the force of Job's drawings. The perspective, composition and framing is absolutely stunning. You get a feeling you are there.

walks by and Napoleon saluting the dog back. However, this was what made the book so popular among its young readers, showing a larger than life Napoleon, friend of the French people and friend of animals as well, all with a certain nostalgia for a bygone and (according to the author) better time. The cover depicts Napoleon positioned with his back to us, wearing his famous bicorn hat, a hand on his back holding a spyglass, standing over a battlefield where we see cannonballs lying on the ground beside him, and staring into a horizon where a bright sun shines. Even the name of the Emperor in the title has the three colours of the French flag. The image was the embodiment of French patriotism, a sentiment which resonated with its readers.

Throughout his career, Job's drawings would grow in impact, and his compositions and framing become more audacious. Working at a time when photography and cinema were in their infancy, Job was showing a snapshot of history with an immediacy that these other media could not compete with. His attention to detail added weight to his illustrations: with locations, uniforms and weapons accurately drawn. When he depicted a battle, you got the impression that you were there in amongst the fighting soldiers. Even his more fanciful artworks were created in such a way, that they added credibility to what he was portraying on paper.

A great admirer of Edouard Detaille (one of his art teachers), Job learned from him that military nationalism, and the use of allegories in his paintings, would find an appreciative audience. Regular use of shadows, the cockerel (a symbol of France), the eagle, the sun and the clouds would give his work consistency and illustrative lucidity. It created an iconography all of its own. The reader had in front of him an image that would convey a sense of time and place, as well as the ideas it embodied. This use of symbolism conferred an

almost god-like status on his depiction of great historical figures such as Napoleon.

Formerly, Job's work was situated among the great painters who depicted the life of the Emperor: David, Vernet, Raffet. He was also influenced by Delacroix, Detaille, Meissonier and the other academic painters of the time, referred to derisively by the French critics as 'Art Pompier' ('Firemen Art', a half-pun on the word 'pompous' and a derogatory reference to artwork that, although technically well-done, has got no real artistic value, and is as insincere and overblown as the values of the bourgeoisie it caters to). He didn't care about

TOP LEFT: *King Henry IV of France, playing with children*, illustration for 'Jouons a L'Histoire' (1908).
TOP RIGHT: *Cadet Rousselle,* illustration for 'Les Héros Comiques' by Emile Faguet (1910). Based on a French bailiff by the name of Guillaume Rousselle, who soon became part of a popular satirical song written by Gaspard de Chenu in 1792.
FACING PAGE: *Fanfan-La-Tulipe,* illustration for 'Allons, Enfants De La Patrie' (1920). Originated in a song, this character would later appear in plays, operettas and eventually films.

the Impressionists or the Cubists. He was a master of composition and colours (used to a strict minimum, which gave the work greater force). The expressive power on the faces he drew, influenced by his love of caricature, set him apart from other 19th century illustrators. We feel every expression and emotion of the characters he drew. He invented an iconography in his imagery and narrative that were totally new. He almost single-handedly set the bench mark for children's book llustration, which attracted many followers, and set the standard for subsequent generations of readers.

Although his illustrations were grounded in reality, they didn't lack his humorous touch, as in the book dedicated to King Henry IV, in which we see, among the many images that accompany the text, one of an elegant lady with tears in her eyes having eaten her baby, with a jar of mustard on the table beside her. Job could be mischievous at times.

A man of his epoch, Job was an uncompromising nationalist, who admired the army and the glory of the military. Although he managed to depict soldiers of the

Text continues on page 80

TOP LEFT: *Louis XIV, J'ai Failli Attendre*, illustration for 'Les Mots Historiques du Pays de France' (1896), written by Trogan. Job's framing, cleverly leaves the rest of the illustration to the reader's imagination.

BELOW: *La Revue De Naples en 1808*, illustration of Joachim Murat, King of Naples, who also happened to be Napoleon's brother-in-law. Date unknown.

TOP CENTRE: *La Marseilleise*, illustration for 'Les Chants Nationaux' (1900).

TOP RIGHT: *Jeanne d'Arc*, illustration for 'Allons, Enfants De La Patrie' (1920). Job's attention to detail in the armour, shows that it wasn't only military uniforms he was good at drawing.

FOLLOWING PAGES LEFT: *La Poule Au Pot*, illustration for 'Allons, Enfants De La Patrie' (1920).
FACING PAGES RIGHT: *Le Tambour-Major*, illustration for 'Allons, Enfants De La Patrie' (1920).

ABOVE: *Le Triomphe Du Poilu*, illustration for 'Allons, Enfants De La Patrie' (1920). This book tells with poems all the history of France, ending with the return of the 'poilus' from the First World War.
BOTTOM RIGHT: *Le Bluet*, illustration for 'Allons, Enfants De La Patrie' (1920).

Text continued from page 74

First World War, these illustrations still carried a certain nostalgic look towards a bygone era, making them look like Napoleonic soldiers (even the citizens he drew during the 20th century looked as though they came from an earlier century).

Made *Chevalier de la Légion d'Honneur*, Job died some years later at Neuilly-sur-Seine in September 15, 1931. ●

Arturo del Castillo

ARTURO DEL CASTILLO IS SOMETHING OF A LEGEND amongst enthusiasts of comic art. His exquisite pen and brush work graced many European comics throughout the latter part of the last century. Born in Chile in 1925, he moved to Argentina in 1948 and teamed up with his brother who was already working in the commercial art field. His first job was working in an advertising agency, but he soon began drawing Westerns for Argentinian comics before joining the D'Ami Agency, whose primary function was to provide top-notch comic strip art to a variety of European publishers.

He excelled at his craft and was in constant demand by publishers, including the UK company *AP* (*Amalgamated Press*—latterly *Fleetway*), for which he created some of his most memorable strips, particularly in the field of Westerns. In his earliest work for AP he created strips for 'The Man in the Iron Mask' and the Three Musketeers' by Alexandre Dumas, where he created strips for 'The Man in the Iron Mask' and 'The Three Musketeers'. The Illustration Art Gallery has very generously provided us with scans of 'The King's Musketeer', a strip which ran in *Film Fun* and was later reprinted in *Lion* comic. All the art shown is currently on sale at: ***www.bookpalace.com***

The King's Musketeers

SUDDENLY LIEUTENANT D'ARTAGNAN HALTED HIS FRIENDS, MIRTH TWINKLING IN HIS DARK EYES. AND AS, HANDS ON HIPS, HE STOOD CHUCKLING, HIS FRIEND ARAMIS BESIDE HIM THREW OUT A HAND

HA! I WONDERED WHY YOU STOPPED! THERE ARE THE FIVE CARDINAL'S GUARDS WE CAUGHT BULLYING AN OLD MAN LAST WEEK!

YOU'RE RIGHT — AND BY THE LOOKS OF THEM THEY HAVEN'T FORGIVEN US FOR THE TROUNCING WE GAVE THEM, EH, ATHOS?

H'M. I SUPPOSE IT'S TOO MUCH TO EXPECT THEY'D LIKE TO CROSS BLADES WITH US AGAIN. MY SWORD-ARM NEEDS SOME EXERCISE

CARDINAL RICHELIEU, ALL-POWERFUL AND MASTER POLITICIAN OF HIS AGE, WAS THE KING'S MOST TRUSTED ADVISER. BUT HIS GUARDS WERE THE MUSKETEERS' DEADLY RIVALS

SO WE MEET AGAIN, D'ARTAGNAN. LAST WEEK YOU TOOK US UNAWARES, BUT TODAY WE ARE READY FOR YOU. PREPARE TO DIE, YOU YOUNG UPSTART!

HA! A CHICKEN SQUAWKS LIKE A HAWK!

A LOUD LAUGH, LIKE A CLAP OF THUNDER, ESCAPED THE LIPS OF PORTHOS, THE BRAWNIEST OF THE FOUR MUSKETEERS

ONE EACH FOR YOU THREE. AND TWO FOR ME! THAT'S HOW I LIKE IT!

GREEDY AS USUAL, PORTHOS. BUT WHAT ARE WE WAITING FOR, MY FRIENDS? OUT SWORDS — AND AT 'EM!

AS D'ARTAGNAN SPOKE, THE FOUR MUSKETEERS STEPPED FORWARD AS ONE MAN AND THE NEXT MOMENT A FIERCE BATTLE WAS IN PROGRESS

THREE MINUTES LATER ONLY ONE GUARDSMAN WAS LEFT UNWOUNDED AND TO HIM D'ARTAGNAN SPOKE CONTEMPTUOUSLY

GET BACK TO YOUR KENNEL, DOG, AND TAKE YOUR FRIENDS WITH YOU! I'LL WARRANT NONE OF YOU WILL EVER CROSS SWORDS WITH A MUSKETEER AGAIN!

WHILE THE CARDINAL'S GUARDS STAGGERED PAINFULLY BACK TO THEIR BARRACKS, THE CARDINAL WAS LISTENING DISTASTEFULLY TO HIS MONARCH, LOUIS THE THIRTEENTH, FATHER OF THE NEWLY-BORN PRINCE.

I AGREE, YOUR EMINENCE, THE PRINCE WILL NEED YOUR LEARNING AND WISDOM TO TEACH HIM HOW TO REIGN WHEN ONE DAY HE WEARS MY CROWN. BUT HE MUST ALSO LEARN THE ARTS OF WARFARE. D'ARTAGNAN IS THE MAN FOR THAT.

AS YOUR MAJESTY COMMANDS

THE KING TURNED TO THE BEAUTIFUL GIRL STANDING BESIDE HIS SON'S CRADLE

AH, LADY CONSTANCE! YOU ARE BETROTHED TO LIEUTENANT D'ARTAGNAN. REPEAT MY WORDS WHEN NEXT YOU SEE HIM!

D'ARTAGNAN WILL BE HONOURED, SIRE!

AT THAT MOMENT, JEAN MOLLET, THE ROYAL DOCTOR, ENTERED THE ROOM BEARING A GLASS OF WATER ON A TRAY

YOUR PARDON, SIRE, BUT THE CARDINAL HAS A SLIGHT COLD AND I HAVE BROUGHT HIM A POWDER TO TAKE

A SLIGHT FROWN OF PUZZLEMENT CROSSED THE CARDINAL'S HANDSOME FACE AS HE TOOK THE POWDER WHICH WAS WRAPPED IN A SMALL PIECE OF PAPER. DOCTOR MOLLET THEN TURNED TO LADY CONSTANCE

SPEAK TO NO-ONE BUT HURRY TO THE QUEEN, GIRL. THERE IS TROUBLE AFOOT!

STEPPING TO ONE SIDE, CARDINAL RICHELIEU OPENED THE PAPER AND HASTILY SWALLOWED THE CONTENTS. THEN HIS MOUTH SHUT LIKE A STEEL TRAP AS HE SAW WRITING ON THE PAPER

A BITTER DOSE INDEED!

THE CARDINAL'S KEEN BRAIN WAS RACING WITH THE DREAD IMPORT OF THE SECRET MESSAGE THE DOCTOR HAD SO SKILFULLY CONVEYED TO HIM — A MESSAGE THAT MIGHT WELL MEAN CIVIL WAR FOR HIS BELOVED COUNTRY

The King now has a second son - A twin prince has been born.

A TWIN SON! THEN TO WHOM WOULD THE THRONE RIGHTFULLY BELONG? IT WAS IMPOSSIBLE FOR TWO KINGS TO REIGN OVER FRANCE, AND CLEVER, UNSCRUPULOUS MEN WOULD BE QUICK TO ENCOURAGE HATRED AND DISTRUST BETWEEN THE TWO PRINCES AS THEY GREW OLDER. IT MUST NEVER HAPPEN! BUT HOW COULD THE CARDINAL PREVENT IT?

LION ISSUE DATED 5 OCT 1963 FLEETWAY PUBLICATIONS, LTD.

The King's Musketeers

LION ISSUE DATED 5 OCT 1963 FLEETWAY PUBLICATIONS LTD.

(The King's Musketeers Episode (2))

AND THE DOCTOR SPED AWAY FOLLOWED BY THE SCOWLING DE ROCHEFORT

THAT SLINKING RASCAL IS UP TO NO GOOD. WHAT WAS THE MEANING BEHIND HIS WORDS? WE MUST BE READY FOR TROUBLE, MY FRIENDS!

AN HOUR LATER CARDINAL RICHELIEU SUMMONED TO HIS PRESENCE THE ONLY OTHER THREE PEOPLE WHO, APART FROM THE QUEEN, KNEW OF THE BIRTH OF THE TWIN SON

THIS SECRET MUST BE REVEALED TO NOBODY ELSE. NOBODY, DO YOU UNDERSTAND? YOUR LIVES ARE FORFEIT IF YOU DISOBEY ME, FOR SHOULD THIS INFORMATION LEAK OUT, THERE ARE EVIL MEN WHO WOULD STRIVE TO SET BROTHER AGAINST BROTHER AND GROW RICH FROM THE RESULTANT WARS!

LITTLE DID THE IRON CARDINAL REALISE AS HE SPOKE THAT ALREADY THE SECRET WAS IN THE POSSESSION OF HIS MOST VALUED HENCHMAN, COUNT DE ROCHEFORT, AND THAT EVEN NOW THE COUNT WAS MAKING PLANS.

DOCTOR MOLLET TREMBLED AS HE LISTENED TO THE CARDINAL'S WORDS. FOR A BRIEF MOMENT HE WAS ABOUT TO TELL THE CARDINAL THAT DE ROCHEFORT HAD DISCOVERED THE SECRET. THEN HE REMEMBERED THE COUNT'S THREAT — AND HELD HIS TONGUE!

THESE ARE MY ORDERS. YOU, DOCTOR MOLLET, AND YOUR NURSE, MADAME PERONNE HERE, ARE TO TAKE THE SECOND SON TO SPAIN TO A PROPERTY THAT I OWN THERE. YOU WILL BOTH RAISE THE BOY IN COMFORT AND PLENTY, BUT HE MUST NEVER LEARN WHO HE REALLY IS. UNDERSTAND?

IT MEANT THAT NEVER AGAIN WOULD DOCTOR MOLLET AND MADAME PERONNE RETURN TO THEIR OWN COUNTRY. BUT THEY DARED NOT DEFY THE CARDINAL'S ORDERS. SILENTLY THEY WITHDREW

AND NOW, LADY CONSTANCE, YOU MUST REALISE YOUR LIFE IS IN DANGER. SHOULD CERTAIN MEN TRY TO DISCOVER OUR SECRET, THEY MIGHT TRY TO FORCE YOU TO SPEAK BY TORTURING YOU. YOU, TOO, MUST GO AWAY

MAY I SEE MY BETROTHED, LIEUTENANT D'ARTAGNAN, BEFORE I LEAVE? WE WERE HOPING TO MARRY SOON

GRAVELY BUT DEFINITELY, CARDINAL RICHELIEU SHOOK HIS HEAD. THEN HE RANG A SMALL BELL, AND IN ANSWER COUNT DE ROCHEFORT HASTILY ENTERED THE ROOM

DE ROCHEFORT, YOU WILL ESCORT THE LADY CONSTANCE TO MY CASTLE OF PLESSIS. THERE SHE IS TO BE LOOKED AFTER UNTIL I ARRIVE TOMORROW. YOUR LIFE DEPENDS ON HER SAFETY

AS YOUR EMINENCE COMMANDS

THE CARDINAL WILL HAVE SENT THE OTHER TWIN AWAY SOMEWHERE — AND THIS GIRL WILL KNOW WHERE! PERFECT! AT PLESSIS SHE SHALL BE MADE TO SPEAK! AND THEN — THEN, DE ROCHEFORT, MY FRIEND, THE WEALTH OF ALL FRANCE WILL BE YOURS TO POSSESS!

← "5/8" → over all

The King's Musketeers

PIERCE FOR TYPE

THE CARDINAL INSTRUCTED HIS CHIEF HENCHMAN, COUNT DE ROCHEFORT, TO ESCORT CONSTANCE TO PLESSIS, NOT KNOWING THAT THE CRAFTY COUNT HAD LEARNED OF THE BIRTH OF THE SECOND BABY. THROUGH THE NIGHT THE COACH SPED ALONG THE DARK COUNTRY ROADS...

INSIDE THE JOLTING COACH, DE ROCHEFORT WATCHED THE IMPASSIVE CONSTANCE. HE KNEW THAT SHE WAS AWARE OF THE PRESENT WHEREABOUTS OF THE SECOND TWIN. WOULD MONEY LOOSEN HER TONGUE?

I AM CONVINCED YOU KNOW WHERE THE CARDINAL HAS HIDDEN THE SECOND TWIN! A THOUSAND GOLD PIECES IF YOU TELL ME WHERE THE BABY HAS BEEN TAKEN

YOU TALK IN RIDDLES, COUNT. I CAN TELL YOU NOTHING

I DO NOT BELIEVE YOU. AH WELL, IF MONEY WON'T MAKE YOU TELL I KNOW SOME VERY UNPLEASANT WAYS OF FORCING YOUR TONGUE TO WAG. BETTER RECONSIDER MY OFFER, MY DEAR

NOW THE LADY CONSTANCE WAS BETROTHED TO LIEUTENANT D'ARTAGNAN OF THE KING'S MUSKETEERS, AND D'ARTAGNAN WAS A MAN OF MANY ENEMIES AND MANY FRIENDS. AND ONE OF HIS FRIENDS — A SHOPKEEPER D'ARTAGNAN HAD ONCE SAVED FROM DROWNING — HAD SEEN CONSTANCE TAKEN AWAY BY DE ROCHEFORT

IN A GIANT BED D'ARTAGNAN SLEPT WITH HIS THREE FRIENDS, ATHOS, PORTHOS AND ARAMIS, KNOWN TO FAME AS THE THREE MUSKETEERS. SUDDENLY D'ARTAGNAN STARTED AWAKE

A PEBBLE ON THE WINDOW!

HALLO, BELOW! WHO IS IT? WHAT'S WRONG?

'TIS I, MARTIN BRILLE, LIEUTENANT. COUNT DE ROCHEFORT HAS TAKEN THE LADY CONSTANCE AWAY IN A COACH. THEY HAVE TAKEN THE ROAD TO PLESSIS

IN TWENTY SECONDS, D'ARTAGNAN WAS BUCKLING ON HIS SWORD-BELT, READY FOR THE ROAD

AWAKE, FRIENDS — TO HORSE! DE ROCHEFORT HAS KIDNAPPED CONSTANCE. I'LL SADDLE OUR HORSES WHILE YOU MAKE READY

75/8

King's Musketeer (3)

TEN MINUTES LATER — THE ROAD TO PLESSIS!

ON, ON THROUGH THE LONG NIGHT GALLOPED THE FOUR FRIENDS. THEY WERE NOT TO KNOW THAT CONSTANCE WAS BEING TAKEN TO PLESSIS ON THE ORDERS OF THE CARDINAL, AS HE THOUGHT, FOR HER OWN SAFETY.

D'ARTAGNAN'S HOT BLOOD POUNDED THROUGH HIS VEINS AS HE THOUGHT OF CONSTANCE IN DE ROCHEFORT'S CLUTCHES

BY THUNDER, IF HE HARMS A HAIR OF HER HEAD, I'LL HAVE HIS LIFE! I SHOULD HAVE SLAIN THE DOG WHEN HE BETRAYED THE QUEEN YEARS AGO!

AT LAST, AS DAWN BROKE...PLESSIS!

AND NOW TO RESCUE CONSTANCE, THOUGH EVERY DEMON IN HADES SHOULD BAR THE WAY!

AS THE FOUR MUSKETEERS RACED TOWARDS THE CASTLE OF PLESSIS, DE ROCHEFORT HAD AT LAST LOST HIS PATIENCE WITH CONSTANCE

YOU ARE A TRAITOR TO YOUR KING AND TO YOUR MASTER THE CARDINAL. BE SURE I SHALL INFORM HIS EMINENCE OF YOUR TREACHERY!

SO YOU'D THREATEN ME, WOULD YOU, WENCH? VERY WELL, THEN. BEFORE THE SUN'S FIRST RAYS TOP THE HORIZON YOU WILL HAVE TOLD ME WHAT I WANT TO KNOW!

CONSTANCE SNATCHED A PIKE FROM THE WALL

STAND BACK FROM ME, COUNT. STAND BACK, OR IT WILL BE THE WORSE FOR YOU!

AH, IF ONLY D'ARTAGNAN WAS HERE. HOW YOU'D CRINGE TO HIM, FALSE COUNT!

A FIG FOR YOUR D'ARTAGNAN. HE'S MILES AWAY IN PARIS. AND IF YOU THINK THAT PIKE CAN HELP YOU, LOOK BEHIND YOU!

LION ISSUE DATED 19 OCT '63 FLEETWAY PUBLICATIONS. LTD. King's Musketeers (4) 7 5/8" over all H

The King's Musketeers

CONSTANCE REFUSED, AND, SEIZING A PIKE, SHE HELD THE COUNT AT BAY. SUDDENLY HE TOLD HER TO LOOK BEHIND HER. IT WAS A RUSE! THERE WAS NO-ONE THERE. BUT SWIFTLY DE ROCHEFORT GRABBED THE PIKE

DON'T BE SO FOOLISH, GIRL! BE SENSIBLE — YOU'LL BE RICH FOR LIFE IF ONLY YOU WILL TELL ME WHERE RICHELIEU HAS HIDDEN THE SECOND PRINCE

NEVER WHILE I LIVE!

UNKNOWN TO EITHER CONSTANCE OR DE ROCHEFORT, D'ARTAGNAN OF THE KING'S MUSKETEERS AND HIS THREE FRIENDS, ATHOS, PORTHOS AND ARAMIS, HAD BEEN RIDING THROUGHOUT THE NIGHT TO HER RESCUE. EVEN NOW D'ARTAGNAN WAS OUTSIDE THE GREAT DOORS OF THE CASTLE

LOCKED AND BOLTED, EH, D'ARTAGNAN? WELL, WE MUST GET IN SOMEHOW!

COME ON, LAD! WE'VE PRACTISED THIS JUMP MANY TIMES! YOU KNOW WHAT TO DO!

AH, PORTHOS, MY GIANT FRIEND! WHAT WOULD I DO WITHOUT YOU? QUICK, I HEAR CONSTANCE CALLING FOR HELP!

CONSTANCE! CONSTANCE! LOOK OUT — THERE'S AN OPEN WINDOW BEHIND YOU!

SUDDENLY, A WHITE FACE APPEARED AT THE BARRED GRILLE IN THE CASTLE DOOR

THAT WAS A GIRL'S SCREAM!

WHAT'S HAPPENING IN THERE? OPEN THESE DOORS IN THE KING'S NAME! WE ARE MUSKETEERS!

THE YOUNG LADY WHO CAME HERE WITH COUNT DE ROCHEFORT HAS FALLEN FROM A HIGH WINDOW. I'LL OPEN THE DOOR, GENTLEMEN, BUT I DON'T THINK ANYTHING CAN BE DONE FOR HER

STRUGGLING TO FREE HERSELF FROM DE ROCHEFORT'S CRUEL GRASP, CONSTANCE HAD TOPPLED BACKWARDS OUT OF THE WINDOW BEFORE D'ARTAGNAN'S HORRIFIED GAZE. HE SPED TO HER SIDE

CONSTANCE... CONSTANCE, MY DEAR... SPEAK TO ME...

LION ISSUE DATED 19 Oct 63 Kings Musketeers (4)
FLEETWAY PUBLICATIONS, LTD. 7 5/8

HE CLUTCHED THE DYING GIRL CLOSELY TO HIM AS WEARILY, PAINFULLY SHE OPENED HER EYES AND GAZED FOR THE LAST TIME INTO THE FACE OF THE MAN SHE LOVED

D'ARTAGNAN... TELL THE CARDINAL... I DID NOT BETRAY HIS SECRET BUT... DE ROCHEFORT KNOWS ABOUT... THE OTHER ONE!

AND RESTING HER HEAD IN D'ARTAGNAN'S ARM, CONSTANCE FELL ASLEEP — FOR EVER

MEANWHILE, THE TREACHEROUS DE ROCHEFORT WAS MAKING GOOD HIS ESCAPE. NOT FOR ALL THE RICHES IN THE WORLD WOULD HE HAVE DARED FACE THE AVENGING SWORD OF D'ARTAGNAN AT THIS MOMENT. ONE OF THE CASTLE SERVANTS, BELIEVING HIM TO BE LOYAL TO THE CARDINAL, LED DE ROCHEFORT TO A SECRET TUNNEL IN THE DUNGEONS OF THE CASTLE

THIS TUNNEL LEADS INTO THE WOODS OUTSIDE THE CASTLE, YOUR GRACE. 'TIS THE BEST I CAN DO FOR YOU!

YOU WILL BE WELL REWARDED. BUT REMEMBER YOU MUST TELL LIEUTENANT D'ARTAGNAN NOTHING! UNDERSTAND? NOTHING!

AND STEALTHILY, DE ROCHEFORT SLUNK AWAY THROUGH THE DANK, DAMP TUNNEL. BUT AS HE WENT HIS AGILE BRAIN WAS SEETHING WITH THOUGHTS OF HIS NIGHT'S MISDEEDS. WITHOUT DOUBT, THE DEATH OF CONSTANCE WOULD BRING THE WRATH OF THE CARDINAL DOWN UPON HIS HEAD

THEN THE CARDINAL MUST DIE! HE SAID HE WOULD FOLLOW ME HERE! I'LL TAKE GOOD CARE TO SEE THAT HE NEVER RETURNS TO PARIS ALIVE!

THROUGH THE CASTLE ABOVE, D'ARTAGNAN AND HIS THREE FRIENDS SWEPT WITH BLIND VENGEANCE IN THEIR HEARTS, SEEKING THEIR OLD ENEMY, THE MAN WHO HAD BROUGHT DEATH TO THE GIRL THEY ALL LOVED. BUT THERE WAS NO SIGN OF DE ROCHEFORT. AND IT WAS PORTHOS WHO AT LAST REALISED WHAT MUST HAVE HAPPENED

HE'S ESCAPED BY SOME SECRET PASSAGE. WE'VE SEARCHED EVERY INCH OF THIS DEN OF EVIL

BROKEN-HEARTED, D'ARTAGNAN WAS AT A LOSS TO KNOW WHAT TO DO NEXT. SUDDENLY...

LIEUTENANT D'ARTAGNAN! WHAT ARE YOU DOING HERE?

THE SPEAKER WAS NONE OTHER THAN CARDINAL RICHELIEU WHO HAD COME TO PLESSIS AS HE HAD PROMISED DE ROCHEFORT HE WOULD

YOUR EMINENCE, I SEEK THE TRAITOR, DE ROCHEFORT. BECAUSE OF HIM, MY LADY CONSTANCE IS DEAD. AS SHE DIED SHE TOLD ME TO TELL YOU SHE DID NOT BETRAY YOUR SECRET — BUT THAT DE ROCHEFORT KNOWS!

DE ROCHEFORT A TRAITOR? WHY, HE IS MY MOST TRUSTED OFFICER. BUT YOU AND HE ARE OLD ENEMIES, AREN'T YOU? YOU CANNOT ESCAPE PUNISHMENT BY LYING, LIEUTENANT. YOU AND YOUR FRIENDS ARE UNDER ARREST!

The King's Musketeers

527.

CARDINAL RICHELIEU CALLED TO HIS CAPTAIN OF THE GUARD...

DE JUSSAC, COUNT DE ROCHEFORT IS TO BE FOUND AND TAKEN DEAD OR ALIVE. DOUBTLESS HE WILL HAVE RETURNED TO PARIS, THERE TO COLLECT HIS BELONGINGS AND SECURE ALL THE MONEY HE WILL NEED TO MAKE GOOD HIS ESCAPE FROM FRANCE

GET YOUR MEN MOUNTED! WE WILL ALL HEAD FOR PARIS. KEEP A CLOSE WATCH ON D'ARTAGNAN AND HIS THREE FRIENDS, ATHOS, PORTHOS AND ARAMIS. NONE MUST BE ALLOWED TO GET AWAY

MEANWHILE IN A NEARBY INN DE ROCHEFORT WAS PLANNING NOTHING LESS THAN THE DEATH OF THE CARDINAL!

THIS IS THE HEADQUARTERS OF GASPARD OF THE BEARD, AN OLD FRIEND OF MINE. IS HE HERE?

YES, MY LORD. IN YONDER ROOM. I'LL CALL HIM

AH, GASPARD. SO WE MEET AGAIN, YOU ROGUE. TELL ME, HOW MANY MEN CAN YOU MUSTER ON THE INSTANT?

TWENTY PERHAPS...IT DEPENDS ON HOW MUCH MONEY YOU HAVE

MONEY? MORE THAN YOU EVER DREAMED OF, MY HAIRY FRIEND. GOLD AND POWER BEYOND DREAMS... IF YOU CAN SLAY CARDINAL RICHELIEU FOR ME!

SLAY THE CARDINAL? THAT'S A TALL ORDER, DE ROCHEFORT! BUT YOU WOULDN'T BE HERE IF YOU DIDN'T THINK IT COULD BE DONE. ALL I WANT TO KNOW IS — WHERE AND WHEN?

AS DE ROCHEFORT SWIFTLY UNFOLDED HIS PLAN FOR AN AMBUSH TO GASPARD THE BANDIT, D'ARTAGNAN AND THE THREE MUSKETEERS WERE RIDING, THEIR WRISTS MANACLED, BEHIND THE CARDINAL'S COACH

IS THERE THEN NO JUSTICE LEFT IN FRANCE? WHY DO WE RIDE IN CHAINS WHILE DE ROCHEFORT GOES FREE TO PERFECT HIS EVIL SCHEMES?

A GOOD QUESTION, D'ARTAGNAN, AND THE ANSWER LIES CLOSE AT HAND. I'M SURE OF IT!

THE NEXT DAY, THE COACH AND ITS ESCORT OF GUARDS SURROUNDING THE FOUR MUSKETEERS GALLOPED INTO A ROCKY DEFILE. AND THERE THEY WERE SEEN BY GASPARD OF THE BEARD

THEY COME! TO ARMS!

A MOMENT LATER, THE COACH RAN HEADLONG INTO A CROSS-FIRE OF MUSKET-BALLS. THE COACHMAN TOPPLED SCREAMING FROM HIS PERCH

SEVERAL OF THE CARDINAL'S GUARDS ALSO FELL UNDER THE HAIL OF BULLETS, AND AS HE WATCHED, DE ROCHEFORT SNEERED WITH TRIUMPH

NOW, GASPARD — PUT AN END TO THE CARDINAL'S LIFE!

AMIDST THAT STORM OF LEADEN DEATH ONE MAN KEPT HIS WITS ABOUT HIM — A MAN ACCUSTOMED TO THE SUDDEN SHOCK OF BATTLE AND AMBUSH — D'ARTAGNAN OF THE MUSKETEERS!

MY LORD CARDINAL! MUST I AND MY FRIENDS SIT HERE CHAINED WHILE BRAVE MEN DIE! GIVE US OUR LIBERTY! GIVE US OUR SWORDS — AND WE WILL SCATTER THESE COWARDLY KILLERS TO THE FOUR WINDS

THE CARDINAL HEARD AND GAVE THE ORDER OF RELEASE!

The KING'S MUSKETEERS

GOOD WORK, D'ARTAGNAN!

D'ARTAGNAN TURNED FROM THE BANDIT WHO HAD FALLEN TO HIS BLADE

SO! ONE OF THE KNAVES SEEKS TO ASSASSINATE THE CARDINAL

WITH THE SPEED OF LIGHT, D'ARTAGNAN DARTED TO THE OPPOSITE SIDE OF THE COACH AND IN ONE MIGHTY LEAP...

...LANDED LITHELY ON TOP...

...AND HURTLED DOWN ON TO GASPARD OF THE BEARD

NO LUCK FOR YOU TODAY, RASCAL!

D'ARTAGNAN'S SWORD GLINTED IN THE SUNLIGHT AND GASPARD FELL DEAD. LOOKING DOWN ON THE SCENE FROM BEHIND A SCREEN OF TREES, DE ROCHEFORT SAW GASPARD FALL AND KNEW THAT HIS PLOT TO KILL THE CARDINAL HAD FAILED — THANKS TO HIS OLD ENEMY D'ARTAGNAN OF THE MUSKETEERS

VERY WELL, THEN, BUT ALL IS NOT LOST! I WILL LEAVE FRANCE AND ONE DAY I SHALL RETURN. THEN, D'ARTAGNAN, BEWARE!

The Bookshelf Gats, Bats and Big Cats!

The Art of Reginald Heade
By Stephen James Walker
Hard-bound 168 pages
Telos Publishing Ltd
£26.99

The Golden Age Batman Omnibus Volume 3
Introduction by Dick Sprang
Art by Bob Kane, Jerry Robinson, Dick Sprang
Hard-bound 776 pages
DC Comics £55.00

All The Mowgli Stories
By Rudyard Kipling
Illustrated by Stuart Tresilian
Hardbound 272 pages
Macmillan Price variable

DESPITE THE FACT THAT Reginald Heade was the cover artist whose work epitomised the post-war era of hard-boiled detective fiction; despite the fact that his work was seen throughout the UK and beyond, and despite the fact that his art continues to be a source of fascination for his legions of fans, next to nothing is known about the man behind the name.

Frustratingly, this recently published retrospective of Heade's art does nothing to rectify this situation. On the plus side though, the book does present the most complete catalogue of Heade's prodigious output. One can only speculate about Heade's work ethic but, bearing in mind that he died at the relatively early age of 56, the man must have been something of a workaholic.

The art contained within this volume goes beyond the more familiar noir-esque depictions of sultry gangsters' molls, and includes everything from Heade's occasional forays into the world of comic strips, to his work for children's books and even a Philmar Jigsaw Puzzle: *The Steeplechase*.

The reproductions appear to be sourced entirely from print, and some of the images suffer as a result. But overall, a must for fans of great pulp art.

THE THIRD VOLUME OF this series spans the years 1943-44, with a superb cover image by the late Darwyn Cooke. By this stage of *Batman*'s genesis, both Bob Kane and (the criminally under-credited) Bill Finger were collapsing under the demands of their runaway success, and stories were being farmed to other talents within the *DC* stable.

The result was an enriching of both the look and tone of the series, which this volume reveals within its generously proportioned pages. The scripts play to the comedic as well as the darker side of Batman's milieu and the art, with Dick Sprang and Jerry Robinson's styles providing a contrast between dynamic cartoon and graceful classicism, is a delight to behold.

What lets this book down, as with previous volumes, is the quality of the restorations, which are, largely unchanged from the earlier *Archives* series. Some of the restoration work is excellent: there is a run of *Batman* comics which are crisp and clean, whereas the *Detective* and *World's Finest* restorations are murky and mediocre, resulting in a loss of detail.

Nonetheless, still the best way to delve into the early years of the Batman and a welcome addition to the shelves.

'ALL THE MOWGLI STORIES' first appeared in print in 1933. It is essentially a compilation of parts 1 and 2 of Kipling's 'Jungle Books'.

Despite the accusations of jingoism that have consigned much of this great writer's work to the literary wilderness, the stories within this collection pulsate with a dark and exotic allure, propelled by the over-arching narrative of a young boy brought up by wolves, deep within the forests of central India.

What makes this particular iteration of the stories so desirable is the coupling of Stuart Tresilian's magnificent illustrations with Kipling's text.

Tresilian, who also acquired a degree of popularity for his illustrations to Enid Blyton's 'Secret Seven' books, had previously provided the dust-jacket illustrations for Kipling's 'Jungle Books', but it wasn't until 'All The Mowgli Stories', that he was able to unleash his superb pen and ink artistry on these timeless tales. The results were breathtaking as this book reveals.

The book was in print throughout much of the latter part of the 20th century and is still easy to come by. For lovers of great storytelling and great illustration, it is an essential book

● *illustrators* is also available in the USA from **budplant.com**

illustrators back issues!

Issue 18: *Mort Drucker, Ernesto Cabral, Puffin Books, Peter Richardson, Katyuli Lloyd*

Issue 17: *Mort Künstler, Francisco Coching, Gustave Doré, Zac Retz*

Issue 16: *Neal Adams, Paul Slater, Will Davies, Cecil Glossop, Mort Künstler*

Issue 15: *Dave McKean, Andy Thomas, Sam Peffer, Jonathan Ball*

Issue 14: *Tara McPherson, Joe Jusko, Maurice Leloir, Adam Stower, Mike Zagorski*

Issue 13: *Mitch O'Connell, Jeff Miracola, Septimus Scott, Brooke Boynton Hughes, Tor Upson*

Issue 12: *Android Jones, Denis Zilber, Howard Chaykin, Sidney Sime, Arty Freeman, Philip Mendoza*

Issue 11: *Donato Giancola, Tomer Hanuka, James McConnell, Mike Terry, Freya Hartas*

Issue 10: *William Stout, Cynthia Sheppard, Patrick Nicolle, Amit Tayal, Wu Chen*

Issue 9: *Bruce Pennington, Miss Led, Eric Parker, Will Terry, Bryn Havord*

Issue 8: *Les Edwards, Bart Forbes, Sidney Paget, John Haslam, Bernie Fuchs, Zelda Devon*

Issue 7: *Alan Lee, John Vernon Lord, Bernie Fuchs, Leif Peng, Mark English*

Issue 6: *Walter Wyles, Dave Gaskill, Graham Coton, Laurence Fish, The Illustrators Workshop*

Issue 5: *Mick Brownfield, Brian Sanders, Derek Eyles, Anne & Janet Grahame Johnstone*

Issue 4: *Mike Johnson, Chris McEwan, Pan Horrors, Leslie Ashwell Wood*

From The Inside: A Bad Idea

Sometimes even the greatest artists can have bad ideas. This was Norman Rockwell's worst idea ever.

ONE OF THE MOST BELOVED ILLUSTRATORS OF ALL TIME was Norman Rockwell. His paintings of the American people gave viewers a look into the typical American family and their social mores. Nicknamed 'America's most popular artist', Rockwell's cover paintings provided a strong motivation to buy any magazine. His uncanny sense of enticing us into the American family during their dinners, holidays, and work, made the American way of life endearing, albeit from a purely whimsical and nostalgic point of view. Rockwell also brought a sense of humour into his paintings evoking the reaction "the same thing happened to me". However, there are times when even a good idea can backfire. Such was the case with *Mrs. O'Leary's Cow*.

For those of you who aren't familiar with the story, which incidentally was true, it involved a certain Mrs. O'Leary who was milking her cow: the cow kicked over a kerosene lantern, and caused the great Chicago fire of 1871. While in reality this was a disaster that killed 300 people, destroyed nine square kilometres of the area, and left 100,000 residents homeless, the incident in itself seemed highly humorous—a cow started a fire that nearly destroyed a whole city!

Rockwell set out to paint the irony of it all and thought it'd be a great idea for a calendar: "So I painted it," Rockwell reminisced in his autobiography. "Rear view, the cow's behind prominently displayed, occupying, in fact, the better part of the picture—and Brown and Bigelow published it." How popular was the calender? It turned out to be Rockwell's worst failure.

The painting itself wasn't bad, but who would want to look at the rear end of a cow for twelve months? To make matters worse Mrs. O'Leary was a hefty and homely middle-aged woman, so not even a hint of feminine allure to rescue the painting.

As Rockwell pointed out: "What you want in a calendar is a quiet sentiment… Something that will last for an entire year, that people won't get tired of looking at. Nostalgia's good. Or a pretty girl. Or a bouquet of flowers. A joke is bad; it's sure to pall by April. To fill a calender with a cow's hind end is sheer folly."

Even the masters make mistakes! ●

RIGHT: *Mrs. O'Leary's Cow* oil painting circa 1945. Published as a calender by *Brown and Bigelow*. Would you like to stare at this image for a whole year?